LIGHTS!
CAMERA!
ADVERTISING!

LIGHTS!

CAME

Joy Satterwhite and
Al Satterwhite

RA!
ADVERTISING!

AMPHOTO
AN IMPRINT OF WATSON-GUPTILL PUBLICATIONS/NEW YORK

Joy Layman Satterwhite is the co-owner of Satterwhite Productions, where she is executive vice president of sales and production. **Al Satterwhite** is a well-known commercial photographer whose award-winning editorial, corporate, and advertising work is highly visible. Satterwhite Productions is expanding into the motion-picture industry and recently moved to Concord, Virginia.

Editorial Concept by Robin Simmen
Edited by Liz Harvey
Designed by Bob Fillie
Graphic Production by Ellen Greene

Copyright © 1991 by Joy Satterwhite and Al Satterwhite
First published 1991 in New York by AMPHOTO,
an imprint of Watson-Guptill Publications,
a division of BPI Communications, Inc.,
1515 Broadway, New York, NY 10036

Library of Congress Cataloging-in-Publication Data

Satterwhite, Joy.
 Lights! Camera! Advertising! / Joy Satterwhite and Al Satterwhite.
 Includes index.
 ISBN 0-8174-4206-5 ISBN 0-8174-4207-3 (pbk.)
 1. Photography, Advertising. I. Satterwhite, Al. II. Title.
TR690.4.S28 1991
770′.92′2--dc20
 91-7844

Manufactured in Singapore

1 2 3 4 5 6 7 8 9/99 98 97 96 95 94 93 92 91

CONTENTS

The question that Al and I are asked most frequently during our seminars is: Will you do work-for-hire assignments? The mere thought of giving up the copyright to a photograph or the rights to an entire shoot for the same fee that photographers earned while maintaining the copyright, makes many photographers' blood boil. Photographers can't resell a photograph if they don't own the rights to it.

At one time, photographers made a great deal of money and had very large expense budgets. But a number of photographers started abusing the agreements that they had made with their clients, completely disregarding business ethics. Agencies were forced to change their policies to correct for the greed. Although the agencies overreacted, most photographers chose to fight rather than to work with the agencies and take responsibility for what other photographers had done.

Photographers abused clients in other ways as well. They shot jobs that were paid for but when a client wanted to extend the campaign and tried to buy additional usage, photographers charged exorbitant prices. They felt they could get away with this unethical practice because the fees were cheaper than the cost of a new advertisement. The agencies got into trouble with their clients, and an all-out war was waged.

First, the agencies came up with the idea of art buyers; then they began using such phrases as "work for hire" and "total buyout" on purchase orders. Next, the agencies put account executives in charge of the shoots because art directors weren't behaving responsibly. But the account executives were not always "talented" visually and would sometimes abuse the power they enjoyed because of their direct line of communication with clients. This situation both prompted the art directors to fight with the account executives and placed photographers right in the middle of the conflict. At this point, photographers were subjected to tricks involving financial commitments. Each abuse by one group caused the other group to think up ways to retaliate.

In addition, rumors of the large sums of money that could be made glutted the market with get-rich-quick photographers. They didn't think in terms of career planning or reputations, and they didn't know how to produce or to provide clients with good service. Furthermore, they didn't care. As a result, all photographers are suffering. Fees are going down, and overhead expenses are going up. And for the first time ever, advertising-photography rates seem more like the much lower editorial-photography rates. Don't misunderstand me. I blame agencies and their clients for hiring photographers with bad reputations or, even worse, no experience at all. Advertising is about art, but it is mostly about production and client service—delivering a job.

I know that other photographers want to learn how Al shoots and comes up with his ideas. Although this information is included in this book, I feel that the most important aspects of his career have been his business ethics and practices as well as his ability to solve problems while producing a job without giving the agency and its clients a headache. Also, when Al and I give an agency a bid, we stand by it. When we say we have a solution, we deliver.

Everything in life is cyclical, and I hope that Al and I are still working when creativity again becomes the main objective in advertising. In the meantime, we have to work within the boundaries of the business. This is why I wanted to write this book—to show the experience behind Al's work and to help everyone involved in the business, not just photographers. I hope that account executives, art buyers, art directors, assistants, clients, and any other advertising professionals read this book. Communication can lead to understanding and perhaps more cooperation. I want to inspire at least one person to reach higher, to create a stronger photograph, and to maintain better and more professional business relationships, thereby setting a good example for those to follow. It is my deepest wish that Al and I, by our actions, raise industry standards.

Almost 30 years ago, I began my photography career with a couple of Nikons, a few lenses, and a lot of enthusiasm. Today, I own enough equipment to fill a small camera store. I travel with five or six assistants and sometimes an equal number of support people. I am responsible for hundreds of thousands of dollars in client expense money. Back when I was starting out on the newspaper, however, I spent all my time trying out new techniques and ideas, attempting to catch up with my peers and beat out the local competition. I wanted to learn as much as possible, so I looked at photographs everywhere I went. I soon noticed that certain pictures really grabbed me and that they were usually taken by the same photographer. I wanted to develop my own style and to stand out from the rest. I started shooting for myself instead of for my editors.

Magazine editors noticed a trend in my work and gave me feature assignments. Once I proved myself on those jobs, I was given cover assignments. But after a number of years, I started to feel that editors wanted only the same type of picture over and over. I got bored and decided to investigate other areas of photography. First, I tried corporate photography. I was treated with more respect and given much more leeway to experiment with and expand my style of shooting. Nevertheless, after quite a few years, I switched to advertising photography. This specialty required me to use all the knowledge, experience, tricks of the trade, and creativity that I possessed. It became a big challenge to move into large-production work that called for a good-size crew and support team. Advertising photography also called for a change in my thinking. But change doesn't come easily for me. I had used the same Nikon F2 cameras and Kodachrome 25 film for the past 16 years. I now use the new computerized Nikon F4 and a computer. Soon I'll even be doing my own retouching and final picture composition on a computer. I think photographers should remain in charge of the entire creative process, all the way to the finished transparency or separations.

To give you a comprehensive look at advertising photography, I chose projects that reveal different aspects of what this type of work entails. Almost anyone can take a good picture at some time. But true professionals can make good shots day in and day out, under ideal or adverse conditions. And a great picture has to have soul. This comes when you love your work because how you feel about what you're doing shows through. You must also be willing to spend the time needed to master your craft. You can't just go to a photography school or spend a few years assisting a photographer, and then turn into an instant success. You have to pay your dues, gain experience, and develop a distinctive but versatile style in order to succeed.

You also have to be aware that the advertising industry is changing; it is getting cheaper and is looking for more grip-and-grin pictures. Art directors don't seem to care about creativity, production value, or experience any more. The "money people" are in charge, and only the bottom line is important. To encourage creativity, money people should think in terms of balancing the number of "money" accounts and the number of creative "showcase" accounts they bring to the agency. The type of client that they deal with usually wants to limit creative impulses in order to guarantee a sure thing. This situation has caused agencies to come up with formulas. But they have forgotten—or have chosen to ignore—that creativity can't be controlled. The creative process also needs time to develop so "planned accidents" that culminate in brilliant original work can occur.

Despite the constraints I am faced with, I continue attempting to come up with something that has a creative value. I start with a layout or an idea, add my thoughts, and through teamwork with the art director and my crew members—and, if I am lucky, with the cooperation of the money people—I create. I am still hopeful and excited about the future. I look forward to the next wave of challenges the advertising-photography world will pose.

Al received an assignment from a boat manufacturer that gave him total creative freedom. He could shoot the boats any way he wanted to because the company was willing to design the advertisement around his photograph. The client loved the shot. When the company's usage rights expired, Al put the outtakes into The Image Bank. Years later, Robert Bruenig, a creative director at Ogilvy & Mather, also referred to as O&M, in Frankfurt, Germany, pored through the Frankfurt Image Bank files in order to come up with an idea that would land O&M the coveted Tuborg Beer account. All of the major advertising agencies in Germany were competing for this large, prestigious assignment.

When Robert came across the photograph of two boats shot from a helicopter with a fisheye lens to make them appear to be cruising around the top of the world that Al had done for the boat manufacturer, Robert decided that this was a unique idea. Using a fisheye lens was new to Robert. To his recollection, no one had used the fisheye lens for any major advertising campaigns within the last 10 years. Robert also liked the special way that Al had used the lens: taking a small area and making it appear large.

So, Robert took the photograph and paid The Image Bank for *comp usage*. This means that a shot will be made into a dummy advertisement for internal use only and will never run. Next, Robert showed the picture to O&M and described some of his other ideas that he thought would look interesting shot with a fisheye lens. But the agency didn't want to spend money on a photo shoot while it was just pitching the account to the client. So it tried to find more fisheye shots done in the same manner as the one that Al had done. O&M went to every stock agency in Germany but found none. So Eva Jarchow, O&M's art buyer, was asked to contact Al to see if he had any fisheye-lens shots that weren't in The Image Bank.

LANDING A MAJOR ACCOUNT

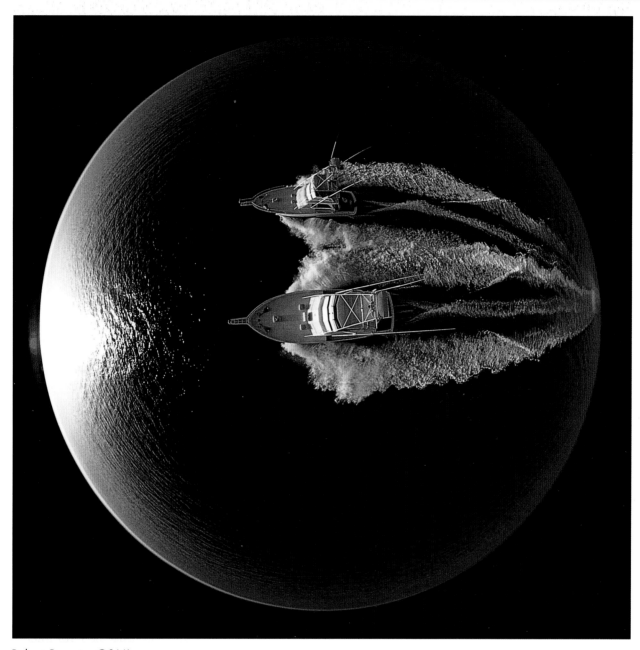

Robert Bruenig, O&M's
creative director, developed
the Tuborg Beer campaign
around Al's stock shot of
two boats taken with a
fisheye lens.

Because Al would be using an 8mm fisheye lens, he would have to be very close to the subject or it would look like a little dot.

When I told Eva that Al didn't, she wanted to know if he intended to shoot with a fisheye lens in the near future. I explained that the lens was popular back in the 1960s and 1970s and that Al hadn't had a request for this rather dated look during the last 10 years. I pointed out, however, that O&M and Tuborg could bring the look back. When I asked her what she specifically had in mind, Eva mentioned that Robert was considering a car, a water sport, and perhaps a land-based sport. I told her that if O&M were willing to pay for Al to go to Florida—an ideal location for this shoot—we would consider this a stock shoot and allow her to have first pick of the shots, which she would then purchase through The Image Bank. She thanked me for the information and ended the conversation.

I didn't think too much about our discussion. When agencies look for stock shots, they have a limited budget and can't afford to send a photographer on location. To my surprise, Eva called back the very next week to inform me that O&M was willing to pay for Al's travel expenses. She also told me that Robert had made a few suggestions about what he wanted to see in the photographs: an old, red Cadillac convertible being driven over a bridge; an airboat in the Everglades; a man tied to a parachute being pulled by a motorboat; and either two jet skiers side by side, two golfers, or two surfers.

I responded that these weren't suggestions; they were rigid specifications. When clients ask us to shoot specific subjects, they're asking us to shoot an assignment. For stock shots, Al photographs whatever he can find. Robert's ideas, on the other hand, required planning, production, permits, and talent. Eva thought about my comments for a moment and then asked me to do an estimate based on Robert's guidelines. She wanted to present all of this information to the other people on the account. I promised to have the numbers for her the following day.

As I calculated the figures, it became obvious that shooting what Robert wanted would be expensive. I had to make quite a few long-distance calls to Florida to investigate options before Al and I could decide on the best way to go, keeping in mind possible creative and budget constraints. After I transmitted the estimate, I didn't hear from Eva for a week and was dismayed. This project was starting to pique Al's interest—as well as mine. So Al urged me to call and find out what was going on. Eva told me that the agency was presenting the numbers to the client that week. She said she would get back to me. (I didn't know that the agency was pitching the account; I thought that it already had the account.)

The O&M team had a successful meeting with Tuborg Beer, during which it introduced the campaign slogan: "Those who know the world, know Tuborg." O&M also had a comp made up using Al's fisheye-lens boat shot and the slogan. Tuborg loved the idea, and the agency won the account. O&M then presented the budget for shooting the other ideas for the campaign, but Tuborg wasn't willing to spend the amount of money required; it wanted O&M to continue looking for stock images. So the agency launched a worldwide search for graphic fisheye-lens shots. When O&M told Tuborg that it had had no luck, the client wanted to investigate other avenues to create this campaign. After six months had gone by and Al and I hadn't heard another word, we felt sure that the numbers had frightened the client off and that the project was probably dead.

So when Eva called to ask about Al's availability, we were elated. We spoke to Robert over the telephone, who said that the client wanted us to shoot six different "motifs," as layouts are called in Germany, and described them in detail. He had developed the Tuborg campaign around Al's original boat shot; it was also going to be used in the campaign. Robert wanted the bulk of the pictures to be simple, with the

focal point to appear to be at the very top of the world and no visible horizon. The first shot would show a vintage, red Cadillac convertible with a couple driving across a bridge; the only other element in the picture would be water. An airboat making a wake in the Everglades would be the second shot. The third photograph would show a parasailer, the boat pulling him, and water. Four jet skiers in an interesting formation out on the open water would constitute the fourth image, and the fifth shot would show three windsurfers on the water. The last photograph would be of two golfers near a hole surrounded by empty greens and fairways.

While listening to Robert's ideas, I immediately thought about having to find a bridge in Florida where we could block traffic. I would also have to locate a golf course willing to close down for a shoot during prime season. I wondered if we would have trouble with the Federal Aviation Agency (FAA); shooting over open water from a helicopter was probably fine, but shooting over public property might not be. Because Al would be using an 8mm fisheye lens, he would have to be very close to the subject or it would look like a little dot. My next concern was Al's safety. In order to avoid including the skids in the shot, he would probably end up hanging out of the helicopter, which is dangerous.

At the same time, Al was thinking about how to rig the camera below the helicopter's skids and how he would see what he was shooting. He determined that he would have to stand on the skids and hang over with the camera in his hands. He also knew that looking through the viewfinder and holding the camera steady to crop out the horizon would be difficult; using a sports viewfinder would enable him to view the image from a distance. Al then realized that he would practically have to sit on the talents' heads in order for them not to look like dots in the shot. He also wondered whether the pilot would have to hover 20 feet

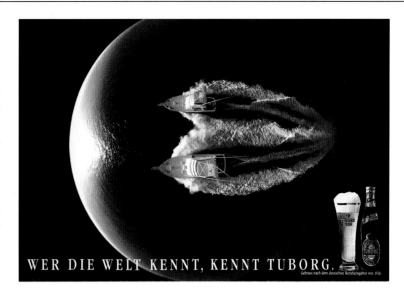

Tuborg used Al's fisheye-lens shot for both a billboard (above) and a single-page advertisement (below).

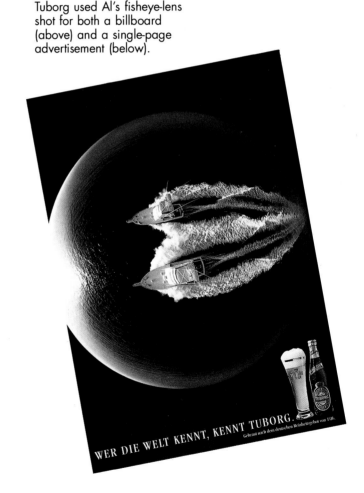

above the models, whether the FAA would allow this, and whether the golf course would agree to this.

I then explained to Eva that due to all this new information, I had to rework the numbers. I promised to give her a production schedule and asked her what the usage would be. She said that Tuborg wanted to run the ads and billboards in Germany only. But she thought that I should also provide a price for usage in Europe. To cover all bases, I decided to send her a firm estimate that included breakouts on usage for Europe and the world.

Later that day, I called the Florida Film Commission and was given the names of contacts for several of the locations that I needed to track down. Surprisingly, everything fell into place quickly. Securing the bridge and finding a golf course were simple. The only problem was that park officials didn't want me to shoot in the Everglades because Florida was having a drought and they were worried about fires. But luckily I came upon a man who owned marshland and a fleet of airboats. He said that he would be delighted to work with us. Next, I called the Act I agency in Florida and spoke to the owner about the stunt people I needed for the water-sports shots. She told me what I should include in my budget for talent and told me who to contact to rent a parasailing rig and boat. A dozen telephone calls later, I not only had accurate numbers for the estimate but I also had the job practically produced. I transmitted the numbers and a tentative production schedule to Frankfurt before the end of the day. I also enclosed a letter to Eva explaining how Satterwhite Productions operates; I told her that we require a cash advance and a purchase order before work can begin.

The next morning at 9:00 AM sharp Eva called to let me know that the numbers had been approved and that my terms were acceptable. She said that she would send me a copy of the purchase order via a fax machine and put the original in the mail. She also promised to call O&M's New York office to arrange for my cash advance of 100 percent of the expenses. From this point on, I was deep into production.

In the meantime, Al booked his assistants, Dennis and Bruce, and called J. P., the pilot he had hired, to discuss the helicopter. Al knew that he would have trouble getting the camera below the helicopter's high skids. He came up with several ideas, but he couldn't try them out until we arrived in Florida and he saw the ship. I had deliberately built a lot of prep time into this shoot because there were so many potential problems. The extra time would also protect the agency from paying weather-day expenses. Since Al would be shooting only two to three hours a day when the light was golden, he was free the rest of the day to do other work. I had also scheduled a couple of production days for casting, finding props, and doing anything else that was needed. Next, after making travel arrangements, I sent the information via a fax machine to Eva so Robert could make corresponding plans.

We then flew to Miami with two assistants and twelve cases of gear, rented minivans, and headed for the hotel in Coconut Grove. As Al and the assistants unloaded the equipment and sent it to the proper rooms, I checked in and found Robert. We set up a production meeting over lunch, during which I gave Robert and the assistants an updated production schedule and discussed our plan of attack with them.

During the casting call later that day, Robert and I discovered that we had the same taste and that we thought along the same lines. We were quite pleased with the jet skiers and the parasailers but were able to find only one suitable golfer. We wanted the models for the golf shot to be tall and thin because Al would be photographing them from above in a helicopter, using an ultrawide-angle lens; this would make them appear shorter and fatter. Hiring windsurfers also required special attention. We needed

Park officials didn't want me to shoot in the Everglades because they were having a drought and they were worried about fires.

people who were experts at water sports because a helicopter hovering low over them could be dangerous. We wanted pros with quite a bit of stamina; we didn't want any accidents resulting from inexperience or fatigue.

On our second day in Florida, we were going to scout two golf courses. I preferred one but had the other as a backup in case Robert didn't approve my first choice. At the first golf course, I introduced myself and my crew to the manager. He had arranged for us to scout the green in three golf carts: one for Al and Robert, one for the two assistants, and one for him and me. Robert liked the course. Then after we took a look at several holes, he and Al settled on one situated near the end of the course and surrounded by trees and the green. Al felt that he would be able to crop out all of the undesirable scenery and calculated that the helicopter would have to hover about 20 feet off the ground.

The manager agreed to work with us and promised to keep people away from the surrounding holes. But he wanted to be named as co-insured and wanted us to work very late in the day. I asked him if he knew any tall, lanky professional golfers who might be willing to be in our shot; we would, of course, pay them. I liked one of the men he introduced me to, so I hired him. Before we left the golf course, I bought several items in the pro shop for the models' wardrobe and arranged to have several golf carts available the day of the shoot.

Next, we left for the bridge, a two-hour drive away. The bridge is crossed infrequently, so we were able to park the minivan in the middle of it for quite some time before having to move to let someone pass. Al and Robert climbed on top of the van, and Al asked Robert to imagine the shot. He explained that the bridge would appear fat in the middle and would taper off onto the land, only a little of which would be visible at either end. This would make the car seem to be driving from one continent to another.

On the ground, Al's assistants had been taking readings of the sun's position. Al set up a camera with the fish-eye lens on a monopod. He then held the monopod at arm's length above his head and shot a couple of Polaroids and a roll of Polachrome. While we moved the minivan in order to let a truck cross the bridge, Al developed the Polachrome. Viewing the tests gave Robert a better idea of how the final shot would look. Although Al, the minivan, and the monopod are all in the tests, Robert was able to see the amount of distortion and the approximate framing. He liked the tests. Afterward, I stopped by the local offices governing the area and made final arrangements for us to shoot on the bridge—mostly paperwork—and secured police protection.

The next day, Al, the assistants, and I went to the launch site near Biscayne Bay where we arranged to meet the talent for the next two days of shooting. When we arrived, Al realized that we needed very strong jet skiers because he would have to leave the bay area to be able to shoot water without the shoreline showing. Fortunately, all three jet skiers were professionals. Al then went over to the heliport to talk to J. P. and coordinate their schedules. I left to finish the arrangements for the next 10 days.

The golf course was set. All of the bridge paperwork was in order, but I double-checked to make sure that we were still cleared to shoot there. I also called the police to verify the traffic-control officers. Then I called the airboat owner to confirm our meeting with him; I had hired him for the entire day to take Al and Robert scouting. He owned the land, so I didn't have to file for any permits. But I did want to check his wardrobe. Finalizing plans concerning the windsurfers would have to wait until Robert was with me because I wanted him to choose the sails. I did, however, make some telephone calls and located a place that could supply the windsurfers and additional talent.

We needed people who were experts at water sports because a helicopter hovering low over them could be dangerous.

At the heliport, Al held a conference to explain how he had decided to shoot the required images during the next two weeks.

After Bruce and J. P. removed the door on Robert's side of the helicopter, Bruce helped Al put the finishing touches on his safety rig.

At the heliport, Al worked on preparing to shoot out of a Bell Jet Ranger. He tried mounting the camera on a monopod and holding it below the skids. But even with a sports viewfinder, he had difficulty seeing the edges of the lens and judging whether or not the horizon line was level and out of the shot. Al realized he actually had to stand on the skids and bend over while tethered to the helicopter by two safety harnesses. This was the only way for him to be close enough to the camera to look through the viewfinder and keep the camera level. Out on the skids, Al couldn't wear a headset, so he wouldn't be able to hear J. P. nor talk to him. To make communication possible, Al and J. P. worked out hand signals that the pilot would be able to see if he flew with the helicopter door off.

The following day, everyone met at the Biscayne Bay unloading point. Al and I assigned one of the jet skiers as the lead since none of us could go out near them and the walkie-talkies would be useless with the noise from both the jet-ski motor and the helicopter. Al and Robert went over the formation they wanted the jet skiers to create, and Al told the lead skier which hand signals would indicate when he was finished with one sequence and ready to move onto the next one. Al also informed the lead to take the other skiers out of Biscayne Bay, away from land and that he would be working 20 to 30 feet above their heads. He explained that they would get into formation and the helicopter would follow. Flying slowly would be hard on the engine, so occasionally they would take off to circle for a while and then come back down. The lead met with the other jet skiers to relay these instructions. Then they suited up and headed out, and Al, Robert, and one assistant left for the heliport that was 10 minutes away. I remained behind with another assistant and waited.

At the heliport, Al put on his working jumpsuit; it protects him from the wind and has numerous pockets for

film and gadgets. He got into his mountain-climbing harness and stood on the skids while the assistant connected it to the support. Next, Al leaned over and the assistant got rid of the slack. The second safety harness was then connected to the ring at the bottom of the helicopter, and the film, cameras, and lenses were organized. This task was simple because Al planned to shoot with only a Nikkor F2.8 8mm fisheye lens. He had brought along two fisheye lenses—one that he owns and one that he had rented—so while he was shooting with one camera, an assistant could be loading the other camera.

Within 20 minutes, the preparation was complete and the helicopter was ready to take off. Out over the ocean, Al and J. P. quickly found the jet skiers. Al had the pilot lower the ship and then signaled the lead to head into the sun in the first formation. Photographing the skiers was quite difficult because Al had to be very low so that the small jet skis would be identifiable in the shot. The bay area was protected by land, but out on the ocean, the weather was brisk and the water was a little choppy. The jet skiers had to travel about 30 minutes out into the ocean and then do maneuvers for 60 minutes knowing that they had another 30-minute trip back to the loading ramp. But they held up and did a fabulous job. Afterward, Al was disappointed that he couldn't get closer to the skiers, but each time he had tried, the helicopter kicked up lots of water. Robert, however, was pleased with the Polachrome and thought that the shot was great.

After lunch on our fifth day in Florida, we headed out to the loading ramp. The lead man from yesterday's shoot was going to be our parasailer. Everyone was nervous about this shot because the parasailer would be drifting 100 feet above the water. If the helicopter got too close to him, it could take the air out of his sail and send him crashing to the water below. The impact would probably kill him. Al

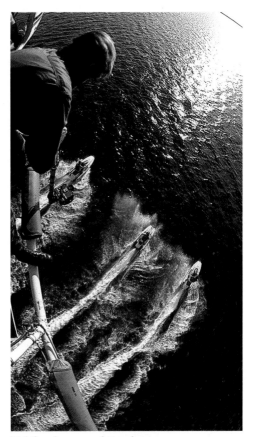

Al realized he actually had to stand on the skids and bend over while tethered to the helicopter by two safety harnesses.

While photographing the jet skiers over the ocean, Al stood on the skids and held the camera at arm's length to keep the helicopter out of the shot.

This was the tightest shot that Al was able to achieve with his 8mm fisheye lens. When he tried to move in for an even closer shot, the sail collapsed and the stuntman started to drop.

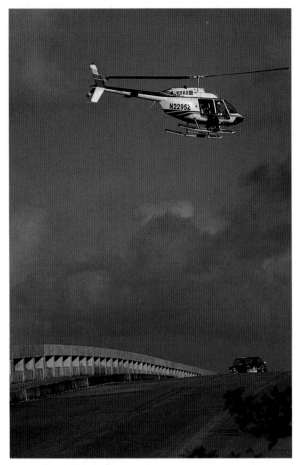

Once the police officers prevented other cars from going over the bridge, Al photographed the convertible as the driver crossed the bridge several times.

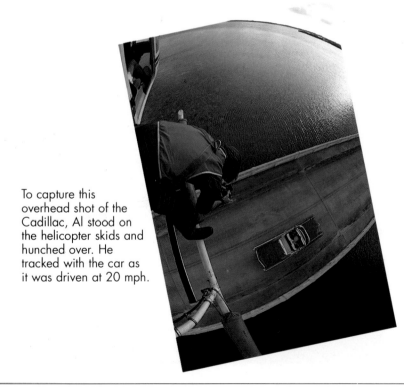

To capture this overhead shot of the Cadillac, Al stood on the helicopter skids and hunched over. He tracked with the car as it was driven at 20 mph.

and Robert agreed that they would do what they could to get the picture but that if there were any problems, they would forgo the shot.

Fortunately, and to everyone's great relief, this dangerous shot went well. But once again, Al was disappointed that he couldn't get closer to the models. He had inched his way in as far as he could go, and at one point the parasail had partially collapsed and the stuntman had started to fall. J. P. backed off immediately. The sail reopened, and the stuntman floated back up. Al didn't go in again. He had already covered the shot with both a 16mm lens and a 20mm lens and hoped that the art director would be able to strip one of the closer images of the sail into the original shot of the boat on the ocean.

The next morning, while I loaded the car and met the models in the lobby to drive out to the bridge, Al went to the heliport for the 30-minute ride to the bridge. I had to get there early to sign for the car and to meet the traffic coordinators. The ride wasn't uneventful. As I was driving, I suddenly noticed a red Cadillac convertible going in the opposite direction. Obviously, the driver was lost. I honked my horn and blinked my lights but the other car whizzed past. Without warning the models, I immediately made a U-turn in heavy traffic and took off after the convertible. I caught up with it and beeped several times. Finally, the driver realized that I must be the person who had arranged for the car and pulled over.

When we got to the bridge, I learned that the traffic control officers I had hired had come and gone because we were late. I called the police, apologized, and promised to pay the officers from the first time that they had arrived. They agreed to come back. As soon as they returned, I explained that we needed the bridge blocked off from both ends. The convertible would then cross the bridge in one direction (toward the sun), and the helicopter would follow it. I also mentioned that

we would have to repeat this several times, so any blocked traffic would be able to cross the bridge while the convertible returned to its starting position. Next, I asked the officers where J. P. could land. They suggested that he use the bridge—just the answer I wanted. We were about ready to begin, so the models got into wardrobe and were given instructions on handling the car. I cautioned the driver not to pull any stunts in the car; we simply wanted him to drive at a steady pace across the bridge.

Then I heard the blades of the helicopter as it approached and talked to Al by radio. I told him that the traffic-control officers had given him permission to land on the bridge, so J. P. set the ship down. Al got out and ran over to talk to the models. He told the driver to go 20 mph, explained how he was going to photograph him, and worked out some hand signals. To enable everyone involved to hear our directions, an assistant gave the officers a radio, put another radio in the convertible for the models, and took one with him that he would use in the helicopter if necessary. Al would have his hands full already.

During the shoot, I stood on the ground out of frame and took production shots of Al working. The scene looked fantastic from my vantage point. The driver did a great job and took direction well. The helicopter hovered slowly just 15 to 20 feet above the car and each time it reached the end of the bridge, J. P. would zoom up into the air and circle before making another pass. This photograph ended up being a favorite of Robert's. The bridge looks like it spans the upper hemisphere, connecting two continents.

The next day, because the golf shot was all set, I decided to work on the windsurfer shot. I asked Robert to accompany me to the beach to choose sails and models and to negotiate with the windsurfing concession owner. I described the shoot in more detail to the owner. The Polachrome fascinated

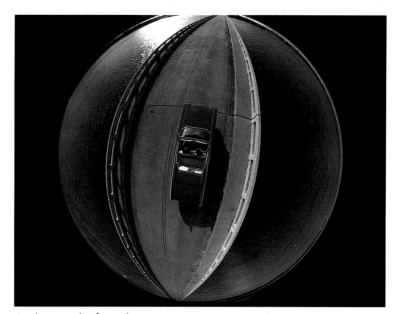

As this outtake from the bridge shoot shows, the closer Al got to the subject, the more distorted the center of the picture became. Here, Al was 20 feet above the car.

Robert particularly liked this image because the bridge appears to join two continents. The final photograph was made into a billboard and a single-page print ad.

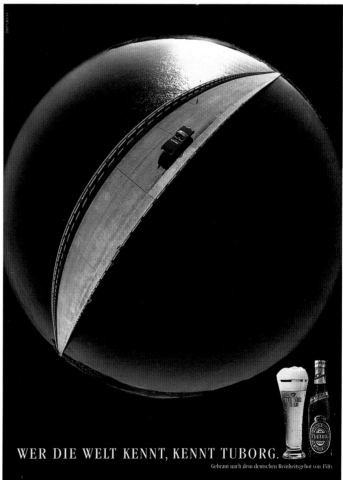

WER DIE WELT KENNT, KENNT TUBORG.

Gebraut nach dem deutschen Reinheitsgebot von 1516.

him. His rates were quite reasonable, so I arranged to rent four windsurfing rigs. Then Robert selected sails, and we put them on reserve. I mentioned that we were looking for experienced windsurfers who could last at least six hours in the ocean. I also explained that as Al photographed the windsurfers from the helicopter, they would have to be able to handle the down draft pushing the sails. The windsurfers would need to be skilled enough to stay in a formation. The owner was an expert windsurfer and knew three others who could help us.

Late in the afternoon the following day, we shot the golf course. Robert, Al, and an assistant went to the heliport to suit up. I went with another assistant and the model we had hired to the golf club and met the manager. The golf professional I had hired to be the second model was there. I gave both models their wardrobe and earplugs. I told them that Al insisted that they wear the earplugs because he would be working very close to them and that the helicopter noise might damage their hearing. The manager secured two golf carts for us to use. The models got in one, the assistant and I got into the other, and we headed out to the hole. We set a golfbag down near the hole, positioned the models as Al had instructed, and gave them some directions. The assistant then hid the golf carts under some trees.

When the assistant and I heard the whir of the helicopter, we quickly ran to hide under the trees. Al was hanging out the helicopter as it hovered 10 to 12 feet above the heads of the golfers. J. P. maneuvered the helicopter to hide its shadow within the shadow of the trees. Al shot for a while, and then the helicopter took off and circled. Al and J. P. repeated this procedure several times. While the helicopter circled, the assistant and I ran out and made any changes that Al had radioed to us. The models were having a rough time. The helicopter kicked up a great deal of sand from the sandtraps, and it was getting in their eyes. I told the

The helicopter kicked up a great deal of sand from the sandtraps, and it was getting in the models' eyes.

models that they could keep their clothes for being such good sports. Al shot until just past sunset even though there was a cloud cover and the light was diffused.

Back at the hotel, Al and Robert told me that they weren't pleased with the shoot: they had hated the weather conditions, and Al said that the sand had really been a problem. He wasn't satisfied with his shooting position either. In order to hide the shadow of the helicopter in the trees, he had had to shoot into the sun—the little there was of it. I had been doing very well with the budget, so I suggested that we try the shot again the morning I had originally scheduled to arrange the windsurfer shot; I had already finished that prep work.

When I called the manager of the golf course, he agreed to allow us to do a reshoot three days later if I would pay an additional 150 dollars to replace the sand in the sandtraps and repair the green on which the helicopter had leaked oil. Al asked me to tell the manager to have the sandtraps hosed down, and the manager thought that this was a good idea and that it would prevent the problem of blowing sand. Both Al and J. P. were surprised about the oil spots found on the green. They decided that the manager must be mistaken because helicopters don't leak.

The next day, we drove to the Everglades to meet up with the airboat owner, who was also going to be our model for the shot. After touring the area in the airboat, Al and Robert told the owner that they were interested in a section with tall grass and a narrow waterway. The owner had no problem with their choice. Then I looked through his shirts and hats but couldn't find anything that looked like what we had in mind. I told him that I would buy him a hat and shirt and that he could keep them.

The airboat shoot began early the following morning because Al wanted the sun in the East. Dennis and I drove to the Everglades while Al and the rest of the crew headed to the heliport.

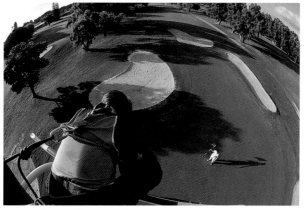

Al hovered approximately 12 to 15 feet over the golfers' heads. Unfortunately, this short distance made the shoot an unpleasant experience for the models; they had to contend with sand blowing into their eyes.

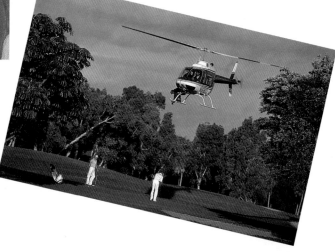

During the golf-course shoot, J. P. managed to guide the helicopter into the shadows of the trees to prevent its own shadow from showing up in— and ruining—Al's pictures.

Al's first attempt to do the golf shots didn't go well. As this picture indicates, there was an extensive cloud cover and the light was flat.

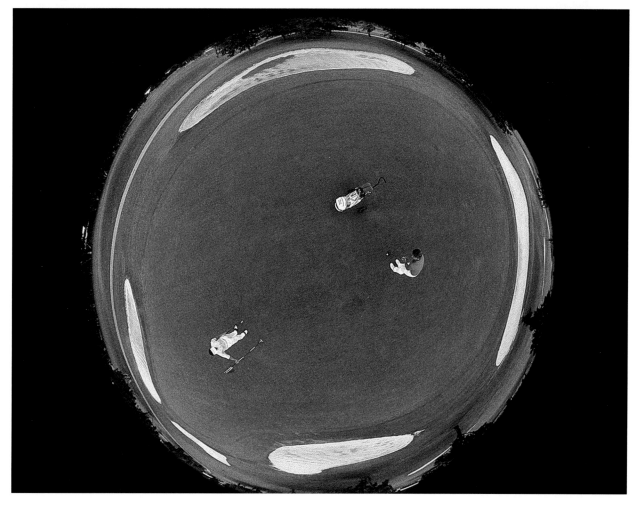

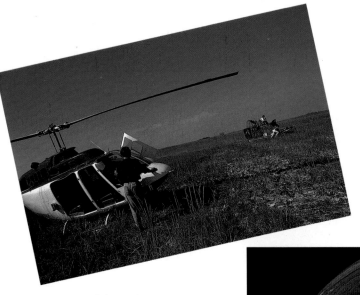

Dennis and the airboat owner found Al and the crew in the downed helicopter after a frustrating search. But there wasn't enough water for the airboat to move on in order to reach the helicopter, and its motor was in danger of burning up. So everyone had to push the airboat through ankle-deep mud for a mile before they were able to ride in it.

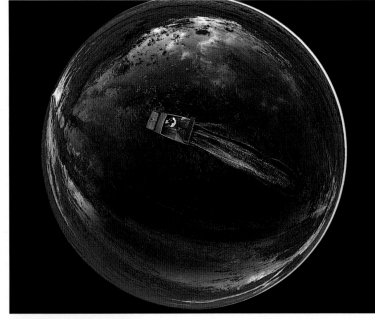

These photographs of the airboat (above and left), which show two different areas of the Everglades, are outtakes from the shoot.

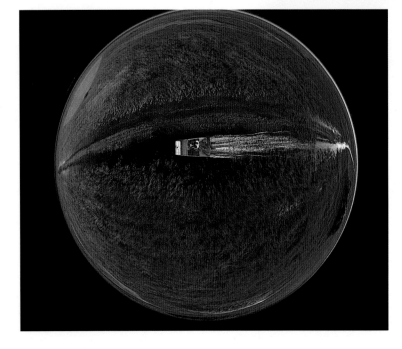

They planned to meet us at the location. The airboat owner had a campground that was empty, and we had arranged with him for the helicopter to land there. When Dennis and I arrived, I quickly found the owner and gave him his new shirt and hat. Dennis was going to ride on the airboat during the shoot and help direct the owner via a walkie-talkie. When the helicopter landed, Al got out and gave us last-minute instructions. In the meantime, J. P. took off the helicopter doors and stored them in the van. After Al was strapped into the helicopter, it took off; then the airboat was revved up, and it took off. I was left standing on the shore with a camera. I had planned to shoot some stock pictures while I waited the two hours.

But just one hour later, I heard the whine of the airboat as it came around the corner. Dennis jumped on the shore and helped the owner tie up the airboat. The owner asked me if I had seen Al. Dennis explained that Al had been photographing them when the helicopter made a circle and disappeared. So we tried to radio Al and the crew, but they were obviously out of range. After an hour of waiting, the airboat owner's wife suggested that I call the local airport to see if it had any information about them. The tower operator I spoke to first connected me with another person who had heard a helicopter pilot talking to a small aircraft, but he didn't recall what was said. He was, however, able to contact the airplane. That pilot said that there was a helicopter down in the glades that had asked him to get help. I told the tower control that I would send someone out after Al and the crew if I could find out what their coordinates were. I took down the vague information I was given and turned it over to the airboat owner. After getting some rope, he and Dennis headed out to locate the helicopter.

Dennis and the airboat owner looked, but they couldn't see anything. They called out, but they couldn't hear anything. Meanwhile, Al and the crew could hear the airboat, but they couldn't see it. They called out, too, but they weren't heard. The small plane came by and signaled the airboat to follow. Finally, Dennis and the airboat owner saw the helicopter upright but sunk up to its belly. Everyone appeared to be fine.

Al said he had been shooting when he suddenly felt something wet hit him in the face. He wiped off his face and saw that his hand was dark and oily. He looked up and realized the helicopter was losing hydraulic fluid. Al immediately jumped back into the cabin. Not even a minute later, the engine quit. The helicopter was 100 feet above the ground and traveling at about 85 mph. J. P. reacted fast, killing the speed as much as possible before flaring. The helicopter had a bumpy landing in the Everglades. It hit the ground at 20 mph and slid 8 feet before coming to an abrupt stop in the muck. Thankfully, no one and nothing—the equipment, the helicopter—were hurt. After everyone calmed down, J. P. said that he would get another helicopter to rescue the first one. As the producer on this job, I had to ask Al if he got his shot. He said that he didn't; the light was just getting good when the helicopter went down. I quickly made arrangements to come back in three days and repeat the shoot—without any more drama, I hoped.

The following day, we woke up early to try the golf shot again. J. P. was busy rescuing his ship, so he had lined up another pilot for us. I went to the golf course with one assistant; we drove out to the hole and set everything up just as we had done several days ago. The helicopter approached, and Al began to shoot. The morning light couldn't have been better. The shadows fell on the other side of the green, making it easier for the pilot to hide the helicopter's shadow, and Al was in a better position to shoot from. Wetting the sandtraps worked well; there was very little sand churning in the air. The final shot turned out to be quite beautiful. Later that afternoon,

Al looked up and realized the helicopter was losing hydraulic power. Not even a minute later, the engine quit.

This photograph is an outtake from the windsurfer shoot. The positions of the colorful sails were less than ideal.

Every once in a while, the pilot moved up too close and the ensuing blast of air knocked all of the windsurfers over.

Al called J. P. to find out how the rescue mission was going. J. P. was in a good mood because his ship was unharmed and back at the hangar. He also said that he would be able to complete the shoot with Al.

The windsurfer shot had been scheduled for the next day of the job. Everyone got into the two vans and headed out to the beach, where we had arranged to meet the models. They were outfitted and ready to go when we arrived. Robert was pleased when he looked over the windsurfers with their sails. Al explained to the models how he was going to photograph them and expressed his concern about their being able to travel a good distance out of the bay and away from land. He wanted to make sure that the designated leader understood his hand signals. Al also told the leader that they should keep the nose of the boards toward the sun while he was shooting, and he pointed out that the helicopter might get too close at times and knock them over. None of this was new to the windsurfers. They fully expected to be physically exhausted after

the shoot but felt confident that they could withstand the ordeal. If anyone had trouble keeping up with the group, Al said that he wanted that windsurfer to break off and go back to shore. Finally, Al also told them that they would have a 30-minute head-start in order to get out beyond the bay. The windsurfers jumped into their harnesses, which took most of the weight of the sails, and off they went.

Al, Robert, and Dennis then left for the heliport. Just 20 minutes later, I spotted the helicopter in the distance out over the water. The day was beautiful, without a cloud in the sky. But there was no wind either. This was a problem for the windsurfers. Al located them, but they weren't making good time. To solve this problem, the pilot got behind them and pushed them along with the rotor downwash. Every once in a while, the pilot moved up too close and the ensuing blast of air knocked all of them over. Eventually, these strong windsurfers made it out to a good shooting spot. There was just enough wind for them to cruise slowly in formation.

Al photographed them until the sun was too low in the sky. He needed to allow them enough time to return to shore before nightfall. As I watched the sun sink below the horizon as I waited on land, I kept imagining that I saw the windsurfers coming back. It seemed to take forever. When they finally came ashore, I gave the leader a check to cover everything and had each model sign a release. Later that evening, Al told me that he liked what he shot. But just as with the parasailer and the jet skiers, he could get only so close to the models. Robert was more than satisfied with the results and said that if he needed to, he could enlarge the windsurfers and strip them back into the photograph.

Early the next day, we returned to the Everglades. We met J. P. at the airboat owner's campgrounds and then repeated the shoot, doing everything exactly as we had three days beforehand. The only difference between the two shoots was that there were no problems, breakdowns, or disasters the second time. In fact, the morning light was gorgeous, and Al was able to get in close to the airboat.

This two-week shoot was over. We packed up our gear and headed back to New York the following day. We had to drop off the film at the lab. After the film, which looked fantastic, was developed, Al and an assistant edited it and sent it to Robert in Germany. Robert had a brilliant idea to rescue the parasailing shot. He stripped a larger version of the parasailer into the advertisement, placing the parasailer out of the orb. This made the world appear to be three-dimensional. The advertisements were first used in billboard form, and the sensation they caused made Robert a hero. He received many complimentary calls from friends working at other agencies that had competed against O&M for the Tuborg Beer campaign. Despite the helicopter crash and all the other problems we faced, this job was a great adventure—one that none of us would have missed for the "world."

WER DIE WELT KENNT, KENNT TUBORG.

Gebraut nach dem deutschen Reinheitsgebot von 1516.

Because Al couldn't get as close to the subject as necessary, he used 16mm and 20mm fisheye lenses for this difficult and dangerous shot. Then creative director Robert Bruenig placed the parasailer from one of those images in the empty space here to produce a three-dimensional, "top of the world" look.

Despite the helicopter crash and all the other problems we faced, this job was a great adventure.

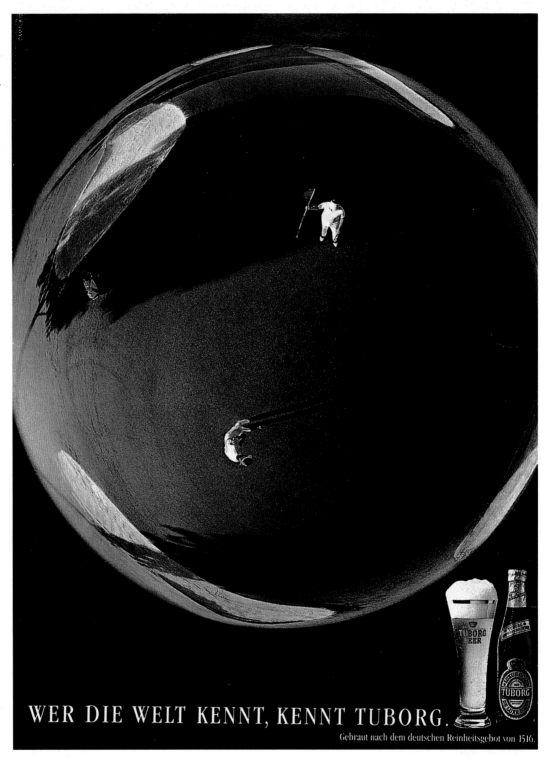

WER DIE WELT KENNT, KENNT TUBORG.

Gebraut nach dem deutschen Reinheitsgebot von 1516.

Tuborg chose the image of the airboat (opposite page, bottom) for both a billboard and a single-page ad, while the three other images shown here were used solely for single-page advertisements.

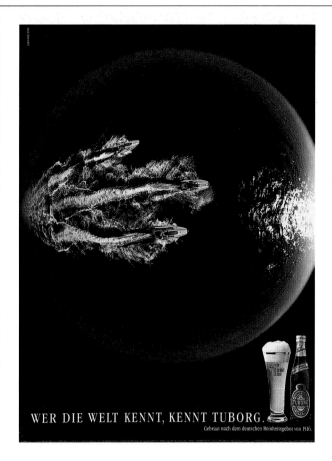

WER DIE WELT KENNT, KENNT TUBORG.

Gebraut nach dem deutschen Reinheitsgebot von 1516.

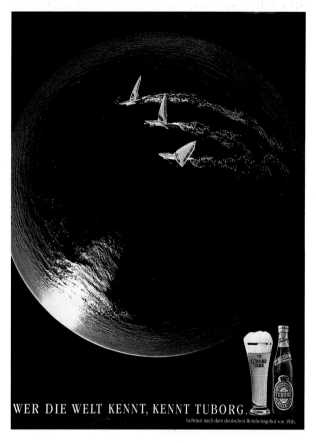

WER DIE WELT KENNT, KENNT TUBORG.

Gebraut nach dem deutschen Reinheitsgebot von 1516.

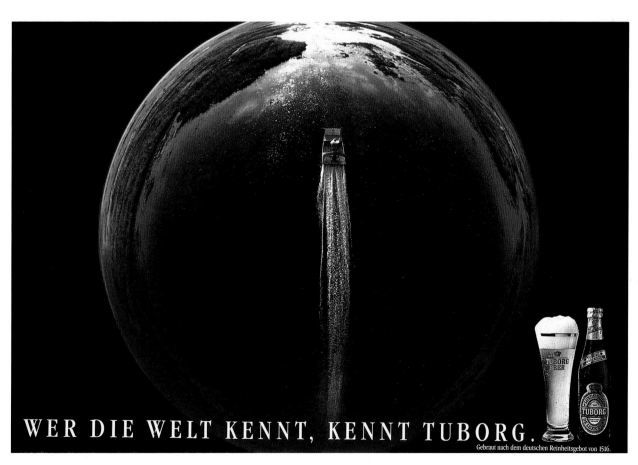

WER DIE WELT KENNT, KENNT TUBORG.

Gebraut nach dem deutschen Reinheitsgebot von 1516.

CREATING ONE IMAGE FROM TWO SHOTS

This layout shows a skydiver holding a Sony Video Walkman freefalling over what looks like farmland in the Midwest. I called Steve Kashtan, the art director, to get an idea of where he wanted to shoot this scene. He wanted a more exciting background. He also told me that he was bidding quite a few photographers and that the one who came up with the most interesting location had a good shot at getting the job. I described the way Al thought this layout should be shot because I wanted Steve to hear our approach before I gave him an estimate.

We wanted to shoot the advertisement in two parts that could be stripped together. We planned to photograph the background as an aerial shot and the skydiver in a studio with simulated sunlight. I explained to Steve that we would have to do it this way so that he would have more than one roll of pictures to choose from—and that was only if Al didn't break his neck in the process. Steve laughed, but I had made my point. I wanted him to remember our introduction and to have confidence in us. I also asked him to take a look at our book *Satterwhite On Color and Design* and pay special attention to the Molson Golden Beer shoot. For that advertisement, we photographed a winter background on a miniature set in one shot and live people and horses in another shot. To strip the two images together, we had to match the lighting perfectly. I was counting on this example to convince Steve that lighting would be the key to making the Sony advertisement seem as if it had been shot as one photograph.

I am sure that our book helped us get this job because Steve showed it to his clients, enabling them to trust his judgement. At the same time, he was beginning to trust ours. This is essential. If you mislead your client by making promises you can't possibly keep, you'll ruin your reputation. Once I had established a rapport with Steve and received the specs for the job, I told Al

Steve Kashtan, the art director of this Sony Video Walkman campaign, asked me to put together an estimate based on this layout.

what Steve had said. Al came up with all sorts of locations, but none sounded right. Bruce Wodder, our assistant at the time, happened to be visiting us and mentioned that he had just completed a job in Kauai. He told us that the island was lush and contained an area that looked like a miniature Grand Canyon. Al and I agreed that Kauai sounded spectacular and then decided to pursue the idea because probably no other photographer would come up with it.

I immediately looked up producers in my *New York Production Guide.* After a few calls to Hawaii, I found a producer in Kauai who was very knowledgeable about the island. I asked her if she scouted, what her rate was, and if she could recommend helicopter pilots who were used to working with film crews. She gave me some names that I then gave to Al. He goes by his gut feelings when interviewing pilots over the telephone. He questions them about their skill level, the amount of experience they have working with photographers and cinematographers, and the safety precautions they take. Al also needs to know if the pilots can hover very close

to the ground and at higher altitudes, as well as move sideways. These techniques require different skills. If the pilot is uncomfortable doing certain maneuvers, Al's safety and the success of the assignment could be in jeopardy. When Al found a suitable pilot, he inquired about his hourly rate and checked his availability.

After this "discovery" period—a term I use for the time you spend researching the job and getting an idea of how you'll approach it—I was ready to put together the estimate of production expenses. The art director needs this information to help sell the project and the budget. Al and I have won many bids because the other photographers didn't do their homework and the agency considered their bid to be a stab in the dark. After determining production costs, I discussed the usage that the agency intended to buy with my reps and decided on the fee. We were aware of our competition, but we didn't want to give the job away. I redid the estimate neatly on our form and sent it to the art buyer.

Next, I introduced Al and Steve over the telephone. Al described for Steve

We planned to photograph the background as an aerial shot and the skydiver in the studio with simulated sunlight.

where he wanted to shoot and how the production would work. He told Steve that the two of them would fly to Kauai and scout locations by helicopter first because the terrain was so varied. He explained that he would shoot Polachrome during the scout and then would have a conference with Steve back on the ground to discuss which areas worked best. Al could process the Polachrome in a portable machine in a matter of minutes, and they could view the transparencies through a loupe to check depth of field and focus. Polaroid film, on the other hand, produces printed 88mm images that aren't either large enough or sharp enough for critical scrutiny.

On the second and third days in Hawaii, Al planned to shoot from the helicopter again at dawn and dusk; he wanted clouds in the shot to create more mystery. But since he couldn't guarantee the weather, he included an extra day in the schedule for shooting. When Al and Steve returned to New York, Al would have the film processed and they would select one shot. Knowing how agencies and clients love to shoot every possible variable, Al made it clear to Steve that they were limited to one shot because there wasn't enough time or money to match more than one shot's lighting in the studio when he finally photographed the skydiver.

Al assured Steve that his plan for this advertising campaign would work. He knew that if he shot the background with a strong light source coming from one direction, he would be able to match the color temperature of the light in the studio. At this point, there was no doubt in Steve's mind that he wanted Al for the job. Steve also was excited about the inspired idea of shooting in Hawaii and hoped that the client would agree to the budget. When the agency submitted our bid, our portfolio, and our book, Sony was impressed with the agency's presentation and told it to proceed with the job. The estimate was signed and a purchase order was written up for us.

We would need an actual skydiver who would be able to get into the freefalling position without any direction.

I always check the purchase order carefully to make sure that I agree with the way it is written, particularly in terms of the fee and the usage. If I have any questions, I ask them before I sign the purchase order. If Al and I were to begin working on a job without having received a properly written purchase order, we would have no recourse if there were a cancellation or postponement. When I'm satisfied with the purchase order, I sign it and return it to the agency with a bill in triplicate for a cash advance on expenses. The minimum cash advance that our company accepts is 50 percent of the expenses. (I say "our company" because many photographers forget that they're running a business, even if it's not incorporated.) You can set your own policies, too. Don't give in to the demands of another company. Negotiate and compromise. That is what doing business means.

Sony's purchase order was fine, so production could begin. I instructed my travel agent to arrange for airfare and hotel rooms for Al and Steve. I gave him the location of the helicopter company in Kauai so that he could book a hotel nearby. I then asked the producer I had spoken to for the videotape of aerials of Kauai with a bill. I also offered to pay her day rate for her time because I knew that I might need her services again.

Next, I called a stylist and agreed to pay her a fee in exchange for information that I was sure she had. She mentioned a skydiving group on Long Island (New York) that was used to working with photographers. When I called, I used her name as a reference. The owner told me that he had a number of skydiving suits and that he would be glad to come into the city for a production meeting with the suits for a small fee. Although I had included a model's fee for the studio shot because Al and I knew that we would need an actual skydiver who would be able to get into the freefalling position without any direction, I hadn't planned on these additional ex-

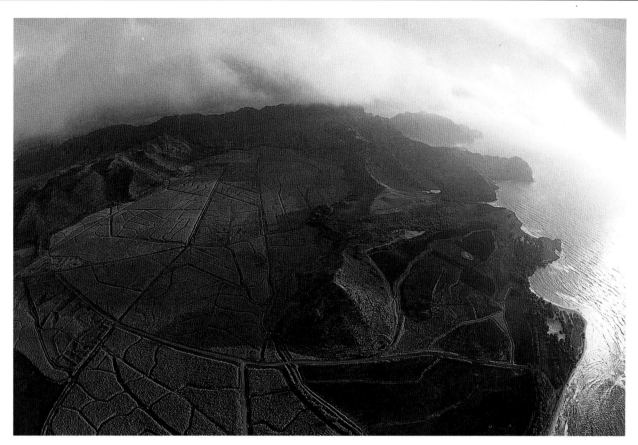

This is one of the aerials selected as a possible background, which was supposed to show wide-open fields.

penses. When estimating, you focus on the essentials and make an educated guess about the other items, being sure that you have enough padding in your estimate to cover surprises.

A production meeting was scheduled so that everyone involved—Al and me, our representative, the art buyer, Steve, two account executives, the creative director, and the sky-diver—could make sure that we were all working toward the same end. The agency was impressed with the choice of location as it watched the videotape of Kauai. We then introduced the sky-diver, who explained how he would look in the freefalling position. When we went over his wardrobe, Steve and Al weren't too thrilled with the color choices and decided on yellow. The skydiver said that he new a manufac-turer who could make a suit very quickly and gave me an idea of the price. The art buyer immediately looked alarmed, but I assured her that I had money buried in my estimate for just such an unexpected snag and that we definitely wouldn't go over budget.

Next, I explained how Al would photograph the skydiver to the cre-ative director and the account execu-tives in order to sell them on the idea one last time. I stressed that the shot should look real, described the earlier Molson shot in detail, and compared the two. The creative director was con-vinced, and the meeting was ad-journed. We headed back to the studio to get to work, and Al and his assistant left for Kauai the next day.

Al had reserved a Hughes 500 D he-licopter; it has five blades and a great deal of lift. When shooting from a he-licopter, Al insists that the art director involved with the advertising cam-paign sit up front with the pilot, so that Al's assistant can sit next to him in the back and can readily load cam-eras, take light readings, and change lenses. Al doesn't allow anyone else to ride in the helicopter during the shoot. During the scout, however, Al asks the campaign's account executive to come; this gives the account executive and the art director a chance to discuss po-tential locations firsthand.

Steve was excited about the inspired idea of shooting in Hawaii and hoped that the client would agree to the budget.

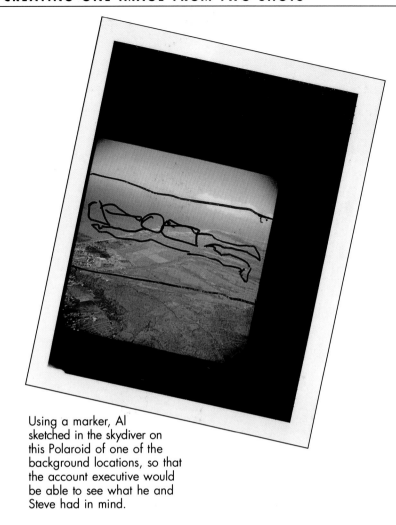

Using a marker, Al sketched in the skydiver on this Polaroid of one of the background locations, so that the account executive would be able to see what he and Steve had in mind.

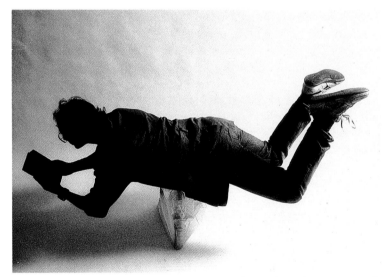

In the studio, Al overexposed black-and-white Polachromes of Bruce in the skydiver's position. Al wanted to check the initial lighting setup. He placed this Polachrome over the aerial shot in order to check proportions.

Al and Steve found several interesting locations. Al shot them while his assistant noted the time and the color temperature of the light. This detailed information would be used for reference to match the studio lighting later. Al also recorded the direction of the sun because some locations, although interesting, might not be illuminated the way the layout called for.

Back on the ground, Al processed the film and held a meeting to review it. Al and Steve, who always seemed to agree, chose a dramatic backlit spot. At this spectacular location, the sun peeked over the left side of a ring of mountains in the background. A field of sugarcane in the foreground provided a simple pattern that the skydiver wouldn't be upstaged by. But because it is dangerous to second guess the agency or client—and brave to shoot only your first choice of locations—Al and Steve picked two other locations to shoot as backups.

The day of the shoot, Al drove to the heliport with his assistant and Steve. Al met briefly with the pilot to tell him which locations he intended to photograph, the order in which he wanted to shoot them, and the altitude at which he thought the pilot should fly. The pilot agreed to remove the door from Al's side of the helicopter so that he could shoot freely. Al wears a safety harness with D-rings on the back that are tied to safety-rated carabiners mounted to the hard points of the helicopter. (Don't attach a safety rig without consulting an expert because some carabiners or attachment points might not be rated to hold the weight.) With the helicopter still on the ground, Al put on the harness, stood on the skids, and leaned over to test the firmness of his position. Once he was satisfied, they took off.

Al had to shoot the overall scenic from a height that a skydiver could conceivably be freefalling from. By eyeballing the location through 18mm and 16mm lenses, he knew that he needed to be between 4,000 and 8,000 feet in the air. Al preferred the 16mm

lens for this shot because he could tilt it down to create a curved-horizon effect; this gives viewers the sense that they're looking at the top of the world. Al used both Kodachrome 28 and Kodachrome 200 because he wasn't sure if a little more grain would enhance the realism and moodiness of the composite shot.

Al always uses several camera bodies when he shoots from a helicopter. If one camera fails, he doesn't lose the whole take. Also, his assistant can be loading one camera while he's shooting with another. He wants to get as many "perfect-light" shots on film as possible and has to bracket a great deal because good light doesn't last long. Finally, Al knows that the helicopter vibrations will force him to edit and throw away much of the film.

After shooting two dawns and two dusks, Al flew back to New York with the others and put the film in the lab. Then he did the preliminary edit, selecting the shots he thought were ideal. Next, he met Steve and the creative director at the agency offices; they spent an hour discussing the various shots that would work. They had a hard time narrowing down the choices. They finally settled on 22 shots, and the location originally preferred remained the favorite. The picture showed a very small body of water surrounding the land mass and pleasing cloud formation. Al liked the strong, directional sunlight because it would be easier to match in the studio. The account executives then presented the shots to the client, who approved the first choice.

Now it was time to do the studio shot. The crew was told to arrive at our studio at 8:00 AM, the skydiver at 9:00 AM, and the agency at 10:00 AM. Before the skydiver arrived, we had quite a bit of work to do. Al and three assistants set up the lights and did a test shot of Bruce in the skydiver's position. Al shot the tests on overexposed black-and-white Polachrome and then placed each of the chromes over one of the aerials when the client arrived.

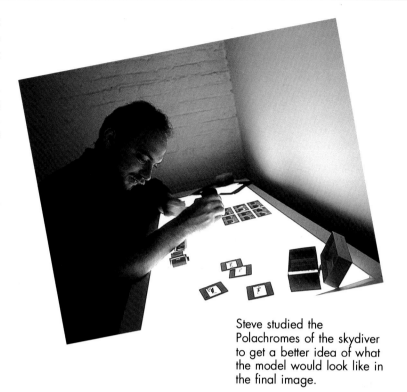

Steve studied the Polachromes of the skydiver to get a better idea of what the model would look like in the final image.

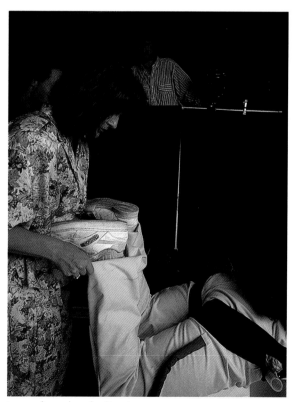

I taped up the skydiver's shoelaces with double-stick tape to achieve a convincing windblown effect.

Before Al began shooting, he put together a chart of f-stops, strobe power settings, and speeds as a guide; he wanted to be able to concentrate on other details without having to stop and remember what he had covered. One of Al's assistants was in charge of making sure that the shots listed in the chart were done in sequence for each setup and with all the appropriate lenses.

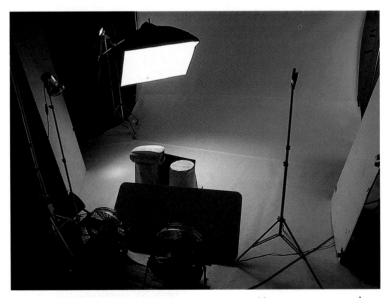

Here, you can see the lighting arrangement and the supports for the skydiver used for the studio shot.

Projecting the chromes in pairs saved large amounts of both time and discussion and enabled the client to see how the shot would work. This approach also prevents some mental wear and tear on the photographic team.

When the skydiver arrived, we showed him the sandwiched shot of Bruce. The skydiver was impressed and understood immediately what we wanted. He put on his new yellow skydiving outfit and got into position. The lighting was adjusted, and a test Polaroid was shot. By the time Steve showed up, Al had finished shooting a roll of Polachrome. While we waited for the film to develop, an assistant put the selected background shot with the test shot of Bruce.

We then projected the Polachrome of the skydiver sandwiched over the background for Steve, who became excited. He loved the new jumpsuit, but he wanted it to appear as if filled with wind. Steve also wanted the light to be stronger on the skydiver's legs and the shoelaces to be rigged up as if the wind were blowing them. I used double-sided tape to hold the laces in position, and Al had three fans placed around the skydiver to create the "puffed" effect.

After all of the test Polaroids were shot and double-checked for little imperfections, Al made up a shooting chart so that his assistants would always know what he wanted to do next. In the heat of a shoot, many mistakes can be made. A chart helps prevent them. For each shot, Al listed the power settings of the strobes, f-stops, and speeds. In this situation, he was going to use strobes to provide a certain amount of sharpness and shoot long exposures to create some blur.

Al illuminated the skydiver with a large 4 x 8-foot banklight. It was placed 8 feet away from the model to make the light a little harder, to give it more edge and contrast. Al positioned a 4 x 8-foot piece of white foamcore below the camera and in front of the skydiver to fill some of the shadow area. The light from the banklight

bouncing off the foamcore and onto the skydiver best simulated the natural light that Al had shot about 4,800 feet above Kauai. In addition to the main banklight, he aimed a strobe head with a normal reflector at the white ceiling to help open up some of the shadows. Another strobe head with an 8-degree grid spot was aimed at the black Sony videocassette recorder (VCR) in the model's hands to show a little more of its details. (The simulated television picture was stripped in later.) Color temperature readings were taken, and filters were added to the strobes to match the light perfectly with that in the selected background photograph.

To give the art director a little leeway when he stripped the two photographs together, Al shot with 24mm, 28mm, 16mm, and 18mm lenses. These would create different distortion perspectives. As the film was developed, edited, and labeled, Al felt that the shot of the skydiver taken with the 28mm lens was the best. Pleased with the results, Al made his selections and sent them via messenger to Steve. The agency was responsible for stripping the shots together; this had been determined at the time of bidding. Agencies usually handle such postproduction tasks. The art director might want to do some retouching, especially if there is a product in the shot.

As you can see in the Sony advertisement, the final result is beautiful. Al's studio lighting was perfect; it looks as if the sun is the source of light. You might notice, though, that the VCR in the skydiver's hand is sharper than he is. The agency felt that a soft-focus skydiver seemed more realistic, but Sony wanted its product to be sharp. So Steve took the product shot that Al had done for the lower part of the advertisement and stripped it into the skydiver's hands. This is creative license. Sony was so pleased with this advertisement that it negotiated with us for additional usage, such as posters and point-of-purchase cards and small advertisements.

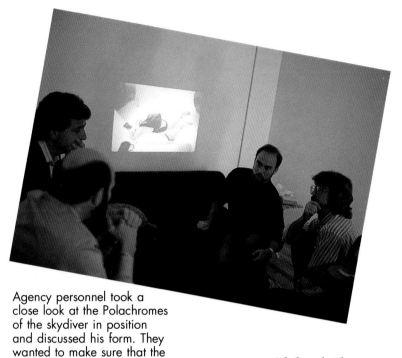

Agency personnel took a close look at the Polachromes of the skydiver in position and discussed his form. They wanted to make sure that the product would appear large enough in the final advertisement.

Al had three fans placed around the skydiver to create the "puffed" effect.

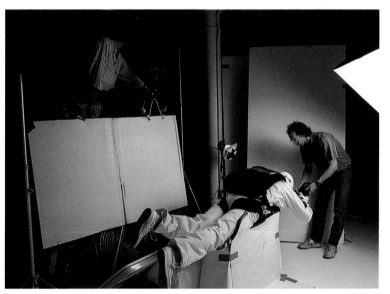

Bruce showed the skydiver how to hold the Sony Video Walkman, so that it would be displayed as originally intended.

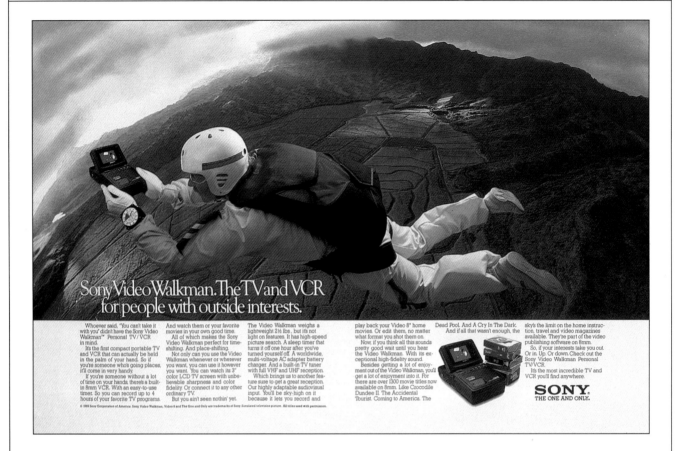

Sony Video Walkman. The TV and VCR for people with outside interests.

Whoever said, "You can't take it with you" didn't have the Sony Video Walkman™ Personal TV/VCR in mind.

Its the first compact portable TV and VCR that can actually be held in the palm of your hand. So if you're someone who's going places, it'll come in very handy.

If you're someone without a lot of time on your hands, there's a built-in 8mm VCR. With an easy-to-use timer. So you can record up to 4 hours of your favorite TV programs.

And watch them or your favorite movies in your own good time.

All of which makes the Sony Video Walkman perfect for time-shifting. And place-shifting.

Not only can you use the Video Walkman whenever or wherever you want. You can use it however you want. You can watch its 3" color LCD TV screen with unbelievable sharpness and color fidelity. Or connect it to any other ordinary TV.

But you ain't seen nothin' yet.

The Video Walkman weighs a lightweight 2½ lbs., but its not light on features. It has high-speed picture search. A sleep timer that turns it off one hour after you've turned yourself off. A worldwide, multi-voltage AC adapter battery charger. And a built-in TV tuner with full VHF and UHF reception.

Which brings us to another feature sure to get a great reception. Our highly adaptable audiovisual input. You'll be sky-high on it because it lets you record and play back your Video 8® home movies. Or edit them, no matter what format you shot them on.

Now, if you think all this sounds pretty good wait until you hear the Video Walkman. With its exceptional high-fidelity sound.

Besides getting a lot of enjoyment out of the Video Walkman, you'll get a lot of enjoyment into it. For there are over 1300 movie titles now available on 8mm. Like Crocodile Dundee II. The Accidental Tourist. Coming to America. The Dead Pool. And A Cry In The Dark.

And if all that wasn't enough, the sky's the limit on the home instruction, travel and video magazines available. They're part of the video publishing software on 8mm.

So, if your interests take you out. Or in. Up. Or down. Check out the Sony Video Walkman Personal TV/VCR.

Its the most incredible TV and VCR you'll find anywhere.

SONY.
THE ONE AND ONLY.

© 1989 Sony Corporation of America. Sony, Video Walkman, Video 8 and The One and Only are trademarks of Sony. Simulated television picture. All titles used with permission.

Satterwhite Takes A Fall For Sony.

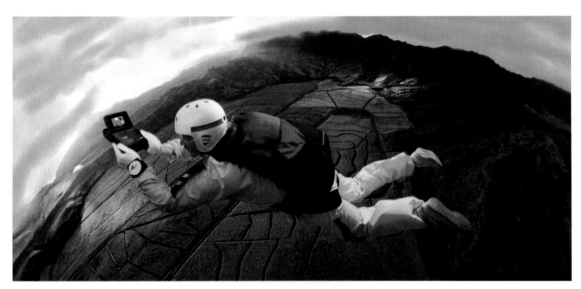

satterwhite

Satterwhite Productions, N.Y.C. 212-219-0808

Represented by: Rita Marie & Friends. Midwest: tel. 312-222-0337 fax 312-883-0375, West: tel. 213-934-3395 fax 213-936-2757

You might notice that the VCR in the skydiver's hand is sharper than he is.

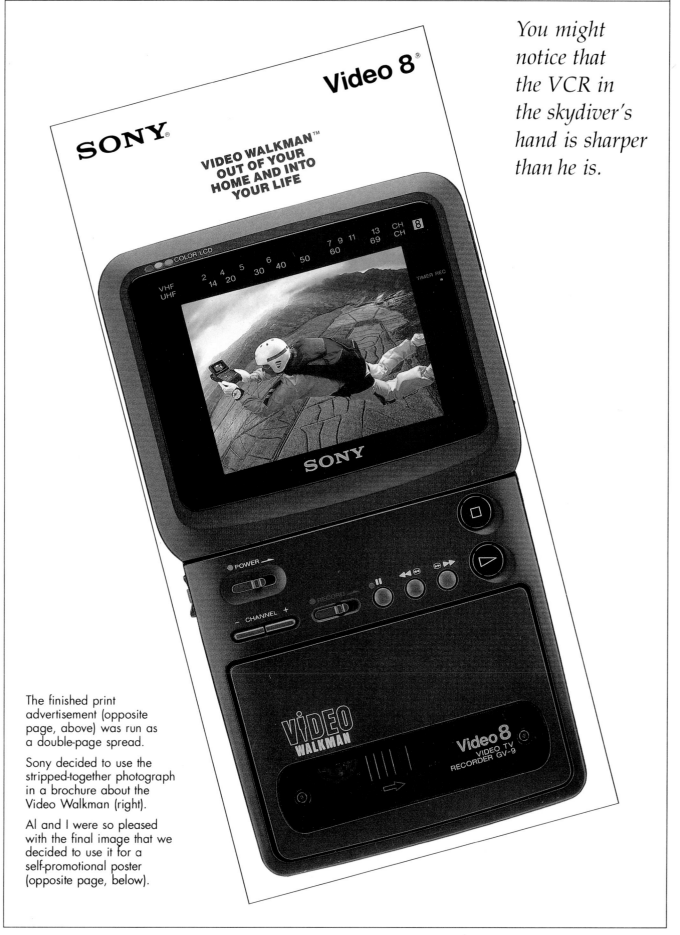

SONY

Video 8

VIDEO WALKMAN™
OUT OF YOUR
HOME AND INTO
YOUR LIFE

The finished print advertisement (opposite page, above) was run as a double-page spread.

Sony decided to use the stripped-together photograph in a brochure about the Video Walkman (right).

Al and I were so pleased with the final image that we decided to use it for a self-promotional poster (opposite page, below).

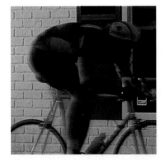

BUILDING A FULL-SCALE SET IN THE STUDIO

This two-part layout for American Express looked straightforward and simple enough when Al and I first received it. The advertisement was a spread with a picture of the Simplon train and a couple on the train-station platform on the left-hand side. The right-hand side showed a bicyclist riding by a quaint bicycle shop. Originally we were asked to bid on the entire advertisement. For the left half of the layout, Ogilvy & Mather (O&M) wanted us to shoot the Simplon in any major city in Italy and to bid accordingly. By the time American Express awarded the job, the agency felt that it would know exactly where the photographer would shoot the train and could adjust the numbers then. The other side of the advertisement would be shot on location somewhere in New Jersey. The agency was looking for a suitable bicycle shop.

After this discussion, a couple of questions came to mind. First, were the Simplon people cooperating with American Express on this advertisement, or did Al and I have to establish contacts? The agency told me that it didn't know yet, but it believed that American Express would arrange for the train to be at a certain station for at least one hour. The second question concerned the bicycle shop. Should I put in for location fees, or would the agency pick up that expense? It told me to put in an amount typical of most shoots and said that it would handle the fee later. This would be a very rough estimate based on the limited information the agency supplied, but I managed to turn in some reasonably accurate numbers.

Shortly after I had submitted the estimate, the agency called to inform me that there were two problems. First, the train shot was going to be picked up from stock because of financial and logistical constraints. Also, the agency couldn't locate a bicycle shop that the client would approve. I asked the agency if it wanted us to scout one. It declined our offer, explaining that

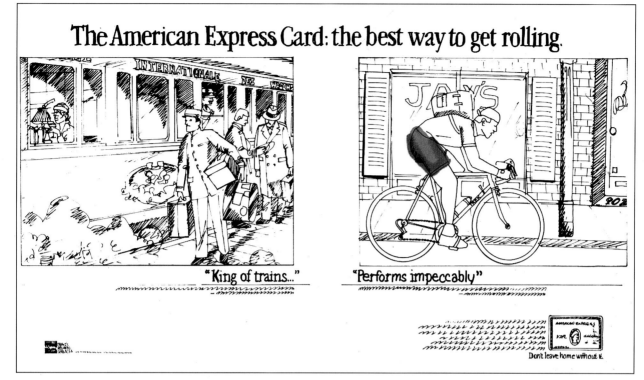

The American Express Card: the best way to get rolling.

"King of trains..."

"Performs impeccably"

Don't leave home without it.

American Express wanted a shop that accepted its card solely. Then Vanessa Rosa, the art buyer, shocked me by asking if Al and I could build a street scene in the studio. Unlike television shoots, print shoots usually don't have money in the budget for building a full-scale set. When I told her that it was possible, she requested a new estimate before the end of the day.

I went in search of Al. I explained that the agency wanted us to build the bicycle shop in the studio because it wasn't able to find one that takes only the American Express card. The idea appealed to Al because we do most of our shooting on location. Also, we had done some miniatures, but we hadn't built a full-scale set. Al loves to work on unusual assignments. A change in the type of work he does seems to make his creative juices flow.

I called Charles Schindler, a set builder, and described the layout to him and asked him to give me a price for his fee, assistants, and materials. He had many questions that he needed answers to before he could give me an estimate. He wanted to know how large the set should be, how many doors and windows were required,

and if the walls could be flats or if an entire room was necessary. I told Charles that I would have to get back to him.

Back in Al's office, I repeated what Charles had said: that we had to be very specific about what we wanted him to build. In order for Al to know what size the set should be, he first had to determine which lens he would use. We then set up the camera and lens on a tripod and marked off the out-of-frame point from left to right. This distance was 22 feet. We would be able to shoot the set in a moderate-size studio; we wouldn't have to rent a big soundstage. Al and I knew, of course, that the bicycle shop would be central to the scene, and we debated whether or not we wanted to see any pieces of neighboring shops because the budget would increase along with the size of the set. Finally, we also decided that we wanted to see sidewalk and some street in the shot.

I then called Charles back and discussed our plans with him. He said that it was possible to build the front of the store as a flat but that he needed to know if the door of the shop should be functional. Al and I thought that

O&M initially asked Al and me to shoot this travel-oriented layout for American Express in two separate parts: the Simplon train in Italy, the bicycle shop in New Jersey. But the budget called for a different approach.

The agency couldn't locate a bicycle shop that the client would approve.

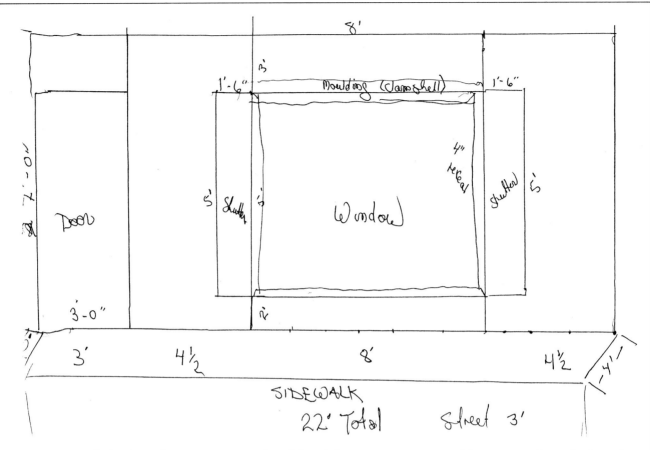

Al made a rough sketch of the bicycle-shop set to be built in a studio.

Having a dramatic sky reflected in the window would be a great effect.

this was a great idea. We might want to shoot variations with the shop owner in the doorway. Charles then asked if I wanted him to build a *return*. This is a short wall that extends the set at corners or behind doors or windows. I told him that a return wouldn't be necessary because when the door swung away from the camera, it would block the view. Charles put together his numbers for time and material and called me with that figure within three hours.

During that time, I had another conversation with Al about what I should put in my budget for dressing the set. When I asked him how we would make a street, he suggested that we lay down roofing tar paper on the studio floor. I wondered if this would actually look like a paved street. Al assured me that from the angle and distance that he intended to shoot from, it would. He told me to put in for a painted backdrop, too. I was surprised by this request because Al would have to stand very far back in the studio to include a sky. In addition, I didn't think that American Ex-

press would agree to a large budget. It had already killed the Simplon shot because of the expense.

Al's answer surprised me even more. He explained that the background wasn't for the sky behind the scene but for the sky in front of the scene. He wanted something to provide a reflection in the shop window. This was a particularly important concern because we would be simulating dusk when shooting the set. Having a dramatic sky reflected in the window would be a great effect. Al thought that it would be a great cheat, and I agreed. He was into this project—and at his best now.

I based my estimate on the cost of the set construction, a painted backdrop, tar paper, studio rental, props, wardrobe, grip equipment, film, assistants, and Al's fee. The agency would be responsible for casting the bicyclist and shop owner and for their payment. I would be responsible for finding their wardrobe. The colors of the wardrobe and the set weren't discussed in great detail. We wanted the

set to look realistic; this is referred to as "editorial style." So it would have been against our best interests to over-style or overthink the photograph. To my surprise, the numbers were approved the next day and Al and I were awarded the job.

The first step was for Charles, Al, the art director, and me (the stylist/producer) to agree on what the set should look like. The art director wanted a brick storefront. Al was willing to go along with this if the bricks would be white. He didn't want the scene to be too dark because the lighting would create the illusion of late dusk. The art director then asked Charles how he would go about making a brick wall. He explained that he certainly didn't intend to build an actual brick wall; he didn't think that the studio floor would hold the weight of one. And, he pointed out, there wasn't enough money in the budget for one. Instead, Charles planned to use a molded-brick form that comes in light-weight sheets, just as wallpaper does. He would simply staple the sheets to the frame of the building.

Al was concerned that the "bricks" would be too uniform to look real. But Charles assured him that they would and described them in more detail. The forms are made out of a plastic substance that is poured on a brick wall or some other brick surface to make an imprint. The sheets come in such different styles as antique bricks and cinder blocks. Everyone agreed that this approach sounded interesting and agreed to it.

Next, the four of us discussed the type of window that the bicycle shop should have. The art director wanted only the word "bikes" in capital letters in the window, and he had said that they should be handpainted. So Charles made a note to himself to book Chris Pfister, a sign painter. Then it suddenly occurred to me that there should be an American Express decal in the big showcase window. I asked the art director to get some decals in varying sizes from the client.

I then asked what I should be looking for in order to dress the set. Charles said that it would be better for him if I were to find and purchase the door. The art director gave me carte blanche when it came to the style of door for the small bicycle shop. He and Al also suggested fire hydrants; parking meters; street signs, such as "One Way" and "No Parking"; bicycles; and window dressing and display items that reflected the quaint character of the bicycle store. I mentioned a tree, but Al didn't like this idea. Because the set was relatively small, he didn't want it to appear crowded. I then suggested placing a tree off set and shining a light on it to cast a shadow. Both Al and the art director agreed that this would work. Al wanted only a tree branch, however, and said that we would attach it to something. He thought that it would be easier to deal with and wouldn't take up a great deal of room in the studio. The last step was to select a sunset out of a backdrop catalog.

This puzzled the art director. He didn't think that there was going to be a sky in the shot. Al explained that a window acts like a mirror, particularly in a low-light situation, so he would need something to reflect in it. The art director, who considered this to be a great idea, approved our choice of backdrop. He then mentioned that the agency had been casting models and arranged to meet us the next day to look over the Polaroids and choose the models we wanted for the shot. Later that same day, I booked the studio for a construction/prelight day, a shoot day, and a strike-set day. I also ordered the painted backdrop and the black tar paper, and Al booked four assistants.

The following day, I was off to a prop house to select fire hydrants, street signs, tree branches, and parking meters. I also went to a bicycle specialty shop and arranged to get bicycles and riding gear on a *borrow/buy* basis. This means that I take whatever I think I need, the store inventories my collection, and makes an imprint of

It occurred to me that there should be an American Express decal in the window.

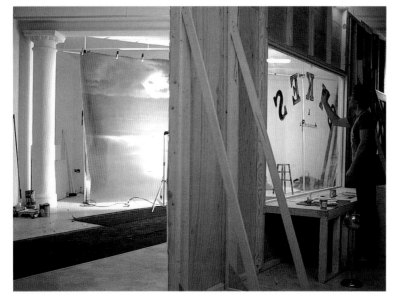

After the window had been set into the wall, the sign painter began to do the lettering.

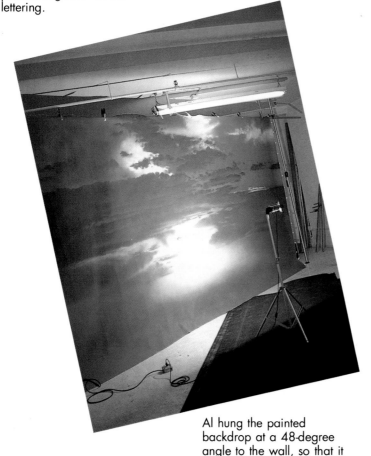

Al hung the painted backdrop at a 48-degree angle to the wall, so that it would be reflected in the window of the bicycle store.

my credit card to ensure that I return all of the items. I then promise to buy a certain amount of the inventory, as well as anything that was damaged during the shoot or looks obviously used. This usually comes to about 20 or 25 percent of the inventory. I also talked the store owner into lending me some of his window-display items to dress the set. My last stop was a door store, where I found the door for the bicycle shop. I had completed my styling in just one day. I then returned to the studio and arranged for our messenger service to pick up all of these items and deliver them to the studio on the construction/prelight day. Later on, the casting pictures arrived from O&M. The agency had already indicated which models it wanted to book. The art director was tied up with other work, so Al and I discussed the models over the telephone. We were pleased with the agency's choices and verified that it would handle releases and contracts.

On the construction/prelight day, Charles and Al marked the studio floor for the placement of the wall. Next, Al determined his camera position and mounted the lens he would use onto the camera body. He then directed Charles while looking through the lens as to the angle and length of the wall. Once this was done, the construction material was starting to arrive, so Al left Charles alone to do his work. Soon afterward, the painted backdrop, the props, and the wardrobe were delivered. At this point, Charles had completed enough of the set to allow the shop window to be put in place. Next, the sign painter began stencilling the word "bikes" on the window for both position and typeface approval. In the meantime, Al's assistants had been laying down the tar paper on the studio floor in order to create the street. When they finished that task, Al instructed them to hang the painted backdrop off set at a 48-degree angle to the flat so that the sky would reflect in the window of the store front.

Al then concentrated on setting up the main lighting. He had warming filters placed on the strobe heads to match the temperature of the lighting for the time of day that the painted backdrop suggested. Al was bothered by the pristine lighting of the set. So he placed a large, 8 x 4-foot mirror, which was on the dressing-room wall, off set and randomly put pieces of tape over it. He then aimed a strobe head at the mirror to create a mottled-reflection effect on the wall; if a car or shiny object were in the street, it would kick light back onto the storefront. This subtle touch made the lighting less perfect and studiolike.

Next, the tree branch was suspended from a lightstand off set, and a light was aimed at it to cast a shadow on the wall. Al preferred the twin hydrant to the more common red fireplug, so it was placed on the newly constructed sidewalk. The parking meter was also used. The last styling task was to dress the window. We put brackets in the window to hold the bicycle. Then the art director selected the props for the window display and told me where to place them. Al then had his assistants hang black velvet (from our shooting kit) behind the set to eliminate the backstage area and to enhance the reflections in the window. By the time the set was prepared, the day was over. Al just shot a quick roll or two of test film before we left. He would have the film developed and delivered to the studio before the actual shooting began.

The next day, Al viewed the test film and noticed a few problems. He didn't like the sky's reflection in the store window; he thought that it was too clean. Also, he wanted the bicycle shop to be surrounded by other buildings, not to be out in the middle of nowhere. To create the illusion of silhouettes of buildings in the distance, Al cut out rooftops from black pasteboard and positioned them over the backdrop. He also felt that the sky was too dramatic for a dry street scene, that the sunset was similar to one you might see after a rainstorm. To take

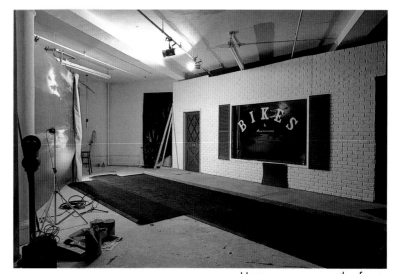

Here, you can see the front of the set with the tar paper on the street. A chunk of brick molding still needed to be stapled to the set wall.

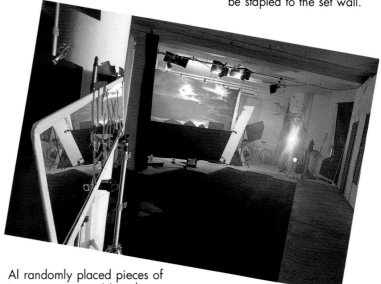

Al randomly placed pieces of tape on a mirror. Next, he illuminated it and positioned it in such a way that it cast mottled light onto the set. He wanted to bring an imperfect realism to the set. Notice, too, the cutout rooftops that are fastened to the painted backdrop.

Al was bothered by the perfect, pristine lighting of the set.

In this variation (below), the cyclist rode past the store while the shopkeeper dressed his window.

This is how American Express used our image in the finished advertisement (opposite page). Al and I show only half the tearsheet in our portfolio because the other shot was picked up from stock, and we don't want to misrepresent our work.

care of this inconsistency, he directed his assistants to wet the tar paper and make small puddles. In between each of these changes, he shot Polaroids to help him see what still needed to be adjusted.

Finally, Al thought that everything was perfect and that it was time to shoot a roll of Polachrome with the models on the set. They were given their directions, and Al began to shoot. He photographed Lauren Woods, the "shopkeeper," decorating the bicycle-store window and then coming out of the shop. Next, Al photographed Jim Johnson, the bicyclist, riding back and forth across the set. One of Al's assistants stood at one end of the set and I was at the other to stop Jim as he reached each side to prevent him from crashing or falling. This was a fun shoot. All of the little finishing touches really made it seem like we did this shot on location. On the strike-set day, we went back to the studio to take

down the lighting and the set walls. I gathered all of the props and wardrobe and had our messenger deliver them to the suppliers. Then I went in person to settle with the bicycle-store owner, who was so cooperative.

American Express was very happy with the results. But when Al and I saw the stock shot selected to run opposite our photograph, we weren't happy at all. We thought that the stock shot looked dated and didn't work well with ours. It is so disappointing when you work hard on a campaign that you like and the final advertisement is not something you care to include in your portfolio. Al and I don't show this tearsheet because it doesn't meet our standards and because half of it isn't our work. But we do show a print of our shot when someone wants to see how we handle shooting full-scale sets. Despite the outcome, this was a great experience for us.

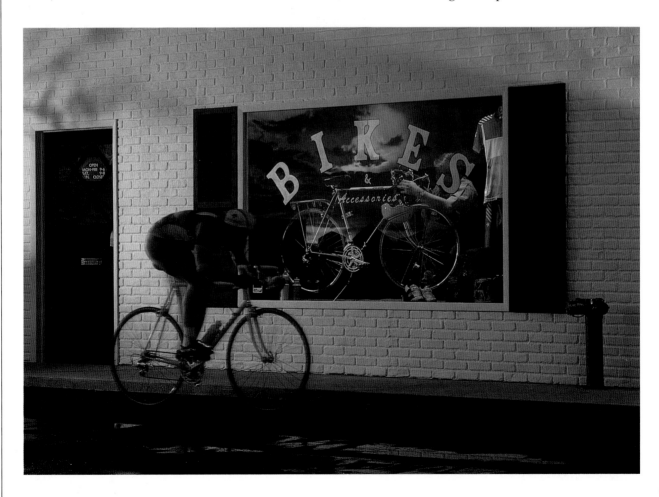

the best way to get rolling.

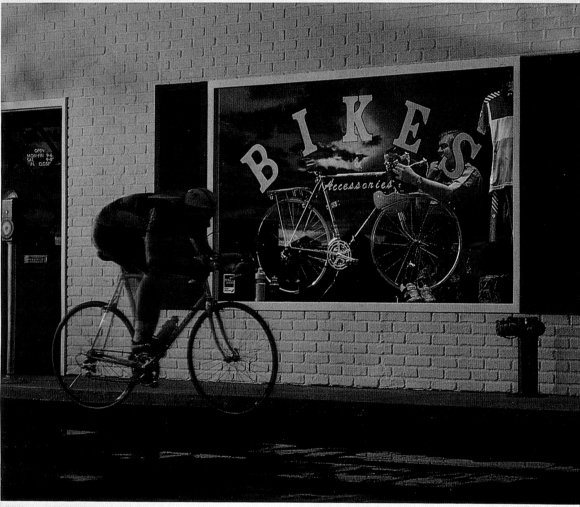

The Trek 2000

"It corners with the best of them and climbs hills efficiently, in or out of the saddle." – *Bicycling, July 1986.*
Available at fine bicycle shops like Jay's Cycles, Princeton, N.J.

Whether it's the transcontinental or a two-wheeler, it has to be the best. As a Cardmember, that's just what you expect. And at the more than 1.8 million places that welcome the Card, that's exactly what you'll find. Because at American Express, we're as particular about who accepts the Card as we are about who carries it. Membership Has Its Privileges.℠

Don't leave home without it.®

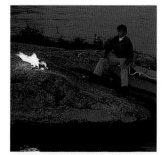

TAKING A CAMPAIGN ON THE ROAD

After we looked over the seven layouts for Johnson Outboard Motors that a Chicago advertising agency had sent, Al and I hoped that we would be chosen to shoot this campaign. Al wanted this assignment because he was in the mood to photograph romantic scenes that included boats. I wanted it because it would be fun to coordinate this obviously large and complicated job that would take us to—I quickly calculated—at least three different parts of the country.

Setting the process in motion, the agency asked us to submit an estimate and told us that we would be bidding against two other photographers. When you make a bid, you have to come up with an angle that will set you apart from the competition and guarantee that you get the job. The angle can be either an individual skill, an innovative approach, or a low price. But keep in mind that dramatically reducing your price can be dangerous. It sets a precedent that is hard for you, as well as the entire industry, to undo. If, for example, a company approves a budget of 2,000 dollars per shoot day for one job, it is unlikely to approve a budget of 4,000 dollars per shoot day for the next job. Coming up with a different idea or utilizing a particular strength to hook the client is a better strategy.

Al and I decided that our angle for this campaign would be to impress the client with our "wrapped tightness," which refers to our production know-how and organizational skills. After doing our homework thoroughly, we presented an estimate and production timetables as well as some appealing and unusual location suggestions. It is nearly impossible to estimate a job this size without first working up a rough production calendar. This approach might seem strange to you, but it is the only way to put together a concise, organized estimation of time and money to be expended. I produce the job on paper first and then use theoretical timetable to estimate the costs. Our

Chicago-based representative told us that we would be shooting only the background images. The agency wanted a local photographer to photograph the people in Chicago in order to keep costs down; the agency also thought that doing the shots in its hometown would give it more control. Al and I didn't agree, so we called the agency directly and tried to talk it into letting us handle the entire project. But apparently the idea had already been sold to the client, and the agency was reluctant to go back and ask it to reverse its decision. You win some, you lose some.

At this point, Al and I looked over the layouts for the campaign and gave some thought to where each one could be shot. The first layout showed two fishermen on the open seas at sunset. We decided that this one could be photographed anywhere along the East Coast from North Carolina southward. Keeping the job on the eastern seaboard would be more cost-effective for us (we lived in New York City at the time), thereby making our bid more competitive. The second layout was of a man fishing in a small boat on a lake. This spread could be shot almost anywhere, such as on a Florida lake or in North Carolina. In the third layout, a boat was pulling a waterskier. Al wanted to shoot this scene from a helicopter, and I felt we should try to shoot this image in Florida. I knew that finding professional waterskiers would be easy because of all the tourist attractions there.

The fourth layout showed two small children snorkeling and the rest of the family in a small boat on emerald-green water. Al and I agreed that the Bahamas would be perfect for this shot. The next layout was of a man camping on a tiny, one-person island. The spread also included a small Zodiac boat pulled up on the shore and a tent. This layout screamed "the Adirondacks" to me—even though I had never been there. I had seen pictures of the Adirondack region, and my instincts took over. Because the sixth layout showed several men bass fishing, Al suggested central Florida for this shot; the area is known for its bass-fishing contests. And since we had already been thinking about Florida for some of the other layouts, it would be cost-effective to group those shots. The last layout was of a family in a medium-sized sailboat. Once again, the client wanted the water to be emerald green, so it made sense to shoot this image in the Bahamas, too.

After Al and I discussed the layouts, we called the agency to get the specifications of the shoot. The agency told us that it would supply the boats and motors and transport them to and from the shooting sites. So we had to keep in mind the proximity of boat dealers before deciding which locations deserved estimates. We also had to give some thought to coordinating boats, agency personnel, talent, and crew schedules. We had been told that we would be responsible for casting and paying the models. How well we negotiated talent costs would be a determining factor when the bids were reviewed. Finally, I had to allow enough time for the arrival of all the pieces of the shoot and to include a little extra time for potential problems. At the same time, however, I had to be aware of the budget; Al and I were bidding against other photographers for this job. Taking these various factors into account, we decided to start shooting in the North and steadily work our way south because this would give us plenty of time to prepare for shooting in a foreign country. It would also give the client enough time to arrange for the boats to travel to the Bahamas. We ended up grouping the shots as follows:

Dramatically reducing your price can be dangerous. It sets a precedent that is hard for you to undo.

Second Layout	Fishing	Adirondacks
Fifth Layout	Camping	Adirondacks
Third Layout	Waterskiing	Central Florida
Sixth Layout	Bass Fishing	Central Florida
First Layout	Deep-sea Fishing	Bahamas
Fourth Layout	Snorkeling	Bahamas
Seventh Layout	Sailing	Bahamas

First layout: deep-sea fishing

Second layout: fishing

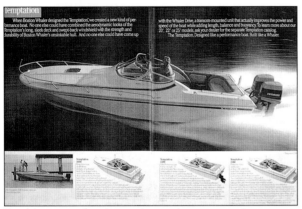

Third layout: a fast boat, changed to a waterskier

Fourth layout: snorkeling

Fifth layout: camping

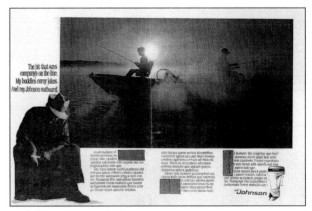

Sixth layout: bass fishing

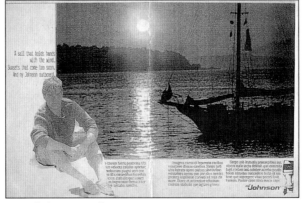

Seventh layout: sailing

I planned as many shots as possible in each location. Airfare can be one of the biggest expenses when you shoot on location. So deciding on a central location where you can shoot more than one layout will keep your final estimate low.

Having chosen locales, I could now put together a tentative production calendar of events. Since the shots depended to a large extent on the weather, I decided to schedule two passes for each layout. It is disappointing when an agency settles for a boring shot—the result of bad weather conditions—because it doesn't want to pay "weather day" costs. If I can get the money approved up front through built-in contingencies, Al and I have a much better chance of getting the shot the way we want it. And I don't have to worry about possibly settling for a less-than-perfect shot because of the client's reluctance to spend the additional money.

Before working on the complicated production schedule, I studied my air-line flight guide. Shooting in small towns can pose problems. The number of flights servicing them might be limited or the local airport might not be large enough to accommodate planes that can carry approximately 20 cases of equipment. I needed to determine how much time to allow for flying and/or driving to the various locations. When making up the production calendar, I also had to keep in mind that the camping layout needed to be prescouted. I didn't know exactly where a one-person island could be found in the Adirondacks.

I started in the first square on my blank calendar form and filled in the prescout of the Adirondacks. I allowed one day for Dennis, our assistant, to travel to the area, two days for scouting, and one travel day back. I wanted him to have enough time to check out the area thoroughly. Next, I counted the number of days that Al and I would need to review the scouting pictures and get approval of the location. On "day one" of the shoot, we would

Airfare can be one of the biggest expenses when you shoot on location.

Al and I came up with a rough production schedule before bidding and submitted it to the agency with our estimate.

Johnson Shoot
NW Ayer - Chicago
Studio Job # A88-115

leave for the first location. I also had to include a block of production time in the schedule, during which we would cast models, find shooting spots and props, and do whatever else was needed once we arrived at the location. Everything required to complete this campaign was assigned a day on the calendar.

At this point, I began to put the numbers together in an estimate. This part of the preproduction process is easy once all of the preliminary decisions are made. I always use the estimate forms that I developed after looking at other photographers' estimate forms and tailoring them to my specific needs. Doing my estimate form before I do the agency's keeps me from forgetting little details. It is important that you always do your estimate on your own form first and then transfer the numbers to the agency form (if it has one). If you don't, you run the risk of forgetting to include something because the agency form doesn't allow for that category.

I calculate expenses first. Once I know what the total expenses are, I decide on a day rate for Al. Usage is the biggest factor that determines Al's fee. For this campaign, the client wanted national advertising for only one year in the United States. So I knew that I would be able to sell the photographs as stock and earn additional money after Johnson Outboard Motors was finished with them. Once I figure out Al's fee, I multiply that rate by the number of shooting days and then add production and travel time at half-day rates. If the bottom line looks too expensive, I adjust either Al's fee or the expenses. After I settle on a budget that I think the agency will consider, I do any supporting paperwork I might want to submit to justify my numbers, such as tentative production timetables and cover letters. This not only impresses the agency and gives it an overview of just how much work will go into this project but also saves me from being questioned about how I came up with the figures.

Next, I type a brief but informative letter that explains how and why I approached the campaign the way I did. I also take advantage of the opportunity to sell Al one more time before the agency awards the job. It is better to make your last sales pitch in writing rather than over the telephone. Just before a big campaign begins, there is a great deal of tension in the agency because of demands made on its already overloaded schedules; it also hates being interrupted for something it considers unimportant. Remember, unless the agency is new to the business, it has heard it all. So be unobtrusively pushy on paper.

I then submitted estimates, and three days later Johnson Outboard Motors awarded the job to us. When deciding whether or not to allow photographers to bid on a campaign, agencies consider their creativity and the quality of their work. Most of the time, however, the job is awarded on the basis of price alone. In this situation, Al and I convinced the agency that ours was the only production house that could handle this complicated job because we had produced it on paper first. With the purchase order and cash advance in hand, we were ready to begin production. The agency had its job cut out, too: it had to find the boats and motors and have them available for us whenever and wherever we needed them. One problem surfaced immediately. The client couldn't get a sailboat to the Bahamas in time. Where were we going to find emerald-green water for the shoot? Al, a native of Florida, suggested Cedar Key to the client, who knew the area and liked the idea. And because Cedar Key is just two hours west of the central Florida location, we could schedule this shoot between the central Florida and Bahamas shoots. This was a perfect solution. I wouldn't even need an overage approved for this change in specifications, or "specs."

But then another hitch occurred: the client couldn't find a Woody for the "fishing" shot. Al and I weren't terri-

It is better to make your last sales pitch in writing rather than over the telephone.

bly concerned, however; we would simply have Dennis look for one while he scouted the Adirondacks. Although my estimate stipulated that the agency was responsible for getting the boats and motors to the sites and paying for their rental, transportation, and crew, ours is a service-related business, so the right move would be to help the agency out rather than to stand on principle. But if that help were to cost more money than I had estimated for, I would notify the agency immediately and get approval for the resulting increase in the budget. This is the proper way to conduct business when fulfilling a contract. Both you and the agency make agreements that you must meet. If the agency changes the specs, you should request an approval for an overage. If you don't, you might have to fight for it after the job is done. This is because agencies make agreements with their clients, too.

The client signs the estimate the agency gives it for the completion of the campaign; this amount is based on your estimate plus postproduction costs—such as prints, retouching, engraving, typesetting, and media placement—agency-personnel travel and per-diem expenses, and the agency's commission. The client won't reimburse the agency for one penny more than the estimate. Although most agencies have a contingency figure, somewhere between 10 and 15 percent of the total, you can build one into your estimate. For example, if I know that an airline ticket costs 1,230 dollars, I have to add taxes, possible overweight charges, and a contingency amount to allow for a possible rise in airfares before Al and I are awarded the job and can book the flights. I would put the figure in for at least 1,500 dollars. You should do this type of thinking line by line.

Keeping these new specs in mind, Al and I had 10 days for preparation before leaving for this two-week shoot. We sent Dennis to the Adirondacks for four days with instructions about what to look for. In the meantime, I

called Richard, our travel agent, and discussed our itinerary. He then booked our flights, hotels, and ground transportation.

Next, I decided to book the models for the "snorkeling" shot through a Florida talent agency. I contacted the agent I prefer to work with, gave her the specs on the talent, and asked her to ship head shots to me in New York. The rest of the talent would be "real" people cast on location because both the agency and the client wanted to keep talent costs down and put the money into production. The amateur models would have to know how to sail, waterski, fish, and drive powerboats. I called the Florida Film Commission to get the names of people involved in the bass-fishing contest held on the St. John's River every year. I also got the names of expert waterskiers who would be able to stay up on their skis a long time doing rooster tails and crossing back and forth over the boat's wake while Al tracked them from a helicopter.

I then started the clearance process for entering the Bahamas with camera equipment. Al and I usually get a carnet when traveling to foreign countries, but we don't bother to when we go to the Bahamas. (In layperson's terms, a carnet is an insurance policy with the government that covers the cost of your equipment and goods if they're seized by another country. Carnets are good for one year, and the security or fee for them is based on your declared value of the shipment.) I simply contact the Department of Tourism and indicate when we're coming and on what island we'll be staying. I also type up on our letterhead a list of all the equipment we'll be bringing, including the serial number and dollar value of each piece. The letter also includes the names of our crew members, their passport numbers, all flight information, and a brief description of what we'll be shooting. I send this information via telex to the Department of Tourism, which makes sure that the proper officials are notified. My final

The amateur models would have to know how to sail, waterski, fish, and drive powerboats.

The father had a perfect fisherman look, so we asked him if he would like to earn some extra money by posing for us.

task while in the States was to book the helicopter time for Al. I told our central and southern Florida pilots the shoot dates. Because we were going to shoot off the coast of Bimini and no fuel would be available there, the Southern pilot had to find a way to have barrels of fuel shipped over.

By the time all of these arrangements were made, Dennis was back with the scouting pictures of the Adirondacks. He had found some great one-person islands and had shot Polaroids of mist on the water in the early morning. Al was thrilled. He wanted to have low-hanging fog on the water to create the mood for the "fishing" photograph, and Dennis' scouting pictures would make it easier to sell the client on the idea. And while scouting, Dennis met a very helpful man who owns a company on Lake Saranac that rents boats and dock space to vacationers. He knew where we could find a Woody and agreed to supply us with dinghies to ferry us to and from shooting sites on the lake. Everything was finally falling into place, and we were almost ready to leave for the shoot.

The Adirondacks

Getting to this region with 24 cases was not easy. Al, the crew, and I had to take a rather small plane from New York City to Burlington, Vermont, pick up two vans, and drive to the spot where we could be ferried across a river to northern New York State. From there we drove to Lake Saranac. When we arrived, we unloaded the vans, settled into our rooms, and then—believe it or not—immediately went scouting. Al wanted to check the sites he had seen in Dennis' Polaroids for any potential obstacles where he would be shooting.

The first location had a small dock that Al intended to use as a shooting platform. The fisherman would be out on the lake in a Woody. The background was beautiful: graceful, rolling hills and autumn leaves just starting to

change color. While we were scouting the location, we met a father and son who were on vacation. The father had a perfect fisherman look, so we asked him if he would like to earn some extra money by posing for us in a few days. Luckily, he was delighted with the prospect and agreed.

Next, we drove over to the boating store to look at the Woody. It was in excellent condition. We then rented some boats to scout the small islands out on the lakes before it got dark. They varied greatly. Some have vegetation; others are simply big, flat rocks sticking up out of the water. Al and B. A. Albert, the art director, liked two of the islands in particular and were trying to guess whether the client would think the smaller, barren one—which they thought looked lonely and romantic—was appropriate for camping. They didn't know if they would be allowed creative license.

Since we had two passes built into this job, I suggested that we shoot both islands and let the client decide later. Nothing is worse than debating what someone who is not present might or might not do. And people like to have options. They feel that they choose the best when they have something to reject.

The next task was to decide on the shooting position, angle, and platform. Al wanted to shoot from an elevated position to include more of the surrounding water in the picture, thereby making the island look more isolated. Al asked if I thought I could rent the pontoon boat tied up at the docks for him. It would provide a much steadier platform to shoot from than a regular hull boat. Al planned to anchor the boat on three sides to keep it from drifting and to set up a ladder on the deck, so that he could shoot down on the scene. We tested the water depth to see if we would have trouble anchoring the boat and were surprised to find out that the water was only 4 feet deep in some places. Al then asked me to have small boats available for ferrying the model and props to the island

and for everyone to sit in during the shoot. He would be working until it was completely dark out, and he didn't want to risk camera movement by having people on the shooting boat.

With the scouting finished, we headed back to shore. I introduced myself to the owner of the boat shop and opened an account in order to rent transport boats and the Woody and to purchase fuel. He also told me the telephone number of the owners of the pontoon boat, who were his clients, and gave me permission to use his name as a reference.

The following day was a prep day. I contacted the pontoon-boat owners; they wanted to meet me and Dennis, who would be driving the boat, at the docks later in the day before handing over the keys. Next, I went out to buy props and a wardrobe. I first needed to find outfits for Gary, the account executive, who was going to be the model for the "camping" shoot. I had to get pants, a shirt, a jacket, and rugged-looking boots. Gary already had a pair of "cool" sunglasses. I also had to buy a primary-colored windbreaker for the "fishing" shot, a primary-colored tent to go with the bright-red Zodiac, and a couple of Sterno logs to simulate a campfire. (I knew that we didn't have time to rub twigs and sticks together to start an authentic fire and to make sure that the logs wouldn't blow out during the shoot.)

Soon, it was time for Dennis and me to meet the pontoon-boat owners. It didn't take Dennis long to convince them that he knew what he was doing. They talked about the water depth needed, fuel, and docking. The owners wanted to go out in the boat with Dennis to make sure that he could handle and dock it. After he passed the test, I explained to the owners how we wanted to use their boat. It was getting late so Dennis and I went back to the hotel for a quick bite before retiring. The following two days would be long ones. We were scheduled to shoot the "fishing" picture at dawn and the "camping" picture at dusk.

Everyone was in the lobby at 4:00 AM. We loaded the gear into the vans and drove to the first location. Although the actual shot would be easy, its success was out of our hands; we needed great weather and were hoping for low fog. When we arrived at the dock, we found our fisherman/model waiting. The light was dull and gray, and the cold air smelled suspiciously like rain. And just as we were thinking rain, it started to fall. Al shot a roll or two of film anyway, but he was counting on better conditions the next day. We went back to the hotel to wait out the weather. By midday, the sky was blue and the rain had stopped. So around 2:00 PM, we headed out to the one-person island to shoot the "camping" picture.

Al had decided to photograph the island with the tree first, and he treated this shoot like a dress rehearsal. When we arrived, we noticed that the tree had a dead limb. One assistant did the necessary pruning while the other assistant set up the tent with me. Then everyone went back to the pontoon boat and worked on anchoring it. Al placed a 12-foot ladder up on deck and climbed on top of it to get an idea of his shooting position. Each of us was in a small boat with an

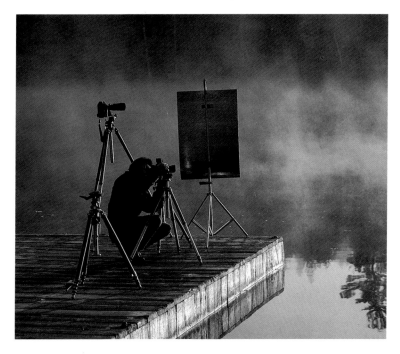

Al set up the cameras for the shot of a man fishing on a lake in the Adirondacks, the location that we thought would be ideal for this image. The reflector was used as a gobo.

anchor and lead. He then directed us in tying off one anchor lead tighter or looser until he was satisfied.

After the boat was stabilized, I returned to the island to finish propping, and Al and his assistants set up the cameras. They mounted Al's Nikon, Nikonwide, and Hasselblad Superwide on top of the ladder, securing them on ball heads and clamps. The water was calm, so Al would be able to shoot as slowly as ⅛ sec.

Gary was brought to the island and given his position. We hid a walkie-talkie in the tent to enable him to hear our directions. The light was just starting to get interesting as the sun sank below the horizon. Al began shooting, alternating among the three cameras and Kodachrome 25 and occasionally Fujichrome 50. The shot went well, and the day was salvaged.

At 4:00 AM the next morning, we were up and out. Al was anxious to shoot the fisherman. The dawn was perfect, and a low-lying fog hung over the water. The fisherman/model got into the Woody, and we taped a walkie-talkie under the seat so that he could hear our instructions during the shoot. He maneuvered the boat out into the water while Al and the assistants set up the cameras. Al had already placed the ladder with a ball head clamped to it and three tripods on the dock. Because Al planned to shoot toward the sun, he positioned a large gobo to block the sun from the lens. Al started shooting with an 85-105mm lens and worked his way up to telephoto lenses ranging from 180mm to 300mm. He shot all of the various camera formats, alternating among the three tripods and the ladder.

An assistant radioed the fisherman to kill the motor once the boat was in position, and Al shot until the boat drifted too far off the mark. The fisherman then started up the motor, and we directed him to either the same position or a new one. We repeated this procedure for nearly two hours. Once the fog burned off, Al got some great clear, early-morning-light pictures.

In these four outtakes of the man in a boat in the Adirondacks shot, you can see how the light changed between the first and last frames. The light was cool and a mist hung over the water while Al shot the first roll of film. But as the sun rose and heated the water, the light changed and grew warmer. Finally, the mist began to burn off.

We taped a walkie-talkie under the seat so that the model could hear our instructions.

Dennis and I set up the tent on the second day we spent shooting the islands. This barren island was Al's favorite.

While Dennis and I set up the island scene, Al started clamping his cameras on a 12-foot stepladder mounted on the flat-bottomed pontoon boat.

This spectacular vista (opposite page, above) of the man camping on the barren island was taken at midday.

Everyone was quite pleased with the romantic quality of this scene (opposite page, below): the glowing tent, the campfire, the calm water, the twilight sky. Then, to our surprise and delight, a beautiful moon made the image absolutely perfect.

After lunch, we packed up the gear, headed to the dock and the pontoon boat, and prepared to shoot the island that Al preferred. He wanted to do some time exposures after dusk, so he decided to place the ladder in the calm, 4-foot-deep water on the lake bed. He poked around on the lake bottom, trying to locate a stable spot, and found a fairly level rock. It would support the ladder nicely. Al and his assistants anchored the pontoon boat right behind the ladder in order for an assistant to work with him.

Al had brought along a battery-powered strobe and placed it bare-tubed without the reflector inside the tent. The strobe was fired by radio control, and the rheostat on it enabled its intensity to be adjusted as darkness fell. The effect would be romantic: a glowing, warm-yellow tent on a lonely island. Next, an assistant made a small "campfire" with a Sterno log, and the model got into position. Al was ready to shoot this incredible scene. The lighting was ideal. Only a beautiful full moon could have improved it.

Then, suddenly, a white globe rose slowly over the water and cast a white beam in the perfect position on it. You don't believe it. We didn't either at first. I teased B. A. that we had known that there was going to be a full moon and had notified the film commission to have it come up a little to the left of this island to balance the picture. Seriously, the moon did come up just the way you see it in the final advertisement. Al didn't even have to shift his shooting position. It is no wonder that the client decided to go with this shot. We were all pleased with ourselves—and our luck.

The next day we packed and headed for New York City to connect with a flight to Florida. We had planned this day as a travel/prep day. While in New York, we dropped off the film at the lab and switched some equipment as well as our warmer clothes for summer ones. The following morning we flew to Gainesville to begin the southern leg of the campaign.

The moon did come up just the way you see it in the final advertisement.

Florida

Since Gainesville is closer to Cedar Key than Palatka is, Al and I decided to scout the area before we drove the two hours to our first shooting location. Furthermore, Al hadn't been to Cedar Key in a long time. Luckily, we discovered that the airport the helicopter pilot would be working out of was only a mile from our hotel. We then drove down to the docks and made sure that the water was indeed the emerald-green color that the client wanted. Our next stop was Palatka. Because the area hadn't been scouted, Al needed to look for scenic spots along the river to shoot from, to check out the lake where he planned to photograph the waterskiers, and to meet the local boat dealer who would be supplying the boats as well as information on docks and loading ramps along the St. John's River.

I had arranged a casting session for early in the evening through the Florida Film Commission and had rented a conference room in our hotel. The call had been put out for real bass fishermen and waterskiers to arrive at 6:00 PM, a time when these people would be finished with their regular jobs. We selected the models and told them we would give them call times later.

The next morning, Al and B. A. went out with the assistants to scout both the St. John's River and nearby lakes while I tied up some loose ends. First, I checked in with the helicopter pilot and found out that his Bell Jet Ranger was down and that he had to borrow a friend's helicopter. He also explained that this helicopter was smaller but that it would do the job. Because Al was out scouting, I couldn't ask his opinion. But that really didn't matter anyway. The only other available pilots near our locale were in Orlando, and they wanted twice the average hourly rate. I didn't want to spend an additional 5,000 dollars since the money would probably have to come out of our profits. I had bid the rate based on my conversation with this

pilot, and I knew the agency wouldn't pay the difference. So I ignored the little voice in my head and arranged to meet the pilot at a small local airport the next day.

Al returned from scouting early and was pleased with what he had seen. We went over the Polachromes that he had shot during the scout, discussed the order of the shots and the call times, and notified the talent and the agency. We also talked about the details of the helicopter problem; because of the money involved, Al decided to stay with the present pilot. All of the prepping was now done.

In the morning, Al and the crew went to the off-loading ramp to meet the fishermen and acquaint them with the boat. I left for the airport to meet the pilot. He wasn't familiar with this part of Florida or the St. John's River so I took him to the shooting site. Al had planned to shoot boat-to-boat early in the morning and to do the tracking shots in the late morning or early afternoon. As I arrived at the airport, I knew that Al would be winding up the dawn shoot. Unfortunately, the weather was not good and the sky was gray. I went to the heliport and waited anxiously. When I spotted the helicopter, I headed toward it to get on board and thought to myself, "Al is going to be upset when he sees this Bell 47." I was angry with the pilot because I felt he should have communicated a more accurate description of this helicopter. But I kept my temper in check because we needed to work with him and yelling wouldn't solve the problem.

I sandwiched in between the pilot and his large copilot. The helicopter was so small that it didn't have doors, and I don't think it was built to carry three passengers because the so-called middle seat didn't have a seat belt. We then took off to meet Al. Before we even landed, I saw Al's annoyed expression. I shot him a warning look because I didn't want him to lose his composure in front of the clients. Clients tend to mirror whatever attitude and feelings you convey. We needed

The boats don't sit properly in the water if they're not moving at top speed, and boat aficionados would notice.

only one great picture from this particular shoot, and it didn't matter if the photograph was taken from the helicopter or from the boat.

Al then showed me the Polachromes he had taken earlier. Although he was not thrilled with them, I thought they were great. He wanted something more dynamic and action-oriented and had hoped to get some great shots from the helicopter. But the boat could go 95 mph at full throttle, and Al was sure that the Bell 47 would have trouble keeping pace. While common sense dictated that Al shoot the boat moving at a slower speed, this was not an acceptable solution to the client. The boats don't sit properly in the water if they're not moving at top speed, and boat aficionados would notice. Al and B. A. bravely got on board the helicopter to make a pass around the fishing boat and exposed a roll of Polachrome. Al found that he was able to respectably keep up with the boat by cheating and cutting across bends and curves in the river.

After finishing this shoot, however, Al told me that he didn't think he had captured anything great on film. He was also disappointed by the cloudy sky because he knew that the sunset shots of the boat wouldn't turn out well either. Nothing was going our way, but there wasn't anything we could do about it. Then, just when we were about to give up, a beautiful orange glow filled the sky and the rain clouds dropped out to black. Trees with Spanish moss hanging from them looked spooky yet romantic, and the fishermen were silhouetted. The scene was beautiful, peaceful, and perfect. We were saved. The last photograph of the day was the winner and was used in the final advertisement.

On the following day, Al planned to photograph the waterskiers on a lake that we had found earlier. Since they would be traveling at a slower speed than the boat, the helicopter wouldn't have trouble keeping up with the action. (We had booked two professional waterskiers, figuring that we could al-

Here, Al prepared to shoot one of the water-scene images from the helicopter, evaluating the light and the angle.

ternate between them every 15 minutes or so when their legs gave out and they needed to rest.) The biggest problem with this picture was that Al wanted to shoot straight down on the waterskier, but the space between the boat and the skier would be exaggerated by the wide-angle lens. The lead rope was shortened as much as possible, and to further compensate for this empty space, Al instructed the waterskier to go back and forth over the boat's wake and to ski up alongside the boat. Al then photographed the waterskiers with a 16mm full-frame fisheye lens pointed straight down on the scene to add a little distortion "jazz" to the image.

In the early evening, we packed up and drove the short distance to Cedar Key. After dinner, we met with the sailboat crew to discuss what we wanted to shoot as well as call times. They were going to have to wake up very early to beat Al to the shooting area; it would take them several hours to get to the location while Al could get there in 15 minutes. In the morning, the sailboat left several hours before Al and Dennis headed toward the airport to meet the helicopter. Al had decided to use an assistant for this aerial shot because he would be shooting fast and needed someone to reload cameras, mark film, and change lenses. The

The helicopter was so small that it didn't have doors, and I don't think it was built to carry three passengers.

pilot still wasn't able to fix his Bell Jet Ranger so he would be flying the Bell 47 again. But since Al would be shooting the slow-moving sailboat under full sail, the helicopter wouldn't have trouble keeping up. And because weight wouldn't be a problem for this shot, Al decided that Dennis would assist at dawn and Bruce would assist at dusk. Bruce and I were to stay on shore and wait until then.

Hovering over the Gulf of Mexico, Al quickly spotted the sailboat. He shot the scene uneventfully until the light became too bright. At that point, he directed the pilot to head back and they made arrangements to meet later for the dusk shot. When the sailboat crew returned, Al told them that he wanted to make some swooping passes during the dusk shot for added drama and gave them a walkie-talkie. Gary and B. A. told Al that they liked the Polachromes from the dawn shoot but felt frustrated because they couldn't see what was going on from shore. So Al suggested that they go out on the sailboat and assured them that they would be unrecognizable in the shot. We were ready to begin. Dennis and I stayed on shore with a walkie-talkie, and Al gave the sailboat crew a 2 ½-hour lead and went to the airport with Bruce.

Up in the helicopter, Al spotted the sailboat easily and started shooting. The pilot swooped toward the boat a couple of times, getting in quite close—in fact, too close. Al felt a hand on his shoulder and turned around to see Bruce looking at him with wide-open, frightened eyes. The helicopter was traveling at about 50 mph only 2 feet above the water and was heading for a sandbar. The pilot made a rough landing on the sandbar and started flipping the magneto switches. The engine was running very hard and missing beats. The pilot finally admitted that he was having engine problems and that he would have to leave either

Al or Bruce on the sandbar while he went back to the airport to fix the problem. Al wanted to stay and shoot the sailboat going back and forth across the horizon because the light was just getting beautiful. Bruce wanted to stay because he had had enough; he wasn't going back with that pilot. The pilot left alone and wasn't able to fix the problem. We never saw him again.

Al radioed the sailboat and told the crew what was happening. He instructed them to sail back and forth until the sun had set completely. After he shot for about 30 minutes, the sailboat nosed into the sandbar and rescued Bruce and Al. Dennis and I had no radio contact with Al for most of that time and didn't know what was going on. It was well past the time that Al was to meet us back at the hotel, and the darker it got, the more worried I became. Eventually the sailboat came in close enough for Al to radio us that he was on the boat and would meet us at the dock. I wondered how he had gotten on the boat. Later, Dennis and I watched the sailboat dock and Al and Bruce disembark. They told us what had happened but didn't say much else at dinner.

The next morning we flew to Miami to meet a plane that I had chartered earlier to fly us and our equipment to Bimini. Al had to stop in Miami first and bring his equipment to the customs office and register it. This wasn't necessary to enter the Bahamas but it was for the return to the United States. American customs officials are strict, so pay very close attention to details when you register your camera equipment. You must come back into the United States with all of the equipment listed in the registration or you will be charged the full amount of the missing equipment. Furthermore, keep in mind that you must register your equipment no more than 24 hours before your flight time.

For this photograph (opposite page, above), Al relied on the standard approach to shooting this type of scene. Then, to provide the client with an alternative composition, Al used a wider-angle lens for a more dramatic shot (opposite page, below).

The helicopter was traveling at about 50 mph only 2 feet above the water and was heading for a sandbar.

Despite the serious trouble with the helicopter, Al was able to photograph the sailboat heading toward the horizon at sunset.

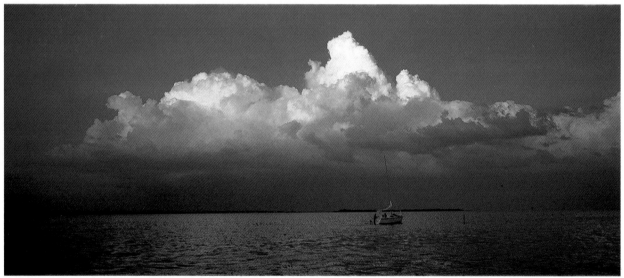

Al made this shot of the sailboat with the striking cloud formation using his wide-format Hasselblad.

Bimini

I had scheduled the day we were to arrive in Bimini as a travel day only. I knew that it would be nearly impossible to do anything other than meet some of the other people involved with the advertising campaign, including the agency representatives and the client, at the hotel. Entering Bimini with 20 cases of equipment was simple because the Bahamian Department of Tourism had made the arrangements for us. Once we were settled into our hotel, we broke up into groups and spent the rest of the day touring the island. The following day, the models, the dog, and his owner flew in from Miami; the pilot flew his helicopter over from Miami; and the boats and their crews arrived.

Al and the pilot went up for a slow tour of the nearby waters, looking for a place with contours on the ocean floor made by sandbars. He found a suitable spot for the "snorkeling" shot and marked it on a map. He then shot a roll of Polachrome of the areas he was interested in to show those of us who didn't go on the scout. In the meantime, I met with the models, went over the wardrobe, and explained what they would be doing. I showed the dog owner how to work the walkie-talkie because she would be hiding in the small cabin on the boat during the shoot and relaying Al's directions to the talent. I then gave the children their snorkle gear and watched them swim in the hotel pool. I wanted to make sure that they were strong enough to be able to swim in the ocean for about an hour, as the talent agent had assured us when Al and I selected them from head shots. The children's father was also a model for this picture so he would be on the boat as well during the shoot. Because we were going to photograph the snorkeling scene the next day, I told all of the models to stay out of the sun. They were already tan, and I didn't want them to get sunburned or too dark. By the time I finished with the models, Al was back from the scout.

Next, I searched for a trustworthy individual to hire as a guard because the pilot was concerned about leaving his helicopter, a Bell Jet Ranger, unattended at night. When I found someone who would work for a reasonable amount of money, I brought him to the hotel to meet the pilot. After they discussed the situation, I told the man that I would meet him the next morning and that if everything was in order I would pay him in cash.

After checking the helicopter the following morning, I gave the guard his money. I then met the models at the dock after breakfast and looked over their outfits. The models got on the boat, and the boat's owner gave the father a quick lesson on the controls. He was going to be responsible for getting the boat to and from the location. Then Al told him where they were to meet. Al instructed the children to stay in the boat until he directed otherwise through the dog trainer. Finally, he reminded the dog trainer not to come out of the cabin.

Al, an assistant, the art director, and the pilot walked over to the helicopter. While the pilot removed its door, Al prepared his safety harness. Once he was satisfied with the lead on the harness, they boarded and took off to find the boat. They caught up with it quickly. Al instructed the father to kill the motor and let the boat drift for a while. Then he told the children to get into the water with their snorkeling gear. Al was going through roll after roll when he suddenly noticed a shark heading slowly in the direction of the children. He quickly had the assistant calmly tell them to get out of the water without telling them why. When they were safely on board the boat, the pilot chased the shark off by casting a shadow in the water near the shark and moving toward it.

After Al finished the snorkeling scene, he had the children get back into the boat; it was time to do the tracking shot with the boat at full throttle. Al radioed the father to move the boat toward the sun. The pilot low-

Al was going through roll after roll when he suddenly noticed a shark heading slowly in the direction of the children.

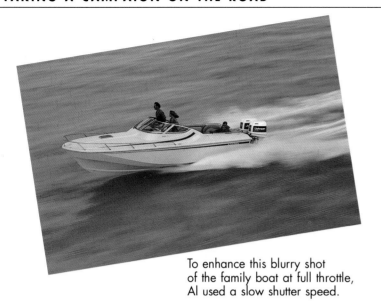

To enhance this blurry shot
of the family boat at full throttle,
Al used a slow shutter speed.

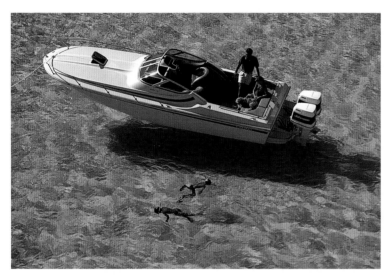

This is the shot of the family boat
indicated in the original layout.
The boat drifted aimlessly
while the children snorkeled.

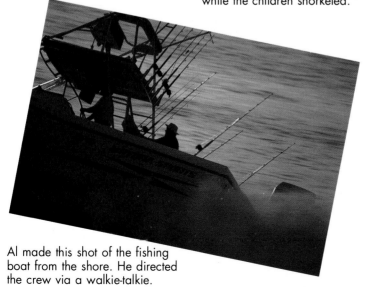

Al made this shot of the fishing
boat from the shore. He directed
the crew via a walkie-talkie.

ered the helicopter until it was 20 feet above the water and parallel to the boat. Al shot at slow shutter speeds, ⅛ sec. and ¹⁄₆₀ sec., to blur the water and add to the sensation of speed. He was pleased with the shoot and signaled the father that it was a wrap.

Back at the hotel, I received reports about how the shoot went. Everyone was happy with the Polachromes. B. A. said she felt that she had everything she needed for that layout. So I released the models and arranged to meet them the next day to sign vouchers and settle their petty-cash expenses. Al and B. A. then decided to do a dusk shoot of the fishing boat from the shore and headed off to the docks to tell the boat crew that they would be needed later.

That evening, there was a beautiful display of clouds and golden sky. Al had the walkie-talkie taped under the boat's fighting chair so that he could communicate with the crew. As the boat drifted about a quarter of a mile offshore, Al first shot it with a 400mm and a 600mm lens. He wanted the boat large in the frame and the sky compressed. Then as the sun set and the colors of the sky became brilliant, he switched to wide-angle lenses that ranged from 16mm to 35mm. He wanted the boat to be small in the frame and surrounded by lots of clouds and water. The final shots were just spectacular.

The next night at sunset, Al shot the fishing boat from another boat. He tried quite a few ideas, but none looked as good as the photographs he had taken the preceding night because Mother Nature wasn't putting on the same display. But everyone agreed that they had all of the necessary shots. With this campaign "in the can," they headed toward shore and a small celebratory dinner party that I was arranging. We toasted each other and our new friendship. There was also a great deal of excited talk about what the pictures were probably going to look like. Everyone was happy but anxious to go home—especially those

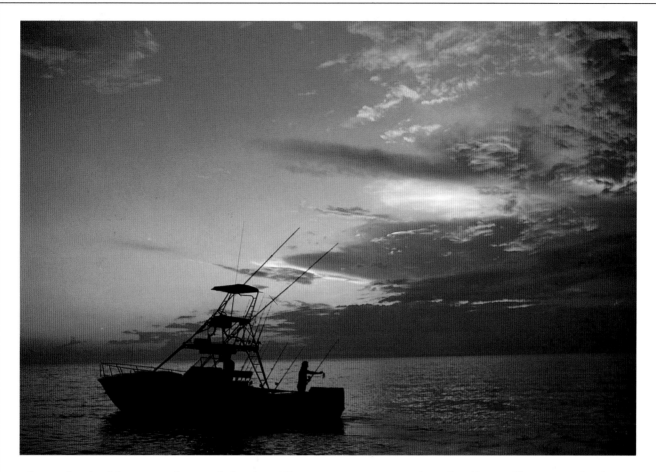

of us who had been on the road for more than two weeks.

Back in New York, we had to return the rented equipment, split the film into batches, and drop it off at the lab. The first batch would be delivered 24 hours later to the studio for editing, identifying, and stamping. At this point, Al is the first one to look at the film. He pulls out what he likes and then checks the film for signs of potential problems with either his lenses, cameras, or the lab. Next, he has an assistant go through the film and stamp each chrome with his name, copyright, and date. The assistants then group the chromes that Al hasn't selected into boxes labeled accordingly. The film from this campaign took four days to edit and label.

The next step was to ship the film via Federal Express to B. A. Afterward, I gathered all the receipts from the shoot and put them into categories. I must do this before I can put together and submit an invoice. (Upon receiving a bill, an agency requires a minimum of 30 days to check and approve the figures and pay the photographer.) At the same time, Al looked over his camera equipment and brought some of it in to be professionally checked and/or overhauled—as he always does after a lengthy shoot. Johnson Outboard Motors loved the film. In fact, B. A. told us that the client said that it was impossible to choose among the variations, that it was like trying to choose between a Rembrandt and a Renoir.

The spectacular sky is the reason why this shot of the fishing boat in shallow water is so strong.

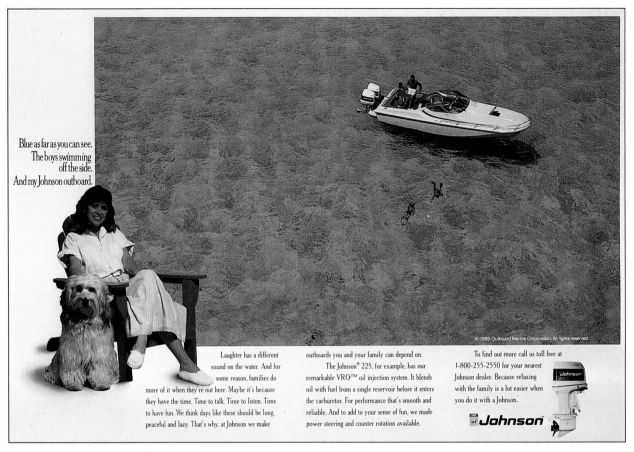

Blue as far as you can see.
The boys swimming
off the side.
And my Johnson outboard.

Laughter has a different sound on the water. And for some reason, families do more of it when they're out here. Maybe it's because they have the time. Time to talk. Time to listen. Time to have fun. We think days like these should be long, peaceful and lazy. That's why, at Johnson we make

outboards you and your family can depend on.

The Johnson® 225, for example, has our remarkable VRO²™ oil injection system. It blends oil with fuel from a single reservoir before it enters the carburetor. For performance that's smooth and reliable. And to add to your sense of fun, we made power steering and counter rotation available.

To find out more call us toll free at 1-800-255-2550 for your nearest Johnson dealer. Because relaxing with the family is a lot easier when you do it with a Johnson.

Johnson

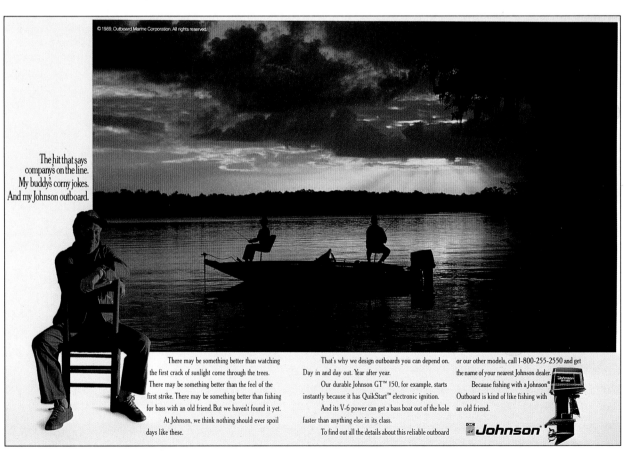

The hit that says
company's on the line.
My buddy's corny jokes.
And my Johnson outboard.

There may be something better than watching the first crack of sunlight come through the trees. There may be something better than the feel of the first strike. There may be something better than fishing for bass with an old friend. But we haven't found it yet.

At Johnson, we think nothing should ever spoil days like these.

That's why we design outboards you can depend on. Day in and day out. Year after year.

Our durable Johnson GT™ 150, for example, starts instantly because it has QuikStart™ electronic ignition.

And its V-6 power can get a bass boat out of the hole faster than anything else in its class.

To find out all the details about this reliable outboard

or our other models, call 1-800-255-2550 and get the name of your nearest Johnson dealer.

Because fishing with a Johnson® Outboard is kind of like fishing with an old friend.

Johnson

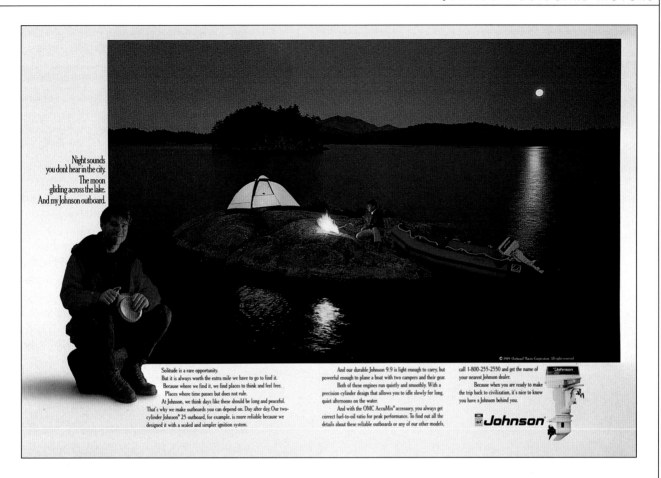

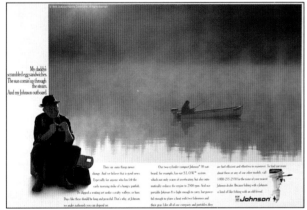

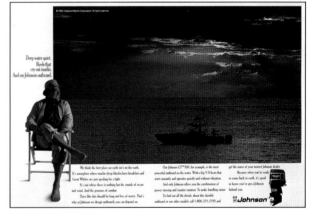

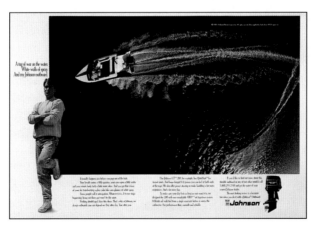

These are six of the finished advertisements for the Johnson Outboard Motors campaign. Photographer Tim Bush photographed the models framing the shots in the finished advertisements in a Chicago studio.

SHOOTING FOR STOCK

For more than two years, Al had been shooting primarily cars and location advertisements. Most of the location pictures included people, but they weren't featured prominently. As a result, our portfolio looked unbalanced. Shooting assignments is important to us not only for generating income, but also for keeping our portfolio current with exciting work in the various categories that Al photographs. So we decided to do a test shoot.

In order to come up with a theme, I pulled out my "swipe" file. This is the idea file where I keep the photographs that I've seen over the years that appeal to me. Al and I don't copy these photographs; we use them as a jumping-off point to create new and fresh ideas. When we went through the file, we found some old Nike advertisements. Since we didn't have anything in our book that was shot in this popular style—sports-oriented, studio lighting—we thought we would try it.

I called the owner of the gym I belonged to and made a deal with her to shoot there on a Sunday (when the gym is closed). I envisioned all kinds of exciting shots. I arranged for an equipment demonstration at the gym for Al, who was unfamiliar with exercise machines. He was fascinated by quite a few of them, especially since some of them would work well with his Hasselblad wide-format camera. We quickly sketched out rough preliminary ideas of the shots. Unfortunately, we couldn't move the gym equipment around because it was bolted to the floor and calibrated. As a result, it was obvious that we would need to use painted backdrops to block off uninteresting walls or machines that interfered with the desired simplicity and clean design of our shoot.

Next, Al and I went back to our studio and put together an estimate of the expenses. We determined that this shoot would cost approximately 7,000 dollars. This total included location fees, assistants, wardrobe and props for four models, catering, film, light-

Al wanted to cover the stock shoot in as many formats as time allowed. Here, he used a Hasselblad 2¼ to photograph one of the locker-room scenes.

I arranged for an equipment demonstration at the gym for Al, who was unfamiliar with exercise machines.

The agency told me not to expect a great turnout at the casting session.

ing-equipment rental, a van for transporting the camera equipment, and a hair-and-makeup person. However, if we paid the models and got releases for stock-photography sales, we could make our money back and earn profits over the years. So it made sense to have this shoot serve a dual purpose. For an additional 3,000 dollars for four models plus their agents' fees, we would own the photographs outright and would be able to place them with The Image Bank.

Investing the 10,000. dollars in this sample/stock shoot could provide us with some new assignments in an area that we hadn't been working in lately. The new photographs would also make our portfolio look more current. Although Al and I probably wouldn't begin to make the expense money back for at least one year—the length of time it takes for the pictures to be categorized, duped, labeled, and shipped to all of The Image Bank offices worldwide—we decided to go ahead. The results are not immediate, but if you shoot continually and build up a substantial quantity of stock shots, the earnings can carry you through slow periods.

My first task was to find backdrops that Al would like. As we looked through the various backdrop catalogs that I keep on file, Al saw two interesting backdrops in Sarah Oliphant's catalog. One was of a row of lockers, and the other was mottled and warm-toned. Al also wanted to use something with texture and/or design in some of the backgrounds. Building a wall at the gym would be too expensive, and we would be able to use it for just one shot. We needed more flexibility. Al didn't like the idea of using fabrics but loved my suggestion about using Levolor blinds that come in designer colors and have either horizontal or vertical slats.

Once we finished discussing the backgrounds, wardrobe, and props and I drew up a production schedule, I tackled my next task: finding models. I called Rogers and Lerman, an agency Al and I frequently work with, and explained that we wanted models willing to work for 750 dollars per day for a complete buyout for a stock shoot. The agency asked if we were going to show the models' faces. Although stock sales increase when faces are obscured, I didn't want to inhibit Al's creativity. The agency told me not to expect a great turnout at the casting session. I needed only four models with good figures. To make this job more appealing to the models, I told the agent that I would give the models any outfits they wore during the shoot.

I was pleased that 20 people showed up for the casting call. I had the models fill out a form asking for general information about themselves. This procedure saves me a great deal of time later because I don't have to call each model to make final arrangements. Models don't make money sitting by the telephone, so I usually reach their answering services and machines. This problem can be frustrating, especially when the schedule is tight. During casting, I also took Polaroids of the models, looked at their portfolios, and got a feeling about who was right for the job. I let them know right then where they stand—to the best of my ability.

Later that day, I showed Al the Polaroids and told him my impressions. We discussed the models and selected four. Since most models don't have bookings on Sundays, it was unlikely that there would be a scheduling conflict. We were in luck. We were able to book and confirm our first choices. Next, I called a friend who does hair and makeup to see if he wanted to work on this project; needing the extra cash and having that Sunday free, he agreed. I then arranged for a caterer. While I was busy planning lunch, Al booked four assistants, one of whom would also do the Friday pickups and Monday returns. I then ordered the backdrops and requested that they be delivered to the gym on Friday. The owner had agreed to store them until the shoot.

Since Al and I didn't want the added expense of hiring a stylist (day rates range from 350 to 500 dollars), we decided that I would take care of the styling. Shopping for this shoot was straightforward; classically designed workout wear and accessories are easy to find in New York City. I found the Levolor blinds at home-decorating stores. The only other props needed were bottles of "designer" water with appealing shapes and colors and a few towels. Al and I decided to use plain, white towels so that the graphic patterns on the sportswear would be the main design element.

Early that Sunday morning, the buzzer sounded and the "troops" entered our studio. In less than 30 minutes, the assistants loaded the rented van with the equipment, wardrobe, and props, and we arrived at the gym, 10 blocks away. Al and his first assistant went over what he wanted to shoot while the other three assistants brought everything into the gym. When the models showed up, we asked them to try out the gym equipment. Al and I then talked briefly about who looked best doing what. We then had the models put on the appropriate workout gear and coordinated the backgrounds. The first assistant made a list of these combinations, and we devised a shooting plan. Following a schedule prevents you from taking up too much time on one idea. We had four specific pieces of machinery we wanted to concentrate on. If there was any time left, we would explore other ideas.

At this point, two assistants began setting up the first shot centered around a workout bench. They put up the locker-room backdrop first and started to prop the set while the other two assistants worked on setting up the second shot; it included the vertical climber. As Al worked back and forth between the two sets making comments or adjustments, the models were getting dressed and made up for their first shot. While the finishing touches were being made on the bench

set, Al positioned all of his cameras. He wanted to shoot as many formats and variations of each setup as possible in order to increase the sales potential of the photographs.

Al's plan was to begin shooting with his Nikon (24mm x 36mm), covering horizontals and verticals whenever he thought it was practical. Then he decided that he would shoot with his Hasselblad 2000FCW, using 35mm backs to get a medium-wide frame (24mm x 55mm). He would use his Hasselblad with the 2¼ back (55mm x 55mm) to cover the setups in a larger format. And finally, if a setup warranted it, he would shoot with his Nikonwide, an ultrawide format (24mm x 108mm) with no distortion. Al planned to shoot only Kodachrome. He shot Kodachrome 25 for the 35mm film and Kodachrome 64 for the 2¼ format. Al likes to shoot these two films for stock shots because they are finely grained and because they last almost indefinitely when handled and stored properly without fading.

When the first set was ready, Al wanted to start with a series of post-workout shots of a male model sitting on the bench with a towel and a bottle of water. (We hide or remove labels, logos, and product names for stock shots to make them more generic.) Al had the set illuminated from the right side with a single strobe head throwing light through the blinds that were out of camera frame. This effect created an illusion of light coming through a nearby window. He deliberately left the backdrop wrinkled because he felt that the overall effect made the photograph look like an old, cracked painting. Smoothing out the wrinkles made the shot seem to be of a row of lockers in soft focus.

Al continued shooting this version until he thought the model appeared stiff. We were about to move on. During the shoot, however, I had been spritzing the model with water to make his skin glisten with "sweat." When I saw him wipe off the water with his towel and the back of his arm,

We hide or remove labels, logos, and product names for stock shots to make them more generic.

I told Al to turn around. I went over to the model, spritzed him again, and asked him to repeat that motion. His gesture was so unplanned, so human. This wonderful photograph ended up in our portfolio.

For the second shot, the bench was adjusted to the situp position. The male model, who was in great shape and had excellent muscle tone, removed his shirt and sat down. Then, as he did more and more situps, he started to grimace. This expression made him look mean and tough under the stress of working out.

Al had other ideas for this setup that he wanted to try out. He changed the lighting by removing the blinds and placing a very large softbox on the right of the set. A chair used for working out with free weights replaced the bench. The other male model got into position and began doing curls. As Al was shooting, I realized that he was losing interest and that I didn't like this shot; it was too posed and pretty. Although this model was working

hard and his muscles were bulging, his face was serene. I asked the model to concentrate on what he was doing, to get into his role, to act; I wanted guts. I told him to imagine that he was on his 150th curl and was straining to do 30 more. This model worked hard to give me honest emotions, and his efforts showed when we got the film back from the lab.

Moving on to the second set, Al decided to shoot the vertical climber from two angles. We wanted the background to drop out, so we hung black velvet behind the climber to reduce the amount of light and to create a deep void in the shot. We placed strobe heads inside white umbrellas on the left and right of the climber to produce a soft fill-lighting effect. While shooting, Al would be able to shut down one strobe or the other. This would change the look of the shot by directing the light source. Al then set up his Nikonwide, the only camera that would work successfully with this extremely long piece of equipment.

The best shots of the male model (opposite page, top) were taken when he thought that Al had finished photographing him.

When Al noticed the model wiping "perspiration" off his face (opposite page, center), Al quickly photographed him repeating the gesture.

After making some shots of the model working out on a situp bench (opposite page, bottom), we decided to remove the offset blinds and use a softbox light.

While shooting the vertical climber (below) on the second set with his Nikonwide camera, Al decided to try some strobing effects.

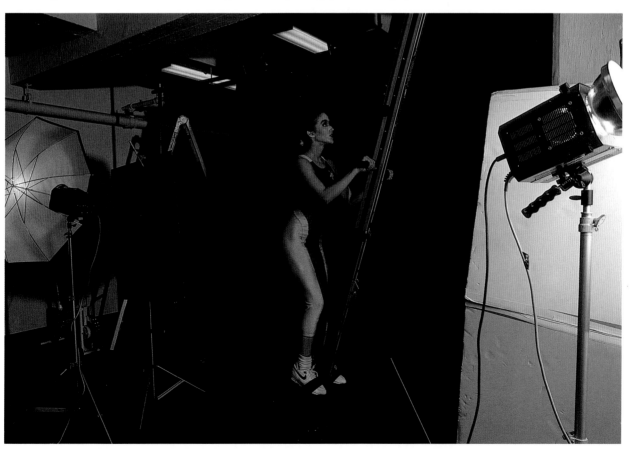

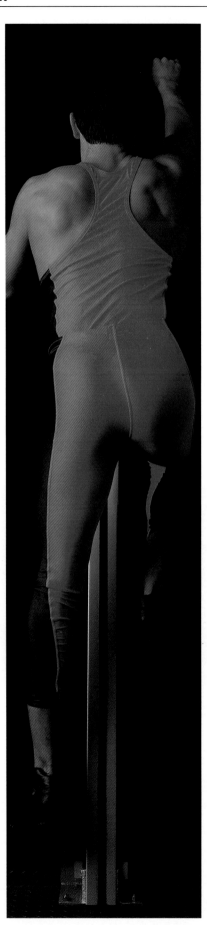

For a creative change of pace, Al turned his ultrawide camera vertically. Up until this point, he had used the ultrawide camera for only horizontal and panoramic views.

We worked with one of the female models first. She "climbed" for 15 minutes. I didn't like the shot, but I couldn't figure out how to improve it. Al wanted to see six ghostlike images of the model at various stages of working the climber. In order to accomplish this multiple exposure, he darkened the room, opened the shutter of the camera, and fired the strobes at the correct f-stop. (To calculate the correct f-stop for multiple exposures, take a reading of the strobes for one exposure and expose an image on one frame. Here, if Al wanted to shoot one exposure, he would have used $f/8$. But he intended to shoot six multiple images of the model in various positions on the climber. So he started at $f/8$ for the first exposure and subtracted accordingly. For two exposures, Al would shoot at $f/11$, and for four exposures, he would shoot at $f/16$.) Since he wanted six exposures, he shot at $f/22$.

Al wanted to see a test of this effect before actually shooting. He loaded the cameras with Polachrome, darkened the room, opened the camera's shutter, and fired the strobes six times at $f/22$. The developed Polachrome showed six "ghosts" in different positions on the machine. Al liked the effect but wasn't particularly knocked out by it. But since he had gone to all the trouble of setting up the picture, he shot a few rolls of film. He then had the male model get into position, photographed him in all of the variations, and also decided to switch camera angles to a back view.

In the meantime, the caterer had arrived at the gym and I worked with her to set up lunch. Al was winding up the climber shot, so I broke two of his assistants for lunch along with the hair-and-makeup stylist and three models. After Al was finished, the two assistants he had been working with struck the set. Then the three of them ate while I prepared the next shot with the other two assistants.

Al and I selected the male model who did the curls to pose on the rowing machine. He wore a conservative,

black-and-white gym outfit. This particular machine was older and unusual looking. At one end, it had a big bicycle wheel with black flaps attached to the spokes of the wheel. Because the flaps blended into the mottled backdrop and got lost, Al put alternating yellow and red tape on them to add a little color. The tape could be easily removed later without damaging the machine. Al illuminated the set from the right with a large softbox and used the white wall on the left for fill. He made the lighting more dramatic by placing black cards on the wall. When the model bent over to give the wheel the first big tug, there was something very romantic about the shot. Dissatisfied with the way the rowing machine looked when the wheel was stationary, Al had the wheel turned; the colored flaps then produced a soft, blurred edge instead of a hard yellow-and-red line. We tried a number of variations of the model on this machine, but the first shot was the best—and my favorite shot of the day.

Next, we had the other female model "row." She didn't look as appealing as the male model, so we asked her to act as if she were resting after a hard workout. This was much better. She then wanted to try some more "model-like" poses, stretching and arching her back. I thought this looked silly but Al shot a roll for her anyway. At this point, we gave her a bottle of water and told her to hold the same position and take a large gulp. The prop gave her a good reason to arch her back. Without it, the shot looked too staged. Al and I liked this image so much that we had it printed and included it in our portfolio. Al used his Nikon and his Hasselblad with the 35mm back for these horizontal pictures. While we were striking the rowing-machine set, the second male model asked if Al would mind photographing him doing karate kicks. He demonstrated. The model has a fabulous kick that he can do on mark every time. This was my second favorite shot of the day.

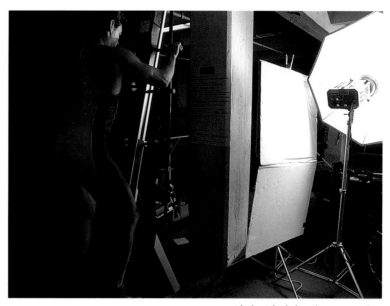

Al decided that he wanted a back view of the male model on the vertical climber. First, however, the lights had to be readjusted.

To add a little color interest to this shot of the rowing machine, Al placed red and yellow tape on the flaps of the wheel spokes. This touch enlivened the otherwise muted scene.

According to my production schedule, the final shot was supposed to show the arm-building machines. But because we were ahead of schedule, Al, his first assistant, and I spent some time planning other pictures. We decided to shoot a machine that works on the upper back and the backs of the arms and to do some jump-rope shots. We concentrated on the arm-building machine first. We chose a pink Levolor blind for the background. After a few tries, we agreed that the effect was cute but unsuccessful. While Al prepared for the next series of shots, I released one female and one male model. We signed vouchers and releases, and I gave them their wardrobes.

For the next shot, I had the remaining female model put on a black outfit with a fuchsia trim and a cutout back. We decided to use the blueberry-colored Levolor blinds because the color combinations were electric. Then we tied the model's hair loosely in back in order to see her jawline. We had her do some shots in a stand/crouch position to make it seem as if she were just sitting down to work out on the upper-back-and-arm machine. After a few variations, we gave the model a break so that she could change into the outfit for the jump-rope shot. Meanwhile, we put the male model on the machine. He looked great because his upper-back and arm muscles were well defined. Both models were very good—and very different. After photographing the male model, we released him for the day and prepared for the last shot.

The jump-rope shot was done with the locker-room backdrop because it was the only one high enough to clear the rope as the female model swung it. Al shot this set with his Nikon vertically and with his 2¼ Hasselblad. The model looked fine jumping in her lime-green-and-black outfit, but I wasn't excited by the effect. Al and I wanted this photograph to be dynamic because we felt the idea had a great deal of potential. While we were discussing how to make it work, the model was lost in her own world while waiting for us. This pensive mood was perfect. We told her to hold her pose. Al shot a couple of frames, but she couldn't sustain the dreamy look for long. Everyone was tired.

Al dropped off the film at the lab and got it back the next day. I was thrilled. The shoot was productive, and the money well spent. We had four shots for our portfolio that had the look of an advertising campaign. But because of their unusual format, it took us one year to get approval to advertise the photographs in The Image Bank catalog. We persevered because we were so pleased with them. When I produce work for Satterwhite Productions, I do it in the same methodical fashion that I use for our clients. I always keep in mind that potential clients expect a certain caliber of work from us. If we were to try the "seat-of-your-pants" production method, the end result might be adequate for stock sales alone, but it wouldn't be acceptable for the sophisticated tastes of the art directors who review our portfolio.

The best shot in the sequence (opposite page, top) revealed itself when the model gave the bicycle wheel the first big tug. The effect was quite dramatic and moody. This ended up being my favorite photograph from this shoot.

When we gave Dominique (opposite page, center) a bottle of water to drink from, she had a reason to lean back. As you can see, this position—and the resulting image—worked well.

John asked Al to photograph him doing a karate kick (opposite page, bottom) which he hit perfectly each time. The result is quite energetic.

The prop gave the model a good reason to arch her back. Without it, the shot looked too staged.

The male model looked great because his upper-back and arm muscles were well defined.

This shot of the arm-building machine (above) didn't work for us, so we decided not to spend too much time on it. The addition of the pink Levolor blind was cute but ineffective.

Dominique had excellent muscle tone and looked great in this shot (right) wearing an outfit with a cutout fuchsia back. Also, its colors were intensified when Al placed the blueberry-colored blinds behind the upper-arm-and-back machine.

Al decided to concentrate on the lines of this model's well-defined shoulder muscles, so he moved his camera in for a very close shot (below).

*We decided
to use the
blueberry-colored
Levolor blinds
because
the color
combinations
were electric.*

Al and I wanted this photograph to be dynamic because we felt the idea had a great deal of potential.

Dominique looked very good jumping rope in this bright outfit. But Al and I preferred the shots of her resting and daydreaming.

While Al reloaded a camera, Dominique took a short break. Al and I liked the effect so much that we asked her to repeat the action in order to record it on film.

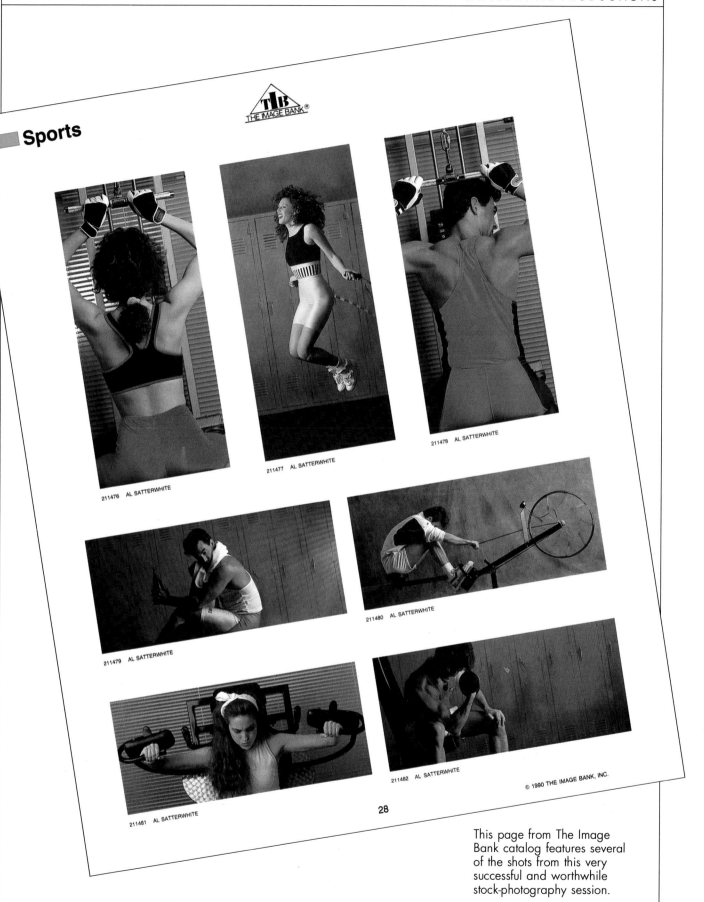

THE IMAGE BANK®

Sports

211476 AL SATTERWHITE

211477 AL SATTERWHITE

211478 AL SATTERWHITE

211479 AL SATTERWHITE

211480 AL SATTERWHITE

211481 AL SATTERWHITE

211482 AL SATTERWHITE

© 1990 THE IMAGE BANK, INC.

28

This page from The Image Bank catalog features several of the shots from this very successful and worthwhile stock-photography session.

SHOOTING CARS ON LOCATION

When Saab switched advertising agencies, the car company had a new creative team working on its account. Whenever a client and an agency first get together, the "creatives," as they're called, look at all the old work done on the account and assess what they like and don't like. Saab's agency thought that the photographs that Satterwhite Productions had shot were strong, so Al and I were asked to work on the account again. As such, we wouldn't be bidding against other photographers. The job was ours—as long as our fee was close to the figure the agency and client had in mind.

The agency sent us six layouts via a fax machine and asked us to call Tony Romeo, the creative director. He explained that the headlines in the Saab layouts were more important than the pictures and that Al and I could pretty much shoot what we wanted to. When I tried to ask questions about the shoot in order to come up with the estimate Tony had requested, he insisted that he needed just a "ballpark" price for shooting six advertisements to be used nationally both in double-page spreads and in single pages.

Putting numbers together for a campaign with an open-ended budget is difficult. You know that the client wants to see if your estimate is reasonable but that it isn't about to tell you the amount it wants to spend. You have to provide a number that won't chase the client away while guessing how much production can cost. If the budget is big enough, Al and I are assured of shooting a dynamite picture for the client. If it isn't, we have to decide where to make concessions.

Photographers' fees for car shoots are somewhat standard. For national advertising, the fees run between 3,500 dollars and, infrequently, 10,000 dollars per shoot day. Travel and prep days are usually charged at half the daily fee. Ordinarily, the usage for a car shoot is one year because car models always change in some way—even

if it is only the selection of colors—and automobile manufacturers would never show the preceding year's models for the current year's campaign. So it is unnecessary for the agency to request a buyout.

Al and I decided to bid the job based on its being shot in Arizona. There isn't much traffic on the roads, and the state is very cooperative when it comes to photography shoots. Al also wanted to do tracking shots of the cars from a helicopter, which can be quite expensive. When the creative director saw the charge for this on my estimate (approximately 700 dollars an hour), he made it clear that shooting from a helicopter was out of the question. We then had another telephone conversation to discuss all the production possibilities that he thought he could sell to Saab. The client would pay for a car prepper to handle the cars, drive them into position on location, make sure the seats are adjusted properly, align the tires and lights, and check for glare on the cars. Saab would also be willing to cover the cost of a car carrier; "zero-mile" cars can't be driven to and from the location because if they have more than 100 miles on them, dealers aren't able to sell them as new. Based on these conditions, my revised estimate was quickly approved.

Next, I requested a purchase order for the agreed-upon amounts and usage and submitted an invoice for a cash advance for job expenses. Ready to begin production, I had a number of telephone calls to make. First, I called the Arizona Film Commission to ask for the names and numbers of location scouts and to explain when and what Al and I wanted to shoot. The commission suggested certain roads and told me how much lead time it needed to put the permits through. Obtaining city and state permits is usually simple, but getting federal permits is a nuisance.

I interviewed the location scouts over the telephone. I found one who seemed to understand what I needed and hired him after negotiating what I

would and wouldn't pay for. You should come to an agreement about the location scout's day rate and the number of days needed to complete the job. Then you should get an idea how much film will be shot, how much it will cost to process it and make prints, and how much time it will take to organize the shots and label them with the needed details. You should also discuss what you will pay per mile if the scout has a car or how much you will pay for a car rental. Finally, you must consider covering the scout's meals and overnight accommodations. You should pay for a hotel room only if the scout has to travel more than three or four hours from home.

When we received the prescout pictures a day before the preproduction meeting, we realized that there seemed to have been a misunderstanding about what our objectives had been. However, we had no choice but to show the shots at the meeting. We assured Tony that we had enough production time and assistants to redo the scout when we arrived in Arizona.

Next, we moved on to the casting pictures. Since the car interiors would be dark—and, therefore, the models largely unrecognizable—we felt that we could use local models. Several days earlier, I had called an Arizona talent agency, discussed our shoot, the fee we intended to pay, and the usage. When the agency agreed to work with us, I requested that it send head shots of people between 25 and 40 years old. I also asked the talent agency to find out which of the models could drive a stick shift and to indicate that on their head shots. During the meeting, we decided that we didn't want women with very puffy hairstyles because the models would look like they had gigantic heads. We also didn't want very short hairstyles because it would be difficult to determine the models' gender. We felt that the women's hair should be at least chin length and that the men's hair should be short on the sides and a little high on top. The

Obtaining city and state permits is usually simple, but getting federal permits is a nuisance.

models also had to be a certain height so that they would look right when seated behind the steering wheel.

After we selected several models, I made a note to call the talent agency and place the models on hold as soon as I got back to the studio. I decided to wait until I was in Arizona with both specific locations in mind and assigned shooting days before confirming the bookings. If you confirm a booking, you can't cancel it without paying a penalty. So I gave the models a week's range and put them on *first refusal*. This means that I had the first right to their time for the days we agreed to. If another client had tried to book the models, their agent would have asked me to either confirm the booking or release the models. Once I confirmed, I owned and had to pay for the models' time whether or not I used them because they might have missed out on other bookings.

The last discussion during the preproduction meeting was about the car models and colors. Tony stressed that the client had been unhappy with the work of previous photographers when the car colors in the pictures weren't the same as those on the color chart. Al explained that dawn and dusk were the ideal times to shoot the cars but that these low-light situations would change the tone of any color, even white. The agency refused to consider these options because it had assured Saab that the pictures would match the color charts exactly.

Al wanted hot car colors in order to shoot graphic images. Unfortunately, Saab's predominant car colors that year were somewhat muted: beiges, grays, and blue-grays. Although Arizona is beautiful, it tends to be monochromatic. But when the sun sets, the rust-colored landscape becomes a rich red. Al thought that bright colors would pop out of this background and told the account team which ones he had selected.

The agency then pointed out that Saab didn't want the cars shot from the rear. Al argued about this, too, but

Al felt that the many restrictions would inhibit his creative instincts once he began to shoot.

was overruled again. Saab's primary concern was to make sure that the pictures didn't show blurred or out-of-focus cars. Al then explained that the only way to get a car tack sharp in an image was to shoot it while stationary. But Saab wanted action in the photographs. At this point, Al mentioned several ways that he could shoot the cars to make them appear to be in motion. This isn't the way Al prefers to shoot, but it was possible.

Al and I intended, as always, to do the best job we could, but we were disturbed that most of the preproduction meeting was about what we couldn't do. Al felt that the many restrictions would inhibit his creative instincts once he began to shoot this campaign. I placated him by saying that when we arrived in Arizona, we could try to convince the client to loosen up a little. We wanted this campaign, and we didn't want to start a fight now. So we went back to the studio and began production. I arranged for the airline tickets, hotel accommodations, catering, and a car carrier; I also did some research on the roads and restaurants in Arizona. At the same time, Al booked a couple of assistants to gather and pack his camera equipment.

On the scheduled "prep" day, the assistants picked up the rental equipment, checked to make sure it was in working order, and then packed it. Based on the preproduction discussions, Al decided to shoot most of the photographs with long telephoto lenses. These compress the foreground and background to provide a different sense of space. They would also enable him to crop out any undesirable scenery. In addition to Al's cameras and lenses, the assistants packed regular and heavy-duty tripods, clampmounts for use on cranes and ladders, and lowboys. The cases were labeled, and the first assistant kept a list of what was in them in the event anything disappeared during travel.

Car shoots require a lot of gear besides camera equipment. If you photograph cars with their lights on, it

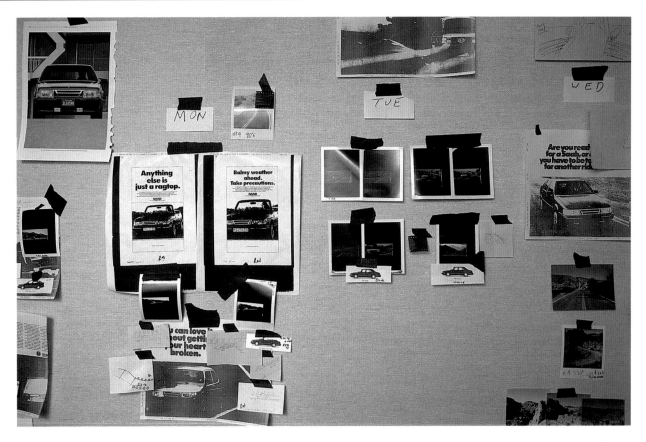

doesn't take long to drain the batteries, so jumper cables are essential. An air pump that can be plugged into a car's cigarette lighter and a tire gauge are important, too. When you shoot on sand, you must partially deflate the tires to make it easier to drive the car without getting stuck, and then you have to reinflate the tires to drive on the pavement. You should pack at least four adjustable jacks that support 1½ tons each. Dulling spray, flat black spray paint, silver spray paint, chrome tape, black tape, white tape, and black magic markers are needed for prepping the car. In addition, Al brings a hammer, saws, staplers, adjustable wrenches, and Phillips and standard screwdrivers (to remove license plates). He also packs both clean rags, which are used to wipe car interiors, tires, and rims, and cloth diapers, which are soft and lint-free and are used to rub the sheet metal so that it shines but doesn't get scratched.

Two days later, we were on our way to Arizona. Our first task was to find interesting bridges; colorful or texture-rich backgrounds or walls; and scenic curving, desert, and hilly roads. So we rented two vans and two cars and split up to go scouting the area. My first stop was the Arizona Film Commission to introduce myself, to submit a copy of my insurance policy with the state named as co-insured, and to gain the staff's trust.

After scouting, we met back at the "war room"—an extra room where everyone can meet to discuss the shoot or coordinate duties and where the models gather for a wardrobe call—with Polaroids of the locations we had found. Al and Tony started discussing the possibilities, concentrating on the angle of the light and potential shooting positions. Once we narrowed down the list, we put together a day-by-day production schedule that included the site, the advertisement or headline, the car model and color, and the driver for each shot. Next, I arranged for shooting permits with the film commission. I gave the staff a brief description of the locations. I was then told to call the police department

Al created a schedule wall and hung it in the "war room" to help organize our production timetable for this hectic shoot for Saab.

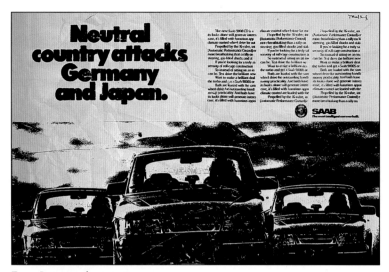

Tony Romeo, the creative director, wanted this layout for the first advertisement to be produced exactly as drawn.

Al, Bruce, and Dennis leveled off the Hasselblad body with a 35mm back and a Nikkor 600mm lens. This combination produced a 24mm x 55mm image of the three Saabs "attacking."

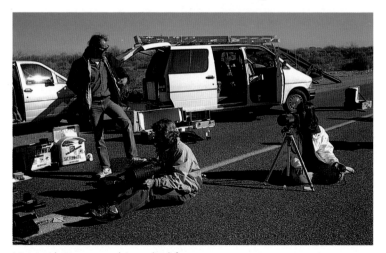

Here, Al, Bruce, and I worked from camera position while the cars were aligned.

in order to hire off-duty police officers to help with traffic control, as Arizona requires. I also called the caterer and the modeling agency to book and confirm. At the same time, the account executive called dealers and arranged to borrow cars.

The following morning, we were ready to shoot the first advertisement. The objective was to make the three Saabs look as if they were attacking; the center car would be out in front as they reached the crest of the hill. Al had hoped for a clear day with crisp early-morning light in order to illuminate the cars slightly on the side and front. He also hoped to be done before 10:00 AM because as the sun rises, the pavement starts to warm up; this causes visible heat waves that make cars look slightly out of focus—an effect that Saab didn't want.

After the cars were unloaded, Al set up his camera approximately where he thought the shooting position would be. He and the assistants then paced off where the cars would go. Don, the car prepper, would finalize the cars' alignment with Al via walkie-talkies; he wanted them dead square to the camera, not at an angle. Don ran to camera position from time to time to check his progress from Al's perspective. He then started prepping the cars. He put black tape or in some cases sprayed flat black paint on the cars' exposed undercarriages. Next, he adjusted the headlights so that they aimed at the same point to prevent flare. Don also matched the height of the headrests. Finally, he asked the models to get into the cars, fastened their seat belts, and told them which way to look and how to hold the steering wheel. Throughout the process, Don was continually conferring with a Saab representative about how the cars should look.

Next, Al finalized his camera position, making small adjustments in framing either for creative reasons or to help minimize the glare off the sheet metal. Al uses multiple cameras when he shoots cars, an approach that

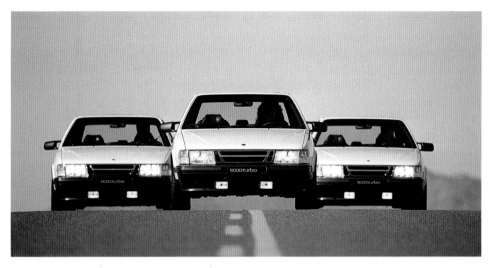

Al made these images with his Hasselblad. This shot (left) shows the cars on the bank, and the other shot (center) shows the second location with the mountains behind the cars.

This is the final "attacking Saabs" advertisement (below); Al shot it as a spread with his Hasselblad with a 35mm back.

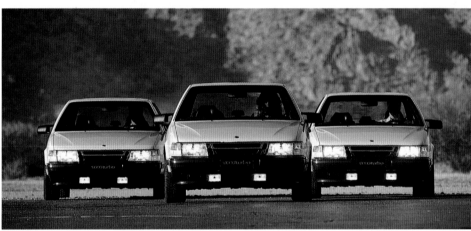

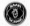

Neutral country attacks Germany and Japan.

In the mad dash to outdo one another, car makers have forgotten something important. You.

The Germans build performance and luxury at prices that offend even those who can afford to make the payments.

The Japanese give you value. But most people can hardly tell one make from another.

Saab sees no reason you can't have it all.

Performance. Room. Character. Value. All at prices that while not inexpensive are at least realistic. (Saabs are intelligently priced from $16,995 to $32,095.*)

The Saab 9000 Turbo that sprints from 0 to 60 in 7.6 seconds costs thousands of dollars less than slower German sports sedans.

The Saab 900, which looks quite unlike anything else on the American road, like all Saabs, has a formidable reputation for protecting its passengers.**

Drive a Saab before you sign up for prestige that isn't practical, or a sensible car that's boring.

Don't buy the wrong car. See your Saab dealer this week.

SAAB
The most intelligent cars ever built.

*MSRP not including taxes, license, freight, dealer charges or options. Prices subject to change.
**The most recent report of the Highway Loss Data Institute reports Saab 900 and 9000 models had lowest injury loss experience in their respective classes. Your dealer has details.

© 1989 Saab-Scania of America, Inc.

streamlines the car prepper's work. This method allows him to shoot different camera positions, focal lengths, film types, and formats at the same time. He shot this spread with a Hasselblad camera with a modified Nikkor F5.6 600mm lens and a 35mm back, which produced a 24mm x 55mm image. On his Nikons, he used 400mm, 500mm, and 600mm lenses. Al shoots mostly Kodachrome 25; occasionally, he shoots a roll or two of Kodachrome 200 and/or Fujichrome for a slightly different look.

Al then draped at least one or two sandbags weighing 20 pounds each to cut down on vibrations, the result of shooting at very slow speeds. He has developed some tricks to prevent camera movement from showing up on film. After he lines up a shot in the camera that has been locked down on a tripod, Al checks the focus and puts a piece of camera tape across the lens to keep it from sliding out of focus. He determines the necessary depth of field and sets the *f*-stop accordingly. Next, he shoots both Polaroids and Polachrome of the subject and checks details. Finally, he corrects any hot spots or reflections on the sheet metal with dulling spray. When Al is ready to begin the actual shooting, the camera's mirrors are locked up. To further ensure against camera movement, Al uses an electrical release so that he touches the camera only when he brackets shots.

When Tony designed this "power" shot, he envisioned the cars looking like tanks and kicking up dust. Because cars don't stir up much dust on paved roads, Al exercised a little creative license and placed two generator-powered wind machines behind the cars and out of frame. Two assistants fed "Fuller's earth" into the machines to produce a small dust storm. Al also tilted one of the camera bodies to give the illusion that the cars were coming at you on a bank. Tony wanted Al to shoot a variation of this photograph on the road with mountains in the background; he wasn't sure which

Al has developed some tricks to prevent camera movement from showing up on film.

picture would be more dynamic and powerful. So Al and four assistants set up the three-car shot at the new location while two other assistants started prepping the hood picture, to be shot there at dusk.

Having fulfilled Tony's request, Al shot the hood of the car from a stepladder as the sun was going down. He wanted to get a range of color saturation. He used large, white foamcore boards as fill lighting for the grill and the opposite side of the fender. For this image, Al used the Hasselblad as well as the Nikons to cover spreads and single-page formats. Al called this shot a wrap shortly before 9:00 PM.

The following morning, we were up and out before dawn to set up the next shot. First, we placed bright highway markers on a slightly curved road to add color to the shots. Don then had to jack up one car and rotate its wheels so that they were in the position Saab specified: the tire logos had to be parallel to the wheel logos. This involved taking the tires off, turning them to the proper position, and then reinflating them. The holes in the wheels were letting light through, so Al instructed Don to put black tape over the holes. All of the running gear beneath the car was spray-painted black, and a straight line of black tape was run down the side to give the car a cleaner, sharper look. Al "sandbagged" his long lenses and repositioned each lens at different angles to get a variety of shots. The resulting compression made the mountains in the background more prominent.

We then moved on to a tracking shot. We didn't have a camera car, so we had to improvise, using a minivan with a rented roof rack. Al added a large piece of ⅝-inch-thick plywood to the top of the rack to make a solid platform to shoot from—even with a tripod. When shooting, Al would sit on the platform wearing a safety harness and direct all of the drivers via walkie-talkies. Depending on the road surface and the shutter speed, he might attach a gyrostabilizer to the camera to help

The next layout that Al and I had to produce called for a closeup shot of the hood.

As the sun set, Al shot this image while standing on a stepladder. He positioned huge white boards in front of the car to kick light onto the grill and to keep the ladder from reflecting in the sheet metal.

Saab ran the final hood shot both as a double-page spread and a single-page advertisement.

Are you looking for a good car or would you settle for a great one?

Whoever said ignorance is bliss never drove a Saab.

Ignorance is the enemy of everything Saab stands for. It's the ally of our competition. And the bane of our existence.

Knowledge, on the other hand, is power. So we'd like to share some with you here.

First, you should know that no other cars in the world offer Saab's combination of performance, handling, utility, safety, and value.

The car you're driving now may have some of the features pioneered by Saab: front-wheel drive, turbocharging, aerodynamic styling, roll-cage construction with crumple zones, astonishing roominess, heated front seats, human-engineered ergonomics.

The list goes on and on.

But a Saab is much more than a list. You should know that absolutely nothing else drives like a Saab. And you should know this before you buy the wrong car.

But of course, if you never drive a Saab you'll never know.

Car and Driver drove a Saab. And found out something you can find out for yourself at your local Saab dealer.

Driving a Saab is "Bliss on wheels."

 SAAB
The most intelligent cars ever built.

Saabs are intelligently priced from $16,995 to $32,095. MSRP, not including taxes, license, freight, dealer charges or options. Prices subject to change. © 1989 Saab-Scania of America, Inc.

Saab gave Al permission to interpret this particular layout his way. The double-page spread shows one of the variations Al tried.

Al uses multiple cameras when he shoots cars, which streamlines the car prepper's work.

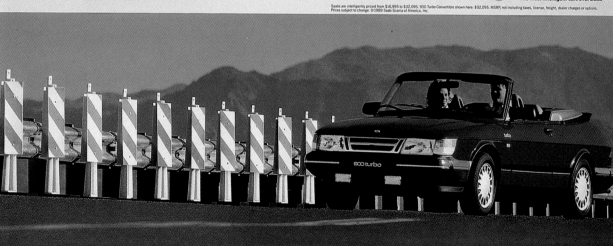

You can love it without getting your heart broken.

All over the country, people are breaking up with their cars in record numbers. It's in the paper every day. Just check the used-car section.

You could avoid this kind of heartbreak with a little foresight and a trip to your local Saab dealer.

There, you might fall in love with a Saab like the 900 Turbo Convertible pictured here. You could do it with an easy conscience, because unlike most convertibles,

ours is a Saab as well.

It wouldn't elate you in the spring, then let you down in the gloom of winter. Like all Saabs, it features front-wheel drive for great traction in any weather. Plus heated front seats and a double-insulated top for comfort, heated glass rear window for visibility and reinforced windshield pillars for safety.

You could drive it all year long and not realize it's a convertible until you dropped the top.

The Saab 900 Turbo Convertible is just one of the ways Saab dealers help keep people from buying the wrong cars – cars that offer fun without practicality or practicality without fun or status at prices that sting long after the honeymoon is over.

Don't buy the wrong car. Don't fall in love with a car you can't live with. Instead, make a date to test drive a Saab.

Your Saab dealer will be more than happy to set you up.

 SAAB The most intelligent cars ever built.

Saabs are intelligently priced from $16,995 to $32,095. 900 Turbo Convertible shown here: $32,095. MSRP, not including taxes, license, freight, dealer charges or options. Prices subject to change. © 1989 Saab-Scania of America, Inc.

cancel the jerking motion of the van. Al would also be able to shoot from a lower angle by sitting in the van with the sliding side or rear doors tied open. Al would also be able to photograph from one position while an assistant shot from the other one simultaneously. And if Al wanted to work with long lenses and pan with the car as it moved, he would use a tripod with a fluid head.

Police officers stationed at either end of the road blocked traffic at 5-minute intervals. They communicated with us via walkie-talkies and with each other on their own radio frequency. Al then directed the driver of the Saab to drive at a certain speed in the right-hand lane while the van matched that speed in the left lane. Al was shooting at a relatively slow shutter speed in order to blur the background and create a sense of action. He shot from the top rear position of the van with a 35mm Hasselblad for the spread, and at the same time, his first assistant shot out of the side-door position with a Nikon for the single-page format.

After lunch, the car was positioned for some tight shots. We wanted to photograph the car at a three-quarter angle with no road surface showing at the bottom of the image but plenty of sky at the top. We worked on this shot until dusk. Then Al came up with another idea. He wanted to shoot the Saab convertible at a three-quarter angle against a metal guardrail. When the sun had just about set, the golden light would reflect off the guardrail and across the sheet metal. The account executive insisted that the client would never run the shot with the convertible top down—the way every other car manufacturer shoots its convertibles. Al tried to persuade them, but the sun was sinking fast and he might miss the shot completely. Time constraints didn't allow him to shoot the car both ways. The shot turned out beautifully. Ironically, however, Saab's top executives in Sweden wondered why we had shot the car with the top

Here, Al was busy checking the tracking shot. He was especially careful while setting up this scene because he had to improvise, substituting a minivan for a camera car.

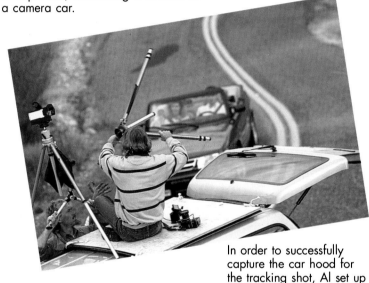

In order to successfully capture the car hood for the tracking shot, Al set up a tripod on the minivan.

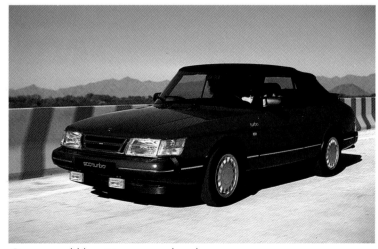

Orange and blue stripes were placed on the wall in order to add some graphic appeal and color to this tracking shot.

Although this photograph of the Saab convertible with the top up, taken at dusk, is beautifully illuminated, company executives rejected it.

This shot was taken in the early morning just outside Phoenix on a road with sharp curves.

This is the Hasselblad version of the curve shot. Al wanted to shoot this scene various ways to give the Saab executives a number of options.

up and decided not to run the picture.

The next morning just after dawn, we all took off for a canyon located right outside Phoenix. The road passing through this canyon has great S-curves that overlook a spectacular view. Al decided to use his 35mm Hasselblad with the Nikkor 600mm lens and two Nikons with a 600mm and an 800mm lens. The lenses were secured with sandbags and checked while the car was prepped. The traffic-control officers could stop the traffic for only a few minutes at a time. We photographed a Saab at a particularly dangerous curve and before the morning ended, we moved down the road to a curve just off the main road at a park entrance. Al positioned the cameras and then put a 180mm lens on the 35mm Hasselblad and 250mm and 300mm lenses on the Nikons. The cameras were set so low that they were nearly resting on the pavement. Just before Al shot, the cameras were secured with sandbags. After we finished this shot, we broke for a quick lunch. During that hour, the weather started to change, and the sun went behind a cloud.

Because the convertible was brought to this location by mistake, Al decided to take advantage of this unexpected opportunity. He had the convertible unloaded from the car carrier and positioned. The rear of the camera van was jacked up to stabilize the shooting platform, and Al climbed on top. He photographed the car on the same curve, but it faced the opposite direction so the car was backlit. Since the agency didn't think much of this shot, Al was allowed to shoot it with the convertible top down. The soft sunlight made it seem like we were shooting the car under a silk. Al added a warming filter to enhance the light quality. In the end, this shot was used in an advertisement—even though the top was down.

For the next shot on this curve, we positioned the car at an angle in order to include the beautiful vista behind it. The cameras were set up down the

hill. As a result, the undercarriage of the Saab was visible and the road's yellow centerline was prominent in the foreground. Once again, Don spray-painted the undercarriage black and adjusted the driving lights to make them flare evenly in the camera. Desperately trying to make these shots exciting, Al decided to place some reflector safety signs in the background to create a little graphic interest. Shooting started as the sun was sinking in the sky and was completed about 20 minutes after the sun set.

The next morning was another early call. The drive to the span bridge that Al and Tony had found during their scout would take two hours. I had secured the state's permission to shoot this bridge. Two off-duty city officers had been hired to assist us, but we got involved in a power struggle when highway-patrol officers shut down our shoot. They told us that the state permits were invalid on the bridge because it was federal property. After I spent several hours trying to obtain the proper permit from the Federal Parks Commission, the state troopers informed us that we needed a permit from the Department of Transportation, too. I was getting angry, but I remained composed. After 6½ hours of torturous telephone conversations with the transportation department, I managed to get a permit issued.

Al now had exactly one hour to set up and shoot before the end of the day. Everyone was exhausted by the waiting. At long last, the car was carefully positioned on the bridge and prepped. We didn't want the bridge to reflect into the hood of the car. Every five minutes, we had to drive the car off the bridge and let traffic through—one of the agreements I had to make with the transportation department. Once everything was arranged and choreographed, Al set up his camera at a low angle. He had just 40 minutes before the sun set. He would shoot a roll, and then the car would be driven off the bridge. We repeated this process about 12 times before the light was gone.

In the late afternoon, Al photographed the female model driving the Saab on the curving road; the depth of field is greater in this image.

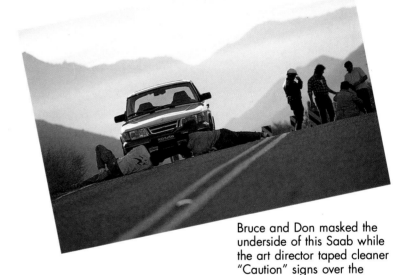

Al made this version of the crest shot with a 35mm back on his Hasselblad.

Bruce and Don masked the underside of this Saab while the art director taped cleaner "Caution" signs over the already existing ones. The police officer observed the details of our production.

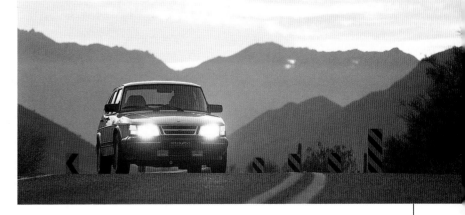

Al and I were given this layout when we bid the job, but during the preproduction meeting we were told not to shoot the Saab from the rear.

The Nikon version of the crest shot (right). This curve shot of the Saab on the curving road (below) was ultimately selected for the spread. Al photographed this scene on an overcast day with diffused light.

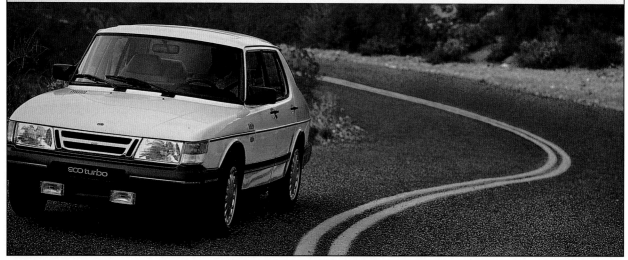

When Al and I were given this graphic layout, we were basically told to use it solely as a guide.

We got involved in a power struggle when highway-patrol officers shut down our shoot.

Saab used this bridge shot as a double-page spread for the campaign.

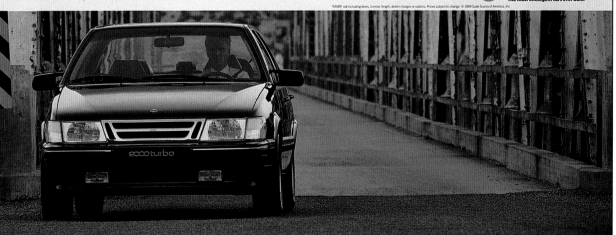

Are you ready for a Saab, or do you have to be taken for another ride?

Your mother told you to be careful whose car you got into. Did you forget?

Have you spent the past four or five years trapped in a car with a bunch of empty promises?

If you have, take heart. It's never too late to put good advice into practice. You can do it at your Saab dealer's.

If you're looking for performance, a Saab can provide it. Three absolutely stock Saab 9000 Turbos averaged

132 mph for 62,000 miles, 21 days straight at Alabama's Talladega Speedway, without a breakdown.

Do you need room? Saabs have that as well. Among all imported cars, the EPA rates only the Saab 9000 and the Rolls Royce Silver Spur limousine as "large" cars.

Saabs are among the world's safest cars, according to a recent insurance industry survey of personal injury claims. Yet a Saab's safety

takes nothing away from its driving fun.

There's one other bit of advice you may have forgotten: don't squander your allowance. Saabs are considerably more affordable than some of their European counterparts–they're intelligently priced from $16,995 to $32,095.*

Don't get taken for a ride in the wrong car. Do the right thing and get into a Saab.

We're sure your mother would approve.

 The most intelligent cars ever built.

*MSRP, not including taxes, license, freight, dealer charges or options. Prices subject to change. © 1989 Saab-Scania of America, Inc.

In retrospect, Al and I question if we should have taken a stronger stand with the agency.

We headed for Phoenix the following day. During my scout, I had found a long, white wall with a reddish-orange stripe running across the top of it and thought that it would be an ideal place for a tracking shot. Al and Tony had been intrigued by my location pictures, but they wished that the stripe was lower or that the entire wall was orange. I then suggested dressing the site with orange fencing that keeps snow from drifting. Tony didn't think that this made sense. Al then proposed stretching the fencing on the wall and shooting the car as it drove past. The fencing would then become an unrecognizable blur behind the car.

I tried to find the fencing in Arizona to no avail. Tony suggested that we get it in New York and have it shipped to us. But I didn't know a New York supplier. Unbelievably, Tony remembered passing by this type of fencing in upstate New York—and remembered the name of the company displayed on it. We found the company and talked it into selling and shipping us the fencing if we paid by a moneygram.

Two days later, the fencing arrived. Al instructed his assistants to staple the fencing to two 12-foot-long 2 x 4s. Then they climbed the wall, stretched out the fencing, and held it. Al had the model drive past the wall at 30 mph for about 50 feet forward and backward. To save time, he photographed her going in both directions; you can't

tell which way the wheels were spinning in the photograph. Al mounted his 35mm Hasselblad with a Nikkor 400mm lens as well as two Nikons with 250mm and 300mm lenses on fluid-head tripods. The three cameras panned with the car simultaneously. The cameras were locked on the car, tracking and panning across the wall to blur the fencing. The car remained in sharp focus. The orange blur against the white wall gave the shot a graphic design and a feeling of speed. This ended up being Tony's favorite picture from the campaign.

In retrospect, Al and I question if we should have taken a stronger stand with the agency. We proudly display the results in our car portfolio, but we wonder: if Al had been less restricted, would we have come up with even better shots? We'll never know. Apparently Al's instincts were right, but no one was allowing him to follow them during the shoot. Advertising photography balances shooting what you think is good against dealing with all the politics. The agency makes promises to the client about which you'll never know. That is why I don't advocate walking off sets to get your way. It makes for a spicy story but doesn't help your reputation. Unlike other specialties, advertising photography relies on how you do business or produce a shot, sometimes at the expense of your creative abilities.

Al photographed this tracking shot using his 35mm Hasselblad with a Nikkor 400mm lens.

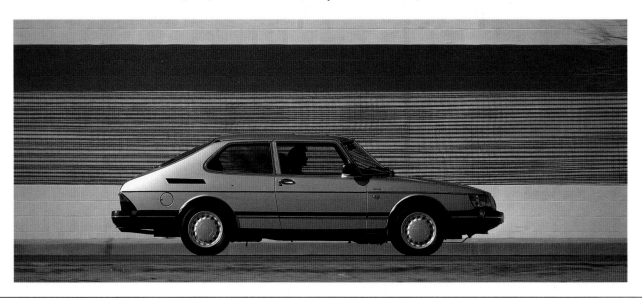

Al and I were asked to interpret this final layout of another tracking shot.

In preparation for the second tracking-shot series, Dennis looked through the camera and directed the other assistants on the best positioning of the fence.

The double-page spread version of the final advertisement showed this graphic tracking shot. The orange fencing created an effective background blur.

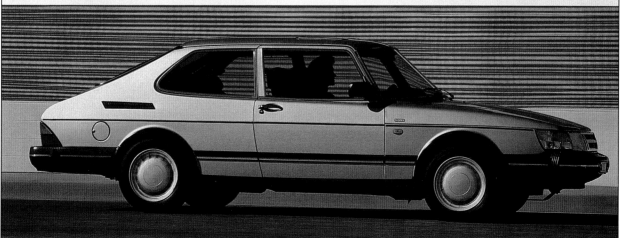

Most car accidents happen in a showroom.

Every day, within a few miles of home, someone loses control and buys the wrong car.

Such accidents could be avoided by pulling into a Saab dealership.

There you'll find there's nothing accidental about a Saab.

You can buy any Saab for its performance and still have a practical car. Three absolutely stock Saab Turbos averaged 132 mph for 62,000 miles in 21 days straight driving, without a breakdown. Yet for all its performance Saab has tremendous room, not just for passengers but for cargo, too.

You can buy a Saab for the fun of driving and still have a safe car. What Saab owners love most about their Saabs is their performance. Yet a recent insurance industry report ranks Saab among the best cars in America when it comes to claims for personal injury.

Don't buy the wrong car. Instead, visit your Saab dealer soon. A test drive is free. And there's no risk involved.

SAAB
The most intelligent cars ever built.

Saabs are intelligently priced from $16,995 to $32,095. Manufacturer's suggested retail prices not including taxes, license, freight, dealer charges or options. Prices subject to change. © 1989 Saab-Scania of America, Inc.

SHOOTING IN A FOREIGN COUNTRY

FCB Leber Katz Partners called and invited Al and me to an R. J. Reynolds bid session for its Salem cigarettes. The company, also referred to as RJR, holds its bid sessions with all of the representatives in one room. This system enables everyone to get the same information and to hear all of the questions and answers, so the estimation process is fairer. I like this type of bid session because I can tell by the competition's questions how they're going to approach the job. These sessions also sometimes help me to devise a strategy that will push the job our way. During this particular meeting, the layouts were passed out along with RJR estimate forms and a pamphlet of guidelines about payment, use, insurance, and cancellation fees.

First, Joel Sobelson, the art director, talked about the layouts and how to shoot them. Although he didn't have a specific location in mind, he wanted the three layouts to be shot in the same general area. He also said that he would place the Salem logo by Scitex in the water. He wouldn't entertain the idea of the photographer putting the logo in the picture using special effects. Shooting the layouts in pieces was acceptable, but we were to indicate that on the estimate so the art buyer could advise the client about retouching costs. Joel also explained that the models, who would be in their late twenties and thirties, and the styling should be upscale. Finally, the shots should say "refreshing."

Referring back to potential locations, Joel said that one of the images had to include a waterfall, one had to be photographed on a beach, and one had to be photographed on a small river or stream that looked like those in Colorado. He wanted some texture in the bottom of the river, such as stones. When pressed about locations, he reiterated that he didn't have preconceived notions. Joel expected us to come up with ideas, and the locations we chose would determine in part who would be hired.

THE REFRESHEST

SURGEON GENERAL'S WARNING: PREGNANT WOMEN WHO SMOKE RISK FETAL INJURY AND PREMATURE BIRTH.

THE REFRESHEST

SURGEON GENERAL'S WARNING: QUITTING SMOKING NOW GREATLY REDUCES SERIOUS HEALTH RISKS.

RJR provided Al and me with two layouts during the bid session. The first layout showed a man floating in an inner tube (top); the second layout (above) featured a woman having a bucket of water thrown on her.

Joel explained that the models, who would be in their late twenties and thirties, and the styling should be upscale.

I felt that the casting should be done in Miami because New York models wouldn't have their tans yet.

Diana, the art buyer, then told us that RJR would own the rights to the photographs and would have the use of one photograph per shoot day. If other versions were shot as well, RJR would pay an additional fee if the pictures were picked up. She asked us to build the national-magazine rate for one advertisement per shoot day into our fee and to break out the cost per shot for point-of-purchase displays, billboards, national magazines, and a complete buyout. She also mentioned that RJR considered insurance to be a part of a photographer's overhead, so she didn't want to see that expense on our estimates. But we would be able—and expected—to use RJR's own messenger service.

Next, Diana explained how cash advances would be handled. One third of the bottom line would be issued with the purchase order, one third would be issued after the film was submitted, and the last third would be billed. Receipts would be necessary only for airfare, props, wardrobe, and film. She also told us that this was a *firm/fixed fee bid*, which basically means that if you bring the job in under budget (excluding the items requiring a receipt), you get to keep the unused money. If, however, you come in over budget, you pay for it out of your pocket. I like this payment method and wish more clients would use it. You still have to give the client a fair estimate because you are in a bid situation, but you have an added incentive to save money whenever possible. Finally, Diana made all of us agree that we would have the figures to her within four days, answered the few remaining questions, and dismissed us from the 40-minute bid session.

Back at the studio, I showed Al the layouts. I told him who we were bidding against and that I didn't think we had any real competition in the group. Al was pleased by my assessment. I felt that none of them had experience shooting a large production job and that their estimates would reflect this. When I told him what the art director

had said about possible locations, Al couldn't think of any places other than California and Hawaii with beaches, waterfalls, and mountain streams. After bouncing other ideas off each other, we agreed that Jamaica had the perfect topography for this campaign. Furthermore, I thought that Joel would go wild about the idea and doubted that the other photographers would come up with this location.

After we settled on a location, Al said that this was a relatively simple shoot requiring a minimum amount of equipment and a crew of only two. I decided to style this job because swimwear was basically all that was needed. I felt that the casting should be done in Miami because New York models wouldn't have their tans yet. I thought that Joel and I should stop there to hold a final casting call before going to Jamaica because it is difficult to see body flaws in composites. The models' bodies had to be perfect because they were the basic design element in the shot.

Jamaica's Department of Tourism provided information on locations, fees, and the process of registering the shoot. It also hinted that the shoot would go more smoothly if I hired a Jamaican as a liaison and supplied some names. I then interviewed several possible liaisons over the telephone, discussing shooting sites, hotels, cars, customs, and other odds and ends. I found a suitable candidate, received a fee quote from him, and put him on notice for the next six weeks. What he told me was a good starting point for my estimate.

Next, I called Richard, my travel agent, who described a pleasant, centrally located hotel in Ocho Rios. I looked at a map of Jamaica and charted the places that the liaison had mentioned and found the hotel. It seemed to be ideally situated. If, however, we needed to go to Negril to shoot beaches, we would have to stay there one night. So I called Richard back, we picked a hotel, and he gave me their rates. He also mentioned that

renting cars in Jamaica was very expensive. Knowing that we were going to have the models as well as a number of other people with us, I asked him to track down how much a van or two would cost. He also agreed to find out what I should put in for daily meal expenses and for airfare rates between New York and Jamaica, New York and Miami, and Miami and Jamaica. Finally, I called the United States Council for International Business, which issues carnets, to check how long the application process took and find out what the fee was.

I now had the bulk of the information that I needed. I made a tentative production schedule that included time for Joel and me to take a detour to Miami to finalize casting and purchase a good selection of swimwear—which is hard to do in New York in April. Even though RJR required that I turn in the estimate on its form, I did the estimate line by line on our form first; I didn't want to leave anything out. The expenses didn't seem out of line, so I looked at my schedule and counted the days that Al would be shooting, traveling, and prepping. I assigned a fee for this time, keeping in mind that the use of one photograph should be included in each shoot day. I transferred these figures to the RJR estimate form, made a neater production calendar, and typed a cover letter.

I completed the estimate in two days and turned it in early, hoping to make a favorable impression. Fortunately, my strategy worked. Diana was impressed with my speed but even more so with my thoroughness because it indicated that I had done this before. About six days later, Al and I learned that we had gotten the job. My first task was to notify the New York City office of the Jamaican tourism department. As requested, I sent it one list of all the camera equipment and accessories that Al and I intended to bring into the country and another list that included arrival dates, crew-member names and passport numbers, and hotel names.

I then called my liaison in Jamaica to discuss locations in more detail. No permits or fees would be required for photographing the mountain stream or beaches. But because the waterfalls were quite popular, the liaison had to get permission for us to shoot there and to arrange for guards to keep tourists away from our shooting spot and equipment. He told me that he would meet us at the airport when we arrived to help us clear customs. I asked the liaison if he could recommend someone to build a bridgelike scaffold for Al to shoot from.

I applied for a carnet and received it that same day. My next call was to Act I and other talent agencies in Florida. I wanted a precast of models done by composites first; then I would select those I wanted to see at a final casting call during my stay in Miami. After I confirmed our travel arrangements with Richard, I called Joel and told him which flights we would be taking so that his secretary could coordinate his plans through his agency's travel bureau. (This is standard procedure. The art director's travel expenses are never included in our budget.) In the meantime, Al hired his assistants and went to a bookstore to do some research on Jamaica and its waterfalls.

The following day, I began shopping. For props, I found a few solid-colored inner tubes, one basic-black inner tube, and some primary-colored buckets in various sizes and shapes. I also picked up shorts and a straw hat for the male model, a few bathing suits, and some sunglasses. I then headed back to the studio to finish up preproduction, where I found Al's assistants checking equipment, packing gear, running film tests, and double-checking the serial numbers on the cameras against both the carnet and the list of equipment that I had given to the Jamaican tourism offices. You can never be too careful.

Al and I went over the casting composites and pulled out the pictures of the models we thought had potential. I sent these over to Joel for his vote.

The models' bodies had to be perfect because they were the basic design element in the shot.

Between the three of us, he and I had 50 people to see in Miami. Next, I called the hotel and made arrangements to rent the lounge for the casting call. After I asked Joel to meet me there, I notified the talent agents about our plans and indicated which models we were interested in seeing. I also cautioned them that I didn't want this to be a cattle call and wouldn't tolerate latecomers. If models can't show up on time for casting, they'll probably be late during the shoot, too. My last task while still in New York was to buy a large quantity of traveler's checks at the bank. People in most foreign countries don't use credit cards the way Americans do. And since Al and I were going to be working off the beaten tourist path, we would most likely run into many local vendors needing to be paid in cash.

I flew to Miami the following day. During the casting call, which lasted four hours, Joel and I agreed on the models for the shoot and planned to go over the wardrobe together the next night. In the morning, I called the Act I agency and booked the models, and then asked Richard to arrange for their airfare. He promised to send me a duplicate copy of the airline tickets for billing purposes. I went shopping afterward and picked up great hats for the two male models. I also ran across a distributor of classic swimwear and liked the designs so much that I practically bought out the entire stock. Later, Joel and I met in my room to go over the wardrobe. I thought neon colors were perfect for our shoot, and I knew Al would, too. The art director liked the hot orange and pink outfits, but I couldn't talk him into the chartreuse ones.

The next day, the two of us flew to Jamaica, where we met Al, his assistants, and the liaison. We were lucky that our escort greeted us at the airport. Even though we had cleared our walkie-talkies in advance, they were seized. When our liaison talked to the customs officials, they agreed to let us have them back the following day

after doing radio tests to make sure that the walkie-talkies weren't on the same frequency as the Jamaican military or police radios. We then checked into our rooms at the hotel and divided up the equipment. Before leaving us that night, our liaison said that he had made arrangements for us to visit the waterfalls and scout locations in the morning.

At the falls the following day, I went into the offices to register, arrange for guards, and pay the location fee. When I caught up with everyone, Al and Joel had taken off their shoes, rolled up their pants, and were walking around in the middle of the falls looking for a good vantage point to shoot from. The scene was magnificent: a series of cascading waterfalls down the side of a large hill to a beach. But because the area was heavily wooded, Al would have only three hours of good light each day to shoot in.

Fortunately, the spot Al decided to shoot from could be blocked off from tourists. One guard would stay on the decking that ran up the hill parallel to the falls. Our equipment would be stored on one of the platforms that could be roped off, and the deck guard would be in charge of watching it. The other guard would be positioned farther up on the decking where the tourists would be detoured. He would use a whistle to control the crowds. The park's waterfall guides would also be notified of the shoot. We were assured that they would cooperate. We then left the falls to look at a small stream that we had seen on the way. From the bridge, this stream seemed promising for the inner-tube shot.

Once again, we were lucky. There was a moderate current in the stream, and the deepest water was knee-high. We came across a spot in the stream just beyond some very large rocks that broke the current. Here, the bottom of the stream contained stones in varying shades of green, gray, and brown—just like Joel wanted. I marked the spot and looked around to see if I could find the people who owned the land.

If models can't show up on time for casting, they'll probably be late during the shoot, too.

When I located them, they said that they didn't mind our shooting pictures on their stream. I also told them that we intended to build a scaffold over the stream so that Al could shoot down on the water. They wondered if they could have the wood from the scaffold after we were finished; I agreed to their request. Then I asked if I could hire two of them to sleep by the scaffold and guard it after it was built. I promised to pay them 50 American dollars. My last stop was the hardware store, where I arranged for the building of our scaffold. The owners wanted me to sketch what I had in mind and to meet with the carpenters.

While I was out scouting with Al and Joel, the models had arrived from Miami. One of our assistants had picked them up and had also retrieved our walkie-talkies. Joel, Al, and I then went to my room for a wardrobe session, and I asked the models to join us. I laid out all of the bathing suits and accessories on the beds. Joel selected the suits in the colors he liked most, and the models tried those on first. I made a list of the suits we agreed to use, and then we discussed accessories and hair. Next, the male models tried on the shorts and hats for the inner-tube shot.

After breakfast the next day, we packed the vans and headed to the waterfalls with the models. Once there, Al and his assistants waded out to set up the tripods. One of the models was asked to pose so that Al could set up all three camera positions. Because of the slight current and the movement of the people in the water, Al secured each tripod with a sandbag weighing 30 pounds. The reflectors were also set up and weighted.

Al photographed the black male model first, then the black female model, and then the two of them together. It was hard for them to appear as if they were enjoying themselves in the water because it was quite cold and was pounding on their backs with a great deal of force. The noise from the falls made it hard for the models

As the sun moved in and out of the trees on the golf course, new shadows were cast. An assistant frequently had to shift the reflectors in order to catch the light and kick it back on the model.

This image of one of the male models in the waterfalls was used as a single-page print advertisement.

SURGEON GENERAL'S WARNING: Smoking Causes Lung Cancer, Heart Disease, Emphysema, And May Complicate Pregnancy.

17 mg. "tar", 1.3 mg. nicotine av. per cigarette by FTC method.

THE REFRESHEST

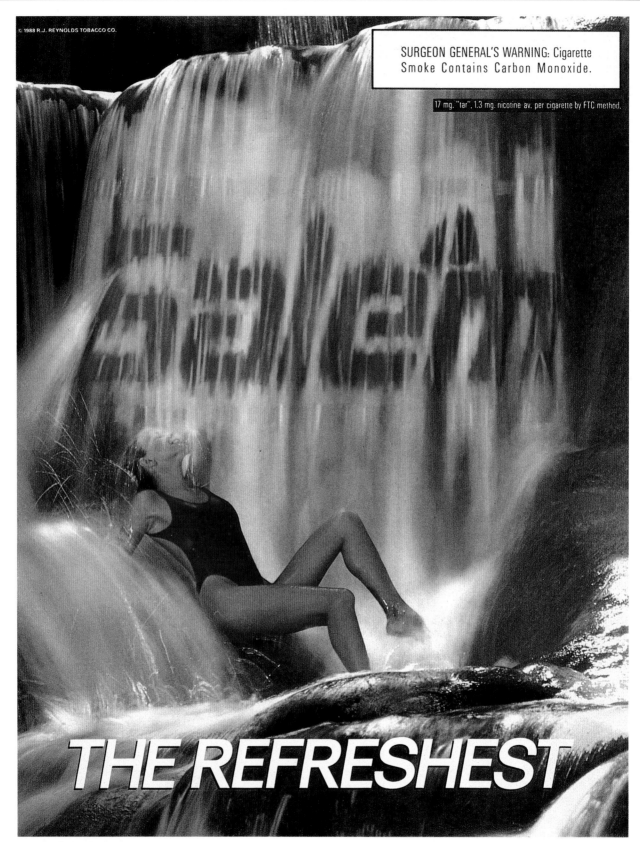

THE REFRESHEST

RJR used another version of
the waterfalls shot in which a
female model is seen relaxing
for this single-page print
advertisement.

to hear Al's directions. To solve this problem, he positioned me at the top of the falls with a walkie-talkie. He told me what he wanted the models to do, and I would relay his instructions to them. When the sun went behind the trees, it was time to dry and pack the gear. We repeated this procedure the next day with the white male and female models.

The day had begun early for me and Al's assistants, Dennis and John. We drove out to the spot where the scaffold was going to be built and waited for the carpenters. When they arrived, I showed them exactly where we wanted the scaffold and discussed my drawing again. First, they put up a structure that would act as a brace across the water. I was worried that they didn't understand that the brace couldn't stay there and that they wouldn't finish the scaffold in one day because they worked so slowly and took quite a few breaks. Finally, I pulled the head carpenter aside and told him that they couldn't take any more breaks. When he replied that it was impossible to complete the scaffold in one day, I told him that if I had to, I would build it myself.

So I yelled to Dennis and John to follow my lead, grab the tools, and start building. I knew that the carpenters weren't about to be shamed into letting us do their work. Not even three minutes later, the men came over, took the tools out of our hands, and went back to work. And three hours later, the 18-foot-high scaffold was done. When we returned the next day, the scaffold was safe and sound. I was so relieved that I rewarded our guards with a small bonus.

Next, Al and an assistant climbed the scaffold and set up the cameras. One of the assistants put a concrete block in the water and tied it to the inner tube so it would serve as an anchor. While this was going on, the guards came back with friends and wanted to know if I had anything else for them to protect. Thinking quickly, I asked them to position themselves

Al and art director Joel Sobelson tried to give the models instructions from the top of the scaffolding.

Al shot this photograph of one of the female models in the inner tube. The starkly contrasting colors worked well. The texture of the rocks at the bottom of the stream also added interest to the image—and pleased Joel.

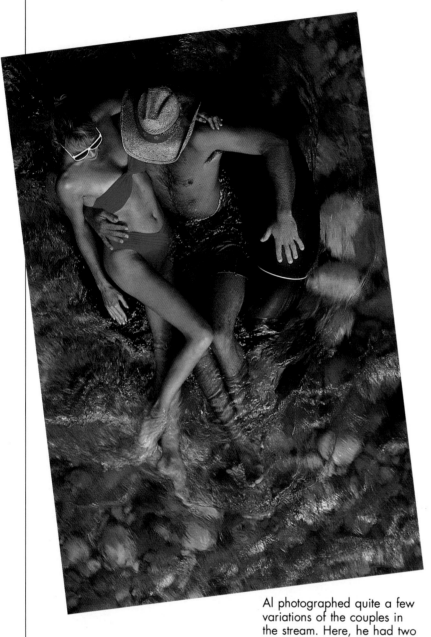

Al photographed quite a few variations of the couples in the stream. Here, he had two models pose together in the inner tube. Al knew that the more versions he shot, the better his chances of making additional usage fees.

One of the assistants put a concrete block in the water and tied it to an inner tube so it would serve as an anchor.

around the shooting site and prevent people from bothering us while we were working. I promised to pay each of them 5 dollars and provide lunch.

At this point, Al was up on the scaffold ready to shoot. He had strategically placed a space blanket and a strobe umbrella over him to keep the very hot sun off his back. The male model got into position, covering the rope connected to the inner tube, and Al photographed him. Next, Joel wanted Al to photograph the female model, and then both models in the inner tube. Al shot until the sun set, getting every version in every format.

The next day was a combination travel/scout/production day. We kept our rooms in Ocho Rios and packed overnight bags for our brief stint in Negril. After checking into our hotel there, we walked along the beach to select the area we would shoot. One spot seemed ideal; the traffic was light, and some trees provided protection from the sun. Early the next morning, we carried the equipment to the beach. Then Al and Joel went over the six scheduled shots: the male model with a bucket, the female model lying on her side and stomach on the beach alone, the male model splashing her in both positions, and the male model alone making a splash.

Before we left New York, Al had done Polaroid test shots of water being tossed from a bucket. He believed that the first scheduled image should be shot as a composite but Joel was skeptical, even after viewing the Polaroids. As a result, Al had decided to do the wet shots last so that the female model's hair wouldn't look wild in the other pictures. The shoot progressed smoothly without any hitches. In fact, there was a bonus. A sailboat appeared on the horizon. We couldn't have planned it better. After the shoot, Al cleaned his cameras to get rid of any sand that might have blown into them and then carefully packed them. He didn't want to have to spend hundreds of dollars overhauling the cameras when we returned to New York.

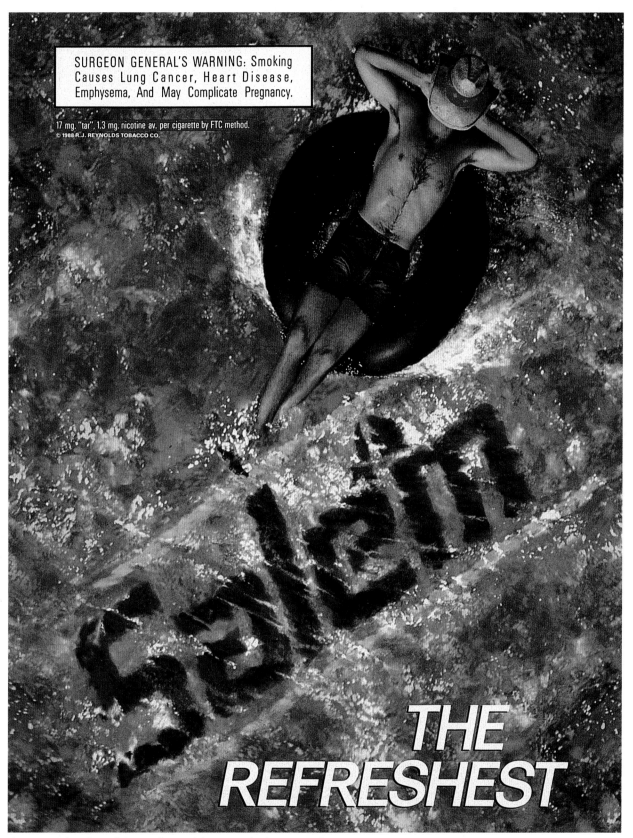

SURGEON GENERAL'S WARNING: Smoking Causes Lung Cancer, Heart Disease, Emphysema, And May Complicate Pregnancy.

17 mg. "tar", 1.3 mg. nicotine av. per cigarette by FTC method.
© 1988 R.J. REYNOLDS TOBACCO CO.

THE
REFRESHEST

The inner-tube shot of this male model was picked up as only a single-page print advertisement. Surprisingly, the agency decided to take the textured rocks out of the water. It felt that the Salem logo didn't pop out of the original color.

The following day was a postproduction day back at the hotel in Ocho Rios. I had to settle up with a number of people. I also had to pack the wardrobe and props, and Al and his assistants had to finish packing the gear. My last task was to arrange a little surprise wrap party for everyone.

Back in New York, we had another week's worth of work to do. Despite Al's efforts, some of his equipment required maintenance and had to be put into the shop. The film was developed and needed editing. While Al was doing the first cut, I looked over his shoulder. The shots were beautiful. We knew that Joel would be pleased. And he was. He told us that when he presented the film to Salem, he had used tropical decorations in the conference room and played reggae music, and that the members of the creative team had worn knitted Jamaican caps. The client loved both the presentation and our photographs, and Joel was promoted to creative director.

Al had to cover the "bucket" shot several ways: the female model on her stomach and on her side, the male model tossing the water (below), and the bucket poised but empty (above). Luckily, a tiny sailboat crossed the frame, producing yet another variation.

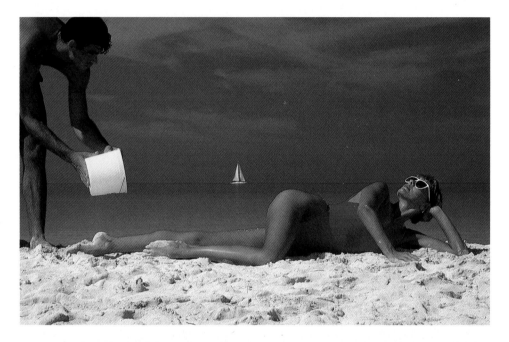

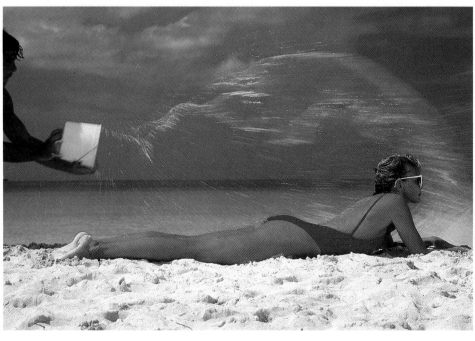

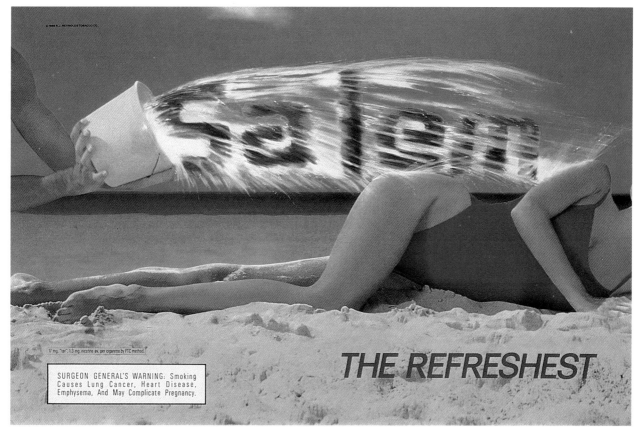

THE REFRESHEST

The "bucket" shot was so well liked that the agency used it for a double-truck print advertisement (above), a billboard (below), and a subway poster.

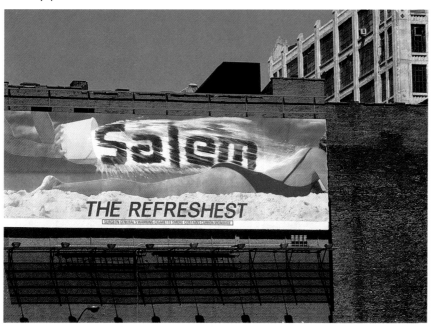

When Al started his photography career as a photojournalist more than 20 years ago, it was just Al, four cameras, film, a couple of camera bags (that he usually left in the trunk of his car) and a small amount of camera paraphernalia. He had no assistants, no cases of equipment, and no production budgets. Now he handles assignments that can bill more than 100,000 dollars in expenses alone. He has crews of anywhere from four to eight assistants and often requires the help of a producer (me), a stylist, a car prepper, a model maker, a pilot, a set builder, and a special-effects person, among others. He can require as many as 20 cases of equipment and around 400 rolls of film for a campaign that produces as few as six images.

When I took over the business side of Al's corporation six years ago, he told me that his biggest frustration was getting pigeonholed. Everyone tried to decide for him what his specialty was as they looked at his portfolio—and then announced that they had no need of his kind of work. So I rearranged Al's portfolio, added a few new pieces, and took the revamped book to agencies.

I pointed out the skills that Al had used to shoot his photographs and drew a parallel between those skills and the ones needed to accomplish a client's job. We didn't always get the job, but we almost always got the chance to bid. It was just a matter of time. First one challenging job would come in, then another, and before we knew it we had a multifaceted portfolio. In fact, we have so much varied work that I divided our photographs into portfolios according to subject: general, military, problem-solving and miniatures, cars, travel, people, and productions and campaigns. Each book has 20 or more examples of Al's work in that area.

One day not too long ago, an exceptionally challenging and problematic job appeared and drew upon every

OVERCOMING TECHNICAL DIFFICULTIES

skill that we had ever learned. We received a call to send our portfolio as soon as possible to Bob Dion, a former creative director from Chiat/Day/ Mojo Advertising who had started his own design firm in California. He was working on an assignment for Universal Studios Florida® in Orlando. I wasn't told much about the job at that point, so I sent out our general portfolio and a copy of *Satterwhite on Color and Design*. Bob was looking for photographers with special and diverse skills. The two-part job would entail major production and organization, shooting interiors and exteriors, helicopter work, unusual lighting, and special effects. After reviewing our portfolio and skimming our book, Bob felt we were good candidates and called to discuss the job.

Because Bob hadn't gone to Universal Studios Florida yet, he started the conversation by apologizing for asking me for an estimate without being able to supply specifics about the job, but he gave me all the information he had. Bob said that Universal Studios Florida was a large back lot with many different studios and sets, designed for tours by the public. The streets were created to represent specific areas of the United States. For example, you could be walking for two blocks in an area that looks like New York and then be on Hollywood Boulevard. There were also stage performances of movie themes with loads of special effects. Bob wanted Al to capture the spectacular special effects of each exhibit in one still photograph, representing each one for a new brochure on the finished working studios.

Bob promised to send me the existing Universal Studios Florida brochure for reference. I called him when I received it the following day. He said that his task was to transform the artist's renditions in the original brochure into photography so that Universal Studios Florida became a reality instead of illustrations. He told me to include all travel expenses to Orlando in my estimate. He also needed num-

THE ART OF MAKING MOVIES

ALFRED HITCHCOCK

The master of mystery. The Academy Award winning director whose name sends a chill down your spine! Alfred Hitchcock. When it comes to suspense, no one comes close...until now. Because now you'll come so close you'll feel the sting of the shower in *Psycho*. Flee the furious attack of *The Birds!* And find yourself actually playing a part in the greatest films of the master of suspense. Films like *Saboteur, Strangers on a Train, Vertigo* or *Rear Window*. How do we do it? That's one mystery you'll have to solve for yourself.

Bob Dion explained that this aerial view (top) in Universal Studios Florida's brochure was just one of the illustrations that Al and I would be asked to transform into a photograph. This artist's rendition (above) of the Hitchcock sets also needed to be realized in photographic form.

Get ready to join in the ultimate special effects thriller in this world or the next. An over, under, around and see-through blitz by Slimer, Gozer, the Terror Dogs and more. But when the *Ghostbusters* fight back, look out! The Neutrona beams cross, the ectoplasmic energy explodes, the Stay Puft Marshmallow Man blows his top and everybody gets creamed. It's a supernatural Spooktacular that will haunt you for years to come!

GHOSTBUSTERS

Here, you can see the artist's rendition (above) of the *Ghostbusters*™ stage included in the Universal brochure as well as Bob Dion's interpretation of our ideas (below).

bers for an overall aerial of the entire facility. Bob then described each ride or event that we would be shooting. One of the shows is Alfred Hitchcock: The Art of Making Movies. Bob wanted us to photograph a model of the house in *Psycho* as well as a representation of *The Birds*. In the latter exhibit, the bird effect was projected by film, so we would have to create our own attacking birds to shoot later. The same was true of the telephone pole with hundreds of birds flying around it. Finally, we were expected to get an audience-reaction shot. All four photographs would be composed on one page similar to the way they are in the brochure (on the left).

For the *Ghostbusters*™ set, complete with actors and special effects, we had to shoot the ghosts and lasers. At that point, I asked Bob how the special effects were done. He said that he didn't know exactly, but he assured me that once he received approval on this first step, we would take a trip to Florida to scout. This would also enable us to provide more accurate numbers. I looked at the illustration of the *Ghostbusters*™ set in the brochure and had no idea how to approach estimating the cost of shooting it.

The Funtastic World of Hanna-Barbera™ ride looked like the inside of a spaceship with a big screen where a window would usually be. The seats were on hydraulics and moved in sync with the action projected on the screen, thereby giving the audience a feeling of lifting off and moving through outer space. Bob and I then discussed the "Animal Actors" stage where Lassie, Benji, Mr. Ed, and other animals perform. We would probably have to do this shoot in pieces because quite a few of the animals couldn't be onstage at the same time. Next, Bob said that we would shoot three postproduction stages: an edit stage, where the editor puts the film together on tape; a Foley stage, where sound effects are made and recorded on the soundtrack; and a scoring stage. "Murder, She Wrote® Mystery Theatre"

would be featured to illustrate how the rooms worked via audience participation. Al and I would also photograph some of the street sets. These were the New York, Amity Island, and Hollywood locales. Bob also included the entrance to Universal Studios Florida.

Finally, Bob described the action that takes place on the central lagoon during the Dynamite Nights Stunt Spectacular. Several good guys chase bad guys in boats. One boat explodes when it goes through a boat house, a trawler with drugs on board blows up and splits in half, and the back end of a seaplane is blown away. Bob then told me that we wouldn't be allowed to shoot the rides or events during show times. Universal wouldn't shut down any exhibit because it didn't want to inconvenience its guests, so we would have to shoot at night. I agreed to have a rough estimate and production schedule to Bob within two days.

This would be an expensive job. I met with Al to go over all of the information. Al had to supply me with the costs for equipment rental, film, and assistants. I briefed Al on my plan in case he had any objections. Sometimes Al suggests simpler technical tricks to make our bid more competitive. We would need a minimum of four assistants. Some of the movie sets would take several days to shoot because they would be available for only a limited time. Orlando didn't have a strobe supplier with enough equipment, so we would have to ship most of the lights from New York. According to my rough schedule, this shoot would take two full weeks.

I sent all of this information via a fax machine to Bob. He called me immediately and asked a number of questions to understand more clearly how we intended to accomplish the job. Bob, a seasoned art director, wanted to make sure that Al and I could deliver. He was satisfied with my answers and felt that he could present our figures to the Universal executives. About a month later, I received another call

To enable Universal executives to better understand the way Al and I decided to approach the Hanna-Barbera stage as shown in the brochure (above), Bob Dion made a sketch based on our plan (below).

ANIMAL ACTORS STAGE

They pawed and clawed their way to the top. Now see how they got there. Thrill to the animal magnetism of Lassie, Mr. Ed, and Jerry Lee the canine star of *K-9*. You'll howl as they, and other famous animal actors, demonstrate their exceptional acting skills. Over 50 stars with a list of movie and TV credits that would make any talent agent drool. We've even got the biggest alligator you've ever seen. But please, no matter what he does, don't give him a hand.

MURDER SHE WROTE

At a real working movie and television studio, everyone works—even you! Your job is Executive Producer, working with Angela Lansbury, on an episode of the Emmy Award winning, hit series, *Murder She Wrote*. You'll get a chance to pick the guest star, the cops, the crooks and the caper. Then pick the "takes" in editorial, select the music on the scoring stage, lay in sound effects on our Foley stage and put it all together. And all you've gotta do is get it right, get it on time and get it in on budget. Then, when you get back home, if they ask "Whodunnit?" You done it!

Al and I were allowed to reinterpret the artist's represent the "Murder, She Wrote® Mystery Theatre" (above, left) and "Animal Actors" (above, right) sets. Bob Dion's sketch (below) shows the shooting plan that Jay Stein requested.

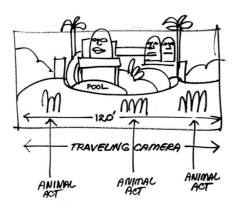

from Bob. He needed to know how much it would cost for Al and me to visit Universal for a scout. He wanted us to see the rides we would be shooting and to meet the people we would be working for. The final figure I gave him was quickly approved, and Al and I were given a departure date.

At Universal, Al and I were issued temporary passes to the facilities. They were still under construction, so we had to wear hard-sole shoes and hard hats in order to visit the rides. The tour was fascinating. The street sets weren't yet completed, but there was a stunning realism to them already. The *Ghostbusters*™ show was our first stop. The stage was up, but we couldn't see the lighting, special effects, ghosts, or lasers. Al knew immediately that he would have trouble with this shot because huge panels of glass supported by mullions separated the stage from the audience. If Al shot the stage while standing between it and the glass panels, he would have to use an ultra-wide-angle lens; however, this lens would distort the stage dramatically. And if he shot the stage looking through the glass, Bob would have to do retouching on the mullions later.

Al, Bob, and I then moved on to the Hanna-Barbera set. We initially thought that this ride would be difficult to photograph. But when we saw the stage, we were relieved to see that the shoot would be relatively simple. Although the shooting space was cramped, using a wide-angle lens here would work in the theater's favor. Al took out a wide-angle lens and showed Bob what he had in mind. The art director agreed that it was perfect. Next, the crew demonstrated the lights that were up and working. Al spoke to the man in charge of the show to learn what the possibilities were and that all of the shows were programmed by computer.

Then while we walked around Amity Island and San Francisco, someone radioed our guide to bring the photographer back to the main office. Jay Stein, the president of MCA Recre-

ation Services Group, wanted to meet us at a small luncheon in the conference room. Shortly after Jay arrived, he asked Al what he thought of Universal. Al told him that he hadn't seen everything yet but that the Hanna-Barbera shoot promised to be easy. Al also discussed the problems he would have to overcome with the *Ghostbusters*™ set. Jay asked Al a couple of questions and then turned to Bob, wanting to know how he intended to put the brochure together. Bob passed around copies of line drawings that none of us had seen yet and described how he envisioned the rides being shot. He said that almost everything would have to be shot in pieces and stripped together. Once Jay was satisfied, we continued our tour.

We headed over to the "Murder, She Wrote® Mystery Theatre" featuring postproduction studios. There were three stages: one for editing, one for sound effects, and one for music scoring. Except for their large sizes, the rooms looked authentic. Al liked the impressive editing room most because there were a number of television monitors hanging from the ceiling around the stage. Each room was approximately the same size. Al selected his shooting position for the editing room and then went into the other two rooms to see if the same shooting position/perspective would be interesting in those rooms as well. The art director intended to run the photographs of the three rooms side by side, and Al wanted a sense of continuity.

On the Hitchcock stage, a small-scale version of the *Psycho* House stood around 15 feet tall. The way the stabbing scene was shot was demonstrated on a movable shower set. This show would be relatively easy to shoot. There was plenty of space for Al to maneuver in, and the computer program controlling the lighting could be overridden. Next, we visited the "Animal Actors" stage. There wasn't much to see except a large, beautiful tropical setting. The lighting wasn't finished, and there weren't any animals around.

But we realized that we would need quite a few animals to fill this set.

At this point, we had seen everything that we had to shoot and were asked to supply a tighter budget. I explained that the way to shoot most of the sets was clearer in our minds. The only exception was the *Ghostbusters*™ stage, which posed even more problems than we had originally anticipated. However, I could now provide more accurate numbers and agreed to send Bob a revised estimate and proposal in two days. The following day, Al and I returned to New York. I immediately started working on the figures and the proposal, which were quite involved and lengthy. But I had them ready the very next day as promised. The numbers looked good to Bob, who told me when his next meeting at Universal was and said he would get back to me then.

Two months later, Al and I flew to Orlando on a very hot, muggy morning. Luckily, more than half of the shoot would take place at night or in air conditioning. Four assistants, 20 cases, Al, and I all fit into two vans and one car. After we checked into the hotel, I called Bob's room and Universal's advertising department. We were told to come over as soon as we were settled. When we arrived, we were introduced to Mike Petty, the V.P. of Advertising. We talked to him a little while and then were issued passes for ourselves and our vehicles to enter the facility, whose entrances are all heavily guarded.

After the meeting, we went out onto the grounds to scout once again what we would be shooting. At the movie rides, we met with the technicians and discussed mechanical and lighting possibilities. During the tour, Al had made some suggestions that would enhance the pictures. He would be recording on film what had already been created by others, and he needed to capture what they had intended. We had to do some creative problem-solving; the designers hadn't planned their rides and shows around us.

The facilities were still under construction, so we had to wear hard-sole shoes and hard hats to visit the rides.

The 30mm wide-angle lens was perfect for the Hanna-Barbera set. Later, the art director would strip in a frame from the movie shown during the ride and eliminate the lights and grids on the ceiling.

The huge, metallic set had great shapes and colors, as well as lighting that wrapped around the audience.

We wanted to photograph the Hanna-Barbera set first because it was the most direct and simple. We entered the stage around 9:00 PM after the last demonstration was over. Al went to the back of the theater and set up his Hasselblad with a 30mm lens and decided to use Fujichrome 64T and Velvia film. He also wanted to cover the shot with his Nikon, a 16mm lens, and Fujichrome 64T and Kodachrome 200 film. The huge, metallic set had great shapes and colors, as well as lighting that wrapped around the audience. The seats in the theater looked similar to roller-coaster seats. They moved up and down, and to the left and right in sync with the action of the cartoon being projected. Al planned to shoot the Hanna-Barbera screen when the "Entrance" slide was showing and have Bob strip in a frame from the cartoon movie later.

Universal had booked extras to play the audience during the shoot. After Al set up his cameras, he asked me to have the extras brought in and positioned for the camera. I explained to them that because we would be shooting time exposures approximately 15 seconds long, we would yell "Now!"

and they had to hold very still until we yelled "Okay!" If they moved, they would be blurred—and we didn't want that effect at this time. I also told them to take shallow breaths so that they would be as motionless as possible. The show's ride operator manually operated the seat controls while Al was shooting to enable him to shoot a roll or two of film with the seats and audience blurred. We called this a wrap around 4:00 AM.

After an early dinner the next evening, we returned to Universal at 8:30 PM to shoot "Murder, She Wrote®." In preparation for the shoot, Al went to the editing room and set up his tripod. Al's next task was to direct Dennis, one of his assistants, to get his Hasselblad with the 60mm lens and his Nikon with the 20mm lens. Al then took an extra camera body, went into the sound-effects room, paced off his distance, and looked through the camera. He discovered that the same camera position would work well here. He repeated the procedure in the third room. By the time Al returned, Dennis had set up and loaded the cameras.

Al then asked the show's technician if it were possible to make the color of the

television monitors warmer and learned that it wasn't. I mentioned that in an actual television editing room, each monitor has a dial on the control board for color correction. The technician acknowledged this but said that for simplicity's sake during the show, the control board had been modified and all the monitors were on one switch that didn't allow him to color-balance the monitors individually. The only way to change the color would be for him to get a ladder, climb up to each monitor, and dial its color-balance knob. Al was concerned that if he filtered the light for the room, the monitors' colors would be cold. So he planned to shoot this room twice, balancing color for the room first and then for the monitors. Bob could then strip the color-balanced monitors into the color-balanced main shot.

After the 40 extras Universal had hired to play the audience were brought in and positioned for the camera, the performers for each show ran through their routines. When Al saw something that he liked, he asked them to repeat that part of the act for a while. Al shot each room in the same manner in the existing light and then used supplemental lighting to enhance the shadowy parts of the room. All three rooms were photographed that night, and we were out of there by 4:00 AM.

Retoucher Jim Crocker took a frame from the Hanna-Barbera cartoon and stripped it into the screen in Al's shot of the stage that included blurred seats. Universal preferred Al's variation of the original photograph, in which the audience was clear.

When Al shot the editing room (left), he corrected for the color; however, the monitors went cold in the resulting photographs. To eliminate the "cold-monitor" problem in his images, Al corrected for the color monitors so that they were warm (below).

The Foley room (opposite page, top) is where movie sound effects are made. The staff asks for volunteers from the audience. Then they're directed as to how to make these effects. This is the final retouched shot of the Foley room. A frame from "Murder, She Wrote®" was inserted into the screen.

A frame from existing footage of "Murder, She Wrote® was stripped into the blank screen (opposite page, below) in Al's original shot of the scoring room.

For the final photograph of the "Murder, She Wrote® Mystery Theatre" editing room, Jim Crocker took the visuals in Al's second version of the shot and stripped them into the first version.

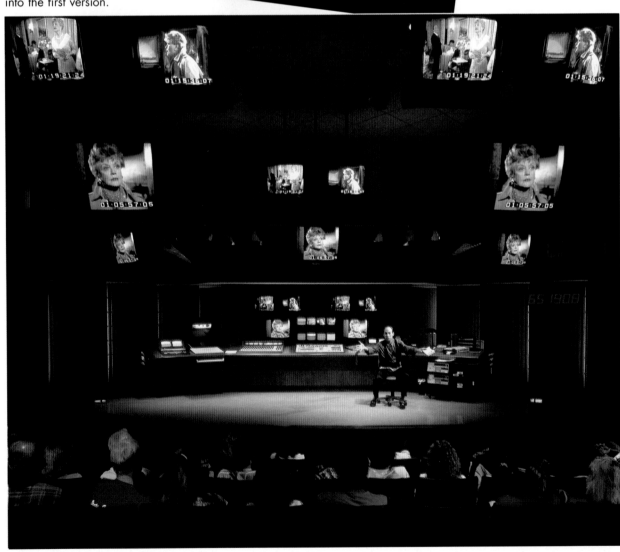

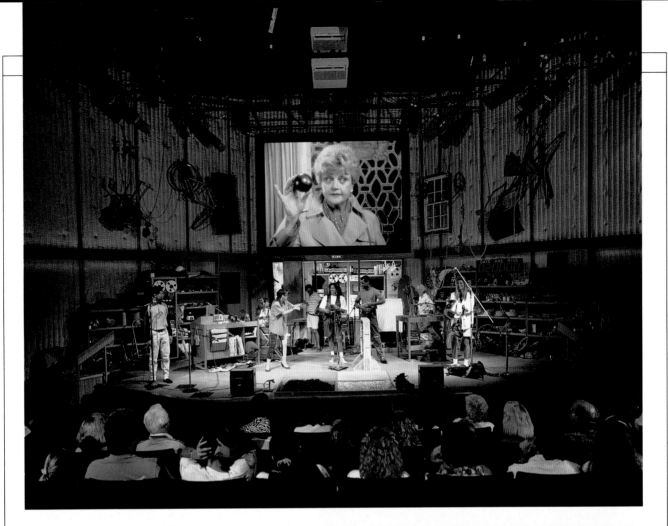

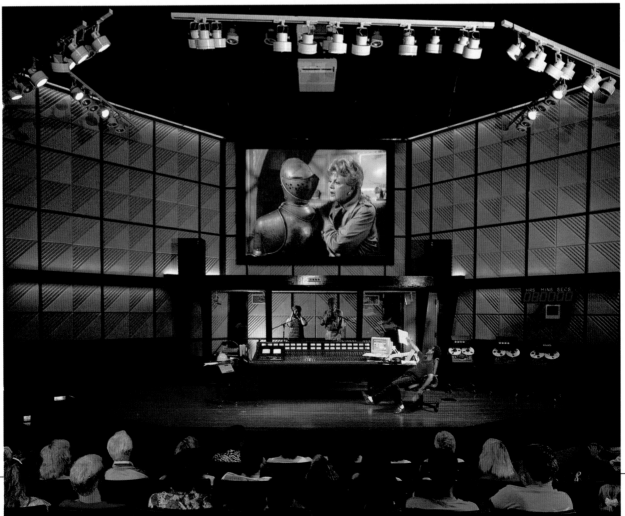

Al and Bob didn't like this shot of the "Animal Actors" set because they had to stand so far back to include the entire stage in the shot. This made the animals appear too small.

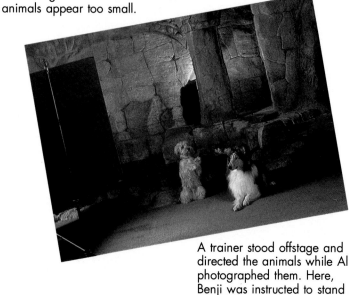

A trainer stood offstage and directed the animals while Al photographed them. Here, Benji was instructed to stand up and beg.

Al photographed Mr. Ed while the trainer made him "talk."

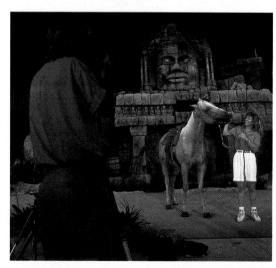

About a week into the shoot, we were on the night shift to photograph the "Animal Actors" stage. A generator had been ordered and delivered to the set. We arrived at 9:00 PM to set up. This attraction is similar to an amphitheater. In a small pond in the center of the set is a wicked-looking alligator that rises out of the water and snaps its jaws. Although the beautiful set is decorated to look like Angor Wat, Cambodia, it isn't interesting enough to stand on its own.

Because the animals we were going to photograph were small and a number of them didn't get along with each other, we had to shoot some separate shots of animals that would be stripped in to the overall shot later. Universal's upper management wanted us to shoot the entire stage, but neither Al nor Bob thought the shot would work. The animals wouldn't fill up the stage when Al was far back enough in order to include the whole set. Furthermore, many of the animals were tired, and their trainers didn't want to overtax them before that morning's performance. But Al had to shoot the set the way management wanted. So Al and his assistants set up the lights and photographed the main shot using monkeys, chimps, apes, birds, dogs, and an animal trainer. Then he did separate shots of Mr. Ed talking, of penguins, and of some other animals. We finally wrapped this shoot at 3:00 AM, collected our gear, and headed back to the hotel.

Because of these problems, we reshot the "Animal Actors" set about a month later. The wide shot of the stage done previously wasn't interesting enough, and everyone agreed that we could shoot a medium-tight shot. Once again, we had problems with the animals; getting along seemed even more difficult for them in closer proximity. At the previous shoot, the trainers tried unsuccessfully to make the animals behave. Finally, Universal decided that we should photograph each animal with its trainer separately and then shoot the background separately.

The images would be put together like a puzzle in a final shot later.

Al didn't like the lighting on the pond section in the center of the set. To enhance it, he set up blue lighting on the stone wall underneath the waterfall. Then he illuminated the rest of the set with strobes and balanced the light. This preparation took quite a bit of time. We had to shoot the set first without animals, then with the alligator, and then with each animal in the spot where Bob thought he would eventually place it. Shooting these various setups took until 5:00 AM. We had just completed a 23-hour workday. I told Universal that I wanted to be compensated for two workdays since it had changed the original specifications. The company realized that this was a fair request and agreed to it. Everyone involved was very excited when they saw the Polachrome of this set with Al's lighting.

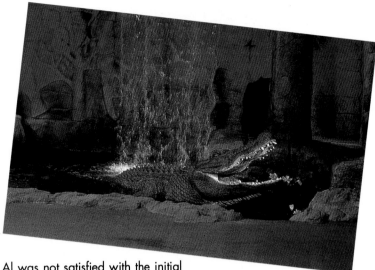

Al was not satisfied with the initial lighting of the "Animal Actors" stage. So when he came back to shoot the tighter version, he decided to set up lights with blue gels. He was able to stop the alligator in any position.

To achieve this final composite shot of the "Animal Actors" stage, the trainers and animals were photographed separately and stripped together later.

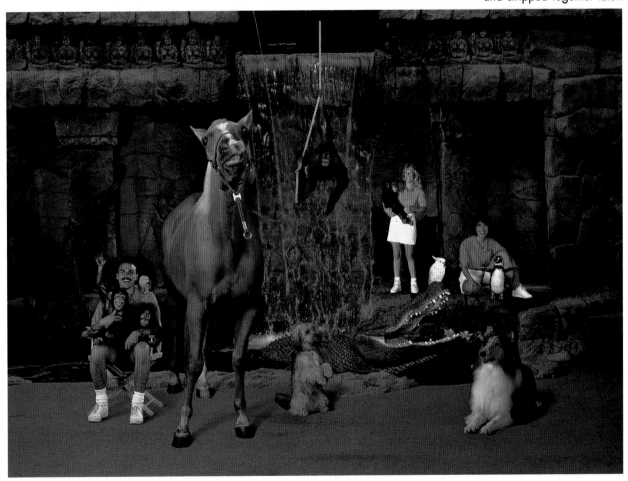

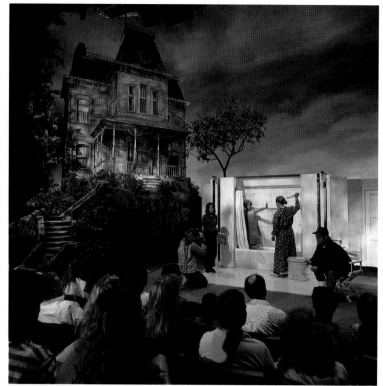

This outtake of the audience watching the *Psycho* shower scene was made with a Hasselblad.

Bob, who was sitting in the audience, started to ham it up and injected some life into the crowd.

Fulfilling a specific request made by a Universal executive, Al shot this reversed view of the *Psycho* shower scene from backstage. The audience was illuminated with strobes, so that Al was able to record their reactions.

On the fourth night of the first shoot, everyone met in the hotel lobby at 10:00 PM to load the equipment into the vans and to drive over to Universal. We entered the Hitchcock set at 10:45 PM. Because the audience consisted of 20 extras, we had to do the secondary shots first so that they could go home. The show's regular actors were also there. The first setup was an over-the-audience's-shoulder shot of a reenactment of the shower scene from *Psycho*. Al used the existing lights, making only a few adjustments in the output of some lamps. The actors were able to hold still very well. It didn't take Al long at all to complete this shot.

Next, he reversed the shot, capturing the audience member's reactions. This was a special request from Jay; he wanted the photographs to show audience participation, and the *Psycho* stage was one of the few sets that allowed us to accommodate him. The audience, of course, had to be illuminated with strobes. But because we were shooting in the wee hours of the morning, the extras were pretty unresponsive. So Bob, who was sitting in the audience, started to ham it up and injected some life into the crowd. In fact, he even revived Al and me. Finally, the audience shots were done, and the extras and actors were released at 2:00 AM.

Al then set up to do a very wide shot of the entire stage. Because it was beautifully illuminated, Al had to make only some slight adjustments for the camera and to change the gels on some of the lights. He balanced the light between the three setups across the stage. In order to create a silhouette of an old woman out of a black board, we cast a shadow of a woman onto the board, traced it, and cut it out. Then Bob scaled it down for us. We put the silhouette in the window behind the curtains so that it would look like the character Mother was home. Al photographed the set with a Hasselblad with a 35mm back using 30mm and 40mm lenses. The final shot of the

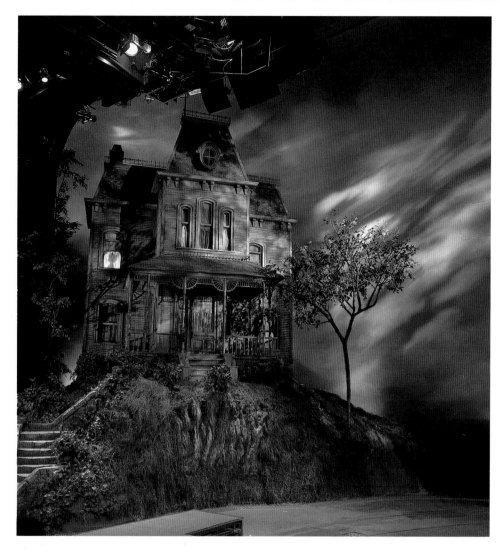

Al shot the *Psycho* House with a 2¼ Hasselblad. Notice the silhouette in the window. This was made by cutting cardboard and taping it behind the curtain. We had to rig our own light to make the shadow.

Al shot the entire width of the *Psycho* stage encompassing three sets with a 30mm lens and a 35mm back on his Hasselblad.

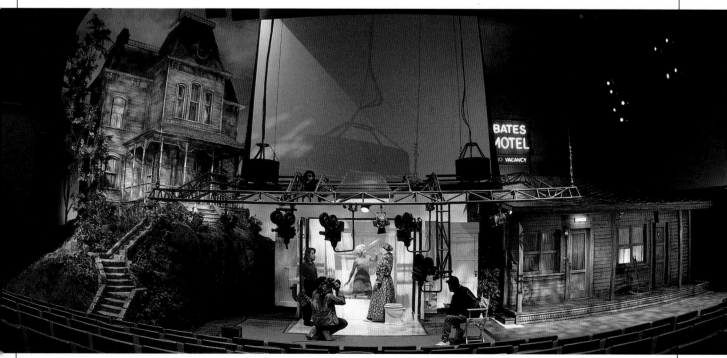

The art director would be able to strip as many as 12 different birds into the main shot of *The Birds* set because Al photographed each of the three bird models from at least four angles.

Universal expected me to find three sea gulls posed and stuffed in an attack position.

morning was of the house itself. Al had the assistants put blue gels on all of the lights on the house to add drama. He made time exposures of the house and bracketed, using the 2¼ and 35mm formats with different lenses. Al was done shooting at 5:30 AM, and then we spent an hour packing our gear and cleaning the area.

On the last day of the first shoot, we had to return the equipment, pack, and travel back to New York. Universal had asked if we could come back to shoot the aerials and the street scenes but hadn't mentioned specific days. While waiting for that information, Al would drop off the film in the lab, edit it, and shoot painted backgrounds of skies for both the final *Ghostbusters*™ and *The Birds* photographs. We wouldn't be able to commission the telephone pole until the Hitchcock layout for the brochure had been decided because we had to match perspective exactly.

In New York, we unpacked the equipment, and Al brought several camera bodies and lenses in for repairs. The heat and moisture of Florida had taken their toll, especially on the electronic gadgets. I then received a call from Universal. I had asked them before leaving Florida to tell me the bird species used in *The Birds*. I thought that they were blackbirds or crows, but I was told that they actually were sea gulls. Universal expected me to find three sea gulls posed and stuffed in an attack position. I was sure that these birds were protected and that it would be illegal to kill them and then to have them stuffed. Eventually, the company decided that black birds would do. So I called my model maker and requested that he make three birds in various attack positions. He purchased the black birds from a taxidermist and made them look menacing. Three days later, I was able to pick up the fake birds.

While I was busy with the birds, Al had been editing film. He had sent a first shipment of film to Bob and the Universal executives. They were in a

hurry to see everything. The editing job, however, was overwhelming because of the volume of film that Al had shot and because Bob had requested that Al do the first selects for him. Furthermore, there were many parts to each set that had to be categorized, selected, labeled, paged, and boxed.

I had included in the budget two studio days for shooting painted backdrops of skies, birds, and telephone poles. However, since some of the creative decisions hadn't been made yet, I split up the studio days. I told Al to shoot one sky background and the birds one day and another sky background and the telephone pole the

next studio day. Bob had selected one sky from a catalog of backgrounds that I had taken with me to Florida. We wanted to match something originally done for a television spot that management had liked. I had booked Dennis and Doug, another assistant, to help us on these studio days.

We had only enough money in the budget to make three stuffed birds. Bob, however, wanted as many birds as possible to strip into his shot. To accommodate him, Al decided to shoot the foreground birds individually. I then asked Al to shoot the stuffed birds from every angle he could think of so that Bob would have at least nine

This image of the painted backdrop of a telephone pole and birds was the final choice for the background of the Hitchcock page in the new brochure.

This final composite shot of the birds
and the *Psycho* House is a compelling
realization of the original illustration
in the Universal brochure.

foreground birds. The background birds would be painted on the backdrop with the telephone pole.

Next, Al hung the stuffed birds from a boom with fishing line. Light-gray seamless was placed in the background 8 feet behind them. Two strobe heads on either side of the seamless illuminated it evenly. Photographed separately, the three birds were illuminated with a bottom light and a banklight for fill. Al then put a blue gel on each of the two rimlights so that the birds appeared to be in moonlight and aimed a catchlight at the birds' eyes to pick up a glint. Al made a series of exposures at each angle before rotating the birds. For even more variety, he photographed the birds with the background lights on and off.

At this point, Al had the painted backdrop unrolled, checked for imperfections, clamped to a crossbar, and smoothed out. The edges of the canvas were then taped to hold it firmly. Depending on the condition of the canvas, running another bar support vertically up the sides and attaching it to the canvas might be necessary. If the sides of a canvas are not perfectly flat, they will reflect in the camera. Hanging, lighting, and shooting a painted backdrop correctly are tedious tasks. Al then bracketed while shooting the backdrop with his Hasselblad.

During the four-week gap between the first and second shoots, I had commissioned the William "Bill" Rogers company to paint a canvas of the telephone pole and birds for the Hitchcock backdrop. I had sent him an outtake of a bird that Al had photographed for reference. I wanted the blue rimlight to be on the painted birds and the pole. I had also sent "Bill" a copy of the Universal brochure so that he could see the perspective used on the set. Al had spoken to "Bill" about how large the canvas should be and had explained that he wanted the pole turned slightly to make the shot appear three-dimensional. We were thrilled with the backdrop; "Bill" had done an excellent job.

Hanging, lighting, and shooting a painted backdrop are tedious tasks.

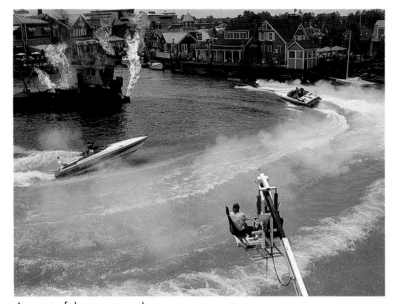

As part of the event on the central lagoon during the Dynamite Nights Stunt Spectacular, the trawler blew up.

Here, you can see Al communicating via walkie-talkie with the assistants who were at different shooting positions. We had rented headsets for the radios to enable us to keep our hands free for operating the camera.

On the fourth day of the first shoot, we photographed the central lagoon during the Dynamite Nights Stunt Spectacular. This show is loaded with action, gunfire, chase scenes, and explosions. Al wanted to shoot from at least six different angles, but he had just two days scheduled for this set. So he decided to allow his assistants and me to do some of the shooting. We needed the cooperation of the show's technicians; they had to coordinate the explosions. We arranged a meeting with the technicians and were pleased to discover that they were pros. They worked out a special 3-hour show for us, during which they would set off three simultaneous explosions for us three times. (Each explosion sequence would last 10 minutes, and the technicians needed 45 minutes to reload and put everything back together between explosions.)

Jay attended this meeting, too. He wanted a shot of the trawler, boat house, and seaplane exploding at the same time. But because the lagoon was quite large and shaped like a long "S," the boat house wasn't clearly visible from the spot where the trawler was, and vice versa. The movable seaplane wasn't a problem. The show on the lagoon during the Dynamite Nights Stunt Spectacular features a second-unit stunt crew shooting a chase scene from the "director's" camera position on a boom on a boat. Jay wanted the boom with the "director" in it included in the composite shot of the explosion scene. We finally agreed to place the "director" and the boom in the foreground on the left side of the photograph. The trawler would be in the center of the foreground, and the seaplane would pass between them. Also, the boat house would be in the background and would appear small in the final image.

Later that day, Al and Dennis walked around the lagoon, checking out all possible angles. They climbed buildings and shot Polaroids using different lenses from different perspectives. Then they mapped out a plan

utilizing every camera body and lens that we had with us, as well as a couple that we had borrowed from friends in the area. Next, Al and Dennis rented additional tripods and clamps. We had two cranes at our disposal, but we needed a third. So I asked Jennifer, my contact at Universal, if we could use one of the booms that I had seen on one of the lots. She checked and came back with an offer of a scissors boom; it would be perfect. A scissors boom is a platform on scissorslike hydraulics that lift the platform as high as 20 feet.

The following morning, Al, the crew, and I met the technicians at Universal at 6:00 AM for our specially designed show on the central lagoon during the Dynamite Nights Stunt Spectacular. Al would do the main shot from a boom on the bridge. Next, he positioned one assistant on the camera boat to shoot the explosions from a low angle. Dennis was then asked to sit on another boom to the left of Al; this was a less desirable but nevertheless good shooting position. Al instructed me to cover the show with his Nikonwide from the bridge.

Al worked on his position first. He placed the 40-foot boom on the bridge. Park personnel barricaded the boom after Al was satisfied with its location. He then set up his cameras and framed the shots. Next, he set up my shooting position. During the shoot, no one would be allowed on the bridge because the vibrations would shake the cameras. Before leaving my position, Al reminded me that I had to cock the shutter and wind the film-advance lever three times after each exposure. So I would be able to shoot only one or two frames of each explosion.

Al then set up positions for Dennis and Ron, the assistant who would be in the camera boat. Except for the Nikonwide I would be using, all of the cameras were clamped and wired so that an assistant could fire them via electrical releases. Each of us had a walkie-talkie. Our other assistants would act as runners moving between the four setups whenever we needed

something, such as film. By the time we had worked out the details, the technicians had arrived and started loading the explosives. The technicians were also on walkie-talkies on our radio frequency and would give us a countdown. They rehearsed a couple of times because this routine differed from the show they usually did. The practice helped us, too; we could see where the boats' marks were.

Tourists began lining up around the lagoon in order to get a good view. The show's director announced that he would do a couple of dry runs with no gunfire and no explosions. Al, the assistants, and I watched the action and made sure that our framing was good. Dennis took a light reading and radioed the rest of us to tell us the right camera settings to use. We would have to open up because the weather was not ideal, only acceptable.

Finally, the big event was underway. Al gave the okay, and the director yelled "Action!" The good guys chased the bad guys in their motorboats. The seaplane motored down frame and fired shots. The good guys shot back, causing the tail of the seaplane to blow up. At the same time, the trawler blew up and split in half; the bad guys drove their speedboat into the boat house. Then it also blew up, causing the speedboat to be blasted through the back wall of the boat house.

There was a slight snag during the first show: one of the explosions went off late. But the second and third shows were perfect. Two takes enabled us to get the shots we needed. I thought that I had captured some fine images with the Nikonwide even though it is a difficult camera for action shooting. Al and Dennis were happy with what they saw from their positions, too. Al felt that the show was so spectacular that it would more than compensate for the dull sky.

The following day, we shot the regular show on the central lagoon in the Dynamite Nights Stunt Spectacular from six positions around the water.

Then the speedboat also blew up, causing it to be blasted through the back wall of the boat house.

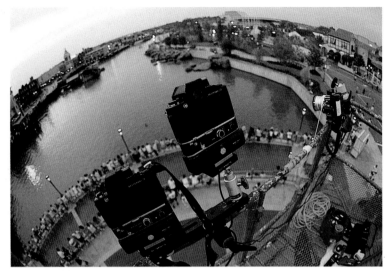

Al set up Dennis' shooting position on the north end of the lagoon. He set two Nikons on an electrical-release system, so that Dennis could fire both of them at the same time.

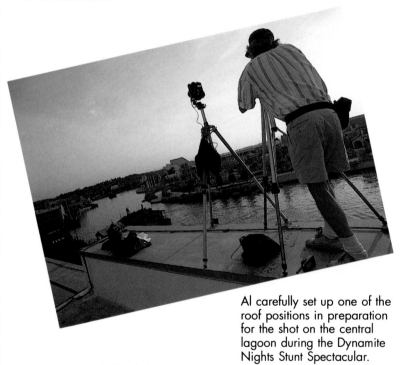

Al carefully set up one of the roof positions in preparation for the shot on the central lagoon during the Dynamite Nights Stunt Spectacular.

When the boat ripped through the wall, it headed straight at me.

This time our objective was to isolate each explosion and to depict crowds watching the action whenever possible. During the scout, Al had selected specific places for each of us to shoot from and with Dennis had made a list of which camera bodies and lenses would cover the various angles. Al then assigned a person to each position. Al shot from the scissors boom at the south side of the lagoon while Dennis was on a boom on the extreme north end. I shot from the ground behind the boat house. I was originally supposed to cover the seaplane, but when I learned that it was out of commission, I concentrated on the boat blasting through the wall of the boat house. I was in an excellent position for that; when the boat ripped through the wall, it headed straight at me. Two other assistants shot from the rooftops of buildings surrounding the lagoon, and another shot from a boom down near the trawler. Al set up each of our positions, framing the shot, and told us what film and shutter speed to use. He also told us to listen to Dennis' instructions about *f*-stops before and during the shoot.

The sky was bright, sunny, and intense the entire day. In fact, we had to cover the cameras in between explosions to protect them from the heat. We hoped to shoot a beautiful sunset during the last show, but the weather changed. Black clouds started blowing in late in the afternoon, so we knew that the sunset would be dull. We then tightened up the framing to exclude most of the sky, and Dennis radioed updated meter readings to all of us.

A few weeks later, Mike told me that the shoot on the lagoon during the Dynamite Nights Stunt Spectacular was his favorite and that Jay could hardly contain himself. They immediately included one of these shots in Universal's newspaper and magazine advertisements. Mike also said that they had had a hard time deciding which photograph to use. Shooting the lagoon from every possible angle cost more but was worth it.

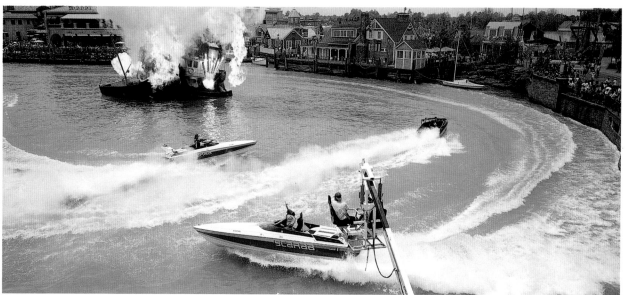

The weather was not the best for the shoot during the Dynamite Nights Stunt Spectacular, so Al cropped the horizon out of this shot to downplay the problem. He used a 38mm superwide Hasselblad with a 35mm back from a boom to make this image.

To photograph this scene, Al had the scissors lift positioned at the south end of the lagoon.

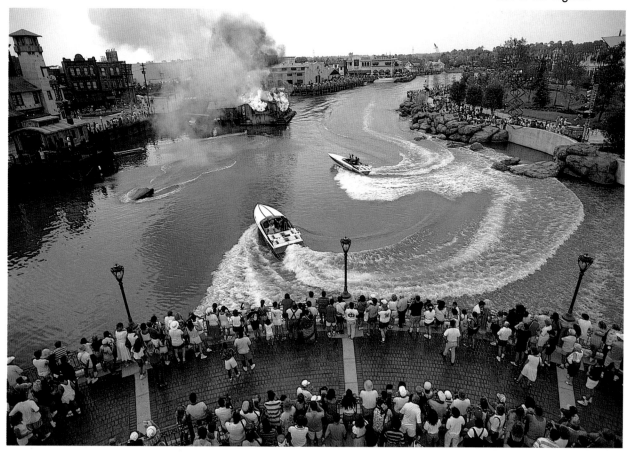

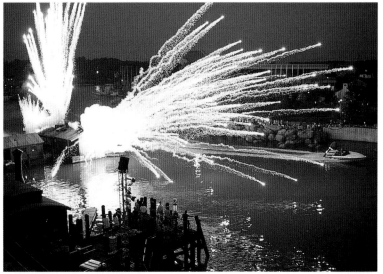

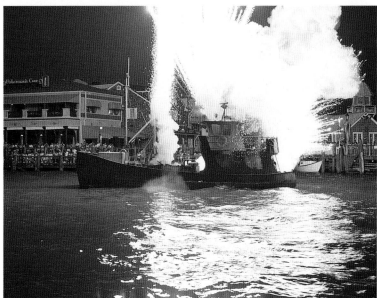

These images of the spectacular stunt show were photographed from various positions, including the scissor lift (left), a rooftop (top), and street level (above).

A month passed before Al, the crew, and I returned to Universal to shoot the street scenes and aerials; the facilities had been under construction during the first trip. The first day that Al and I were there, we toured the streets that Al was going to photograph to determine the best angles. Since we would be arriving on a Sunday, I had called the preceding Friday to rent a 40-foot boom for Al to use on Monday. When we arrived at Universal Monday morning at 6:00 AM, we moved the boom from the back lot to the Amityville street. Everything was po-

This outtake of the Amityville street set was shot from a 40-foot boom.

sitioned at 9:00 AM, but we had to wait until 10:00 AM to start shooting because we needed crowds to be in the photograph. Jennifer, Bob, and I ran around asking Universal's guests to be in the picture and to hold still at certain times. Some of the character actors who walk around the studio wandered into frame from time to time, bringing studio guests with them. Al shot this street until noon.

On the next day of this shoot, we returned to Universal to photograph the studio's entrance gate. Universal had hired 20 extras for us to position wher-

ever we wanted; the other people in the shot would be actual guests. Al had the boom moved to the front of the studio. Jay wanted a shot that showed the front gate and looked down the main street. It was an impressive scene, but the street didn't go straight back. So Al planned to shoot the front gate and the street until the bend, then move up to another point on the street, line up the street in the framing, and shoot it in the same perspective. Bob would then be able to take the main shot, retouch the background out in one spot, and put in the bigger and straighter background. Since the second shot was taken later in the day, it was cooler in color. As a result, Al had to filter it to match the warm morning light of the main shot. While Al was shooting, he gave directions to me or the casting director that we passed on to the extras who were acting out a piece of business for us.

Next, we moved the boom over to the Hollywood street set that was half as long as the main street. Bob wanted to give the street more depth. Al accomplished this by shooting 20 feet off of the ground with a 15mm lens on his Nikon and a 38mm lens on his Hasselblad. Al shot at an angle down the left side of the street and then at an angle down the right side. Later on, Bob would be able to take the two shots, match the converging center of the street, and redo the center line. This would make the street appear much deeper in the final image with a forced perspective. This shot actually proceeded fairly smoothly and quickly—but not to Al, who had to sit in the crane in Florida's sweltering heat and who hadn't had any sleep for the past 32 hours.

Nevertheless, we decided to continue shooting. We had rented a Bell Jet Long Ranger for the aerial night shot of Universal. Al installed a Tyler camera mount in the helicopter's rear-seat area. The mount had to be adjusted to accept both his Nikon and his Hasselblad. Al needed to use ultra-wide-angle lenses because he had to

Al shot the Universal entrance gate from a boom early in the morning.

Al wanted to correct for the bend in the street as well as to make the New York Public Library at the end of the street more visible. So he moved down the street and shot a tighter version that could be stripped into the main gate shot one third of the way down the street.

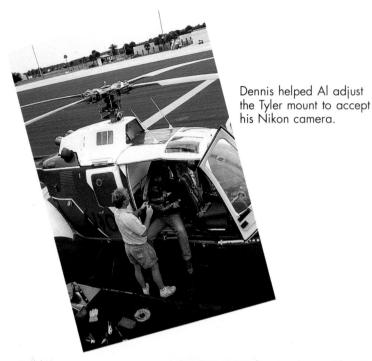

Dennis helped Al adjust the Tyler mount to accept his Nikon camera.

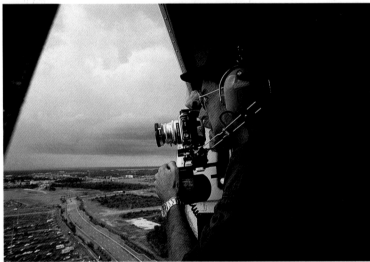

Here, you can see Al framing the aerial image of Universal Studios Florida in his Nikon Superwide camera.

Even though it was pouring when Al was photographing the aerial image of Universal at night (opposite page, top), he continued to shoot. The sky to the west was beautiful, and behind him was a wall of dark clouds.

Al made these two twilight images (opposite page, center and bottom) from a helicopter using his Hasselblad with a 30mm lens and a 35mm back. He pushed Kodachrome 200 1⅓ stops to ISO 500 to create these effects.

include the entire park in one shot. He wanted to shoot as late as possible into the night because Universal's lights would make it look magical. Also, wider lenses are easier to stabilize than telephoto lenses; this makes them better suited for low-light photography, when camera shake is always a consideration. Al selected a 15mm lens, a 16mm lens, and a 20mm lens for the Nikon, and a 38mm superwide lens and a 40mm lens for the Hasselblad. Both cameras have quick-release feet, so Al was able to switch camera bodies easily. He shot Kodachrome 200 film and pushed it 1⅓ stops without sacrificing the film's color or punch.

Al's primary concern was balancing the rig for both camera weights. Once that was done, Al helped Dennis set up his system in the back of the helicopter. Dennis was in charge of reloading the cameras when Al handed them to him and marking the film canisters. Al asked me to stay at Universal and watch the sky while he left for the heliport with Dennis. If the sky to the west was clear, he would shoot. We were hoping the rainy weather pattern would give us a break. Luckily, it did. Al was airborne and hovering over Universal within 10 minutes. I had taken a radio and went out on site to watch him and be available if he needed something. The few clouds in the sky made the sunset dramatic. Without warning, it started to drizzle and then pour. I kept waiting for the helicopter to pull up and head back to the heliport, yet Al continued to shoot.

At first, I couldn't understand why. But when I looked westward, I saw why: the sky was gorgeous. I started thinking about what Universal must look like from up in the helicopter. The streets were wet, the lights were on and reflecting in the water, and the sky was filled with brilliant shades of orange and magenta. Al repeated the shoot the next night, but Mother Nature didn't cooperate. It didn't matter, however, and we didn't care. The aerial photographs from the preceding night were the winners.

We sat in the theater for hours while the technicians tried to figure out how to beat the computer program.

On the second day of the first shoot, we had to do another film-clip test run and pick up the equipment at Panavision. After dinner, we loaded the rest of the gear into the vans and headed to Universal to the *Ghostbusters*™ set to shoot the main background stage. We really should have been photographing this show for two full days with a crew of eight, fifty 2,400 w/s packs, and a hundred strobe heads. But Universal refused to stop paying guests from seeing the show. So we had to wait until the show ended and work from 11:00 PM to 6:30 AM—no earlier, no later, no exceptions. We couldn't set up lights one night and leave them in place for the next night as well, so shooting with strobes was out of the question. Instead, we used six 1-Ks, which are very powerful daylight-balanced incandescent lights.

By 10:45 PM, the last guest had left and we were allowed in to set up. Because we really hadn't seen the show and its lighting cues yet, that was the first item on our agenda. While the assistants brought in the equipment, the technicians ran the show without actors to enable us to get an idea of what the lighting looked like. At the same time, a maintenance worker unbolted the theater seats from the area that Al was going to shoot from. The working space was very limited.

The show is run by a complicated computer program. The cues for the sound effects, lights, special effects, and ghosts are all locked into one another. The show operator pushes just one button to run the whole 20-minute program. Then all of a sudden, the exterior doors to the theater close, the audience lights dim, and the air conditioning kicks in. The *Ghostbusters*™ theme plays very loudly, making conversation impossible. The curtains open. Then the big golden doors of the vault open. Liquid-nitrogen smoke fills the stage. The Stay Puft Marshmallow Man appears and rolls his eyes. Laser beams flash across the stage. Stay Puft turns red and dissolves into liquid nitrogen. After see-

ing the show in its entirety, we decided to shoot the stage just before Stay Puft turned red. The technicians tried several times to stop the show there, but it was virtually impossible. We sat in the theater for hours while the technicians tried to figure out how to beat the computer program. The only possible way to isolate part of the show is to rework the computer program. That, of course, couldn't be done and undone in time for the next morning's first performance.

The technicians then tried one of the simple codes they use to communicate particular problems to one another. The "E-stop" code means emergency stop. The program had protection built into it to keep the mechanical objects from destroying each other during the show. If a ghost or laser didn't come up right, the E-stop would shut everything down until the technicians could solve the problem manually. In this situation, the technicians attempted to trick the program and manufacture an E-stop at the right place in the show. Stay Puft, however, wouldn't lock into place and always sank back down. A technician then decided to manipulate its base, hoping that this would solve the problem.

Al, meanwhile, had been directing the assistants in the placement of the lights and smoke machines. The equipment should have been plugged into the stage's electrical outlets but there were no outlets backstage. So Al had to run about 600 feet of cable down the back steps and out the doors to plug his equipment into outlets in closets and bathrooms. One cable was even plugged into a neighboring building's power.

Next, Al wanted the light behind Gozer, another character, to be special. Unfortunately, at the place we wanted to stop in the show, there was no lighting cue for her. So we decided to create our own lighting effect. Al used Roscoe smoke generators to add smoke fill around both Stay Puft and Gozer. He couldn't use liquid nitrogen because it is very dangerous; someone might suf-

focate if trapped in one of the small areas we would be working in. Although the technicians never got the show working that night, Al and his assistants had a very good dry run in terms of the lighting and special effects. To prevent the same power problem from reoccurring the next night, Al instructed the assistants to bring a generator with them.

The thought that we might be leaving without shooting even one roll of film drove us all crazy. We asked a technician if we could at least shoot the laser. He said we could; he just needed 10 minutes to isolate the laser from the rest of the show. Al was relieved that he would be able to shoot something that evening. When the laser was ready, Al positioned his cameras and photographed the reflection off the glass. This shot took about an hour. We finally left the Ghostbusters™ stage at 6:30 AM.

The next night, the technicians met us at the door with grim faces. One of the ghosts had been malfunctioning, and they needed that evening to repair it. We wouldn't be able to shoot that night. So another night was lost. It seemed Al would have to shoot the entire Ghostbusters™ stage in one day without time to do anything creative. Fortunately, on the next and final evening allotted for the Ghostbusters™ set, the show ran smoothly. We had rented a generator that was left out back for easy access. And within just an hour's time, they were able to accomplish the E-stop needed to freeze Stay Puft in the upright position.

Al was supposed to shoot an overall scene of the 100-foot-wide stage from the audience position; the two areas were separated by optically flat glass panels. Al had spoken to the retoucher earlier about the mullions supporting the panels, and they had come up with a way for Al to shoot the set so that the mullions could be masked out later. The retoucher needed Al to photograph what was behind the mullions in order to replace the mask with that piece of art. Al accomplished this vital

Al photographed this Ghostbusters™ laser effect as a reflection.

For the main shot of the Ghostbusters™ stage, Al stood on the audience's side of the glass and used a 40mm lens. The mullions had to be retouched out of the shot.

Here, you can see Al at work, shooting the Ghostbusters™ set from the outside of the glass. He fired the cameras with a cable release to eliminate vibrations.

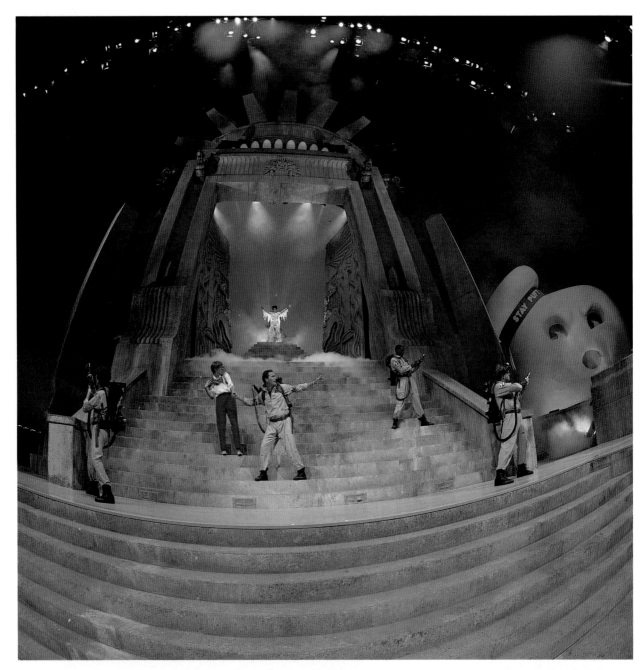

Al wanted to shoot the *Ghostbusters*™ stage from the inside of the glass, too, so that Universal would have another option. He liked this version better because the action was more dynamic from this position, but he was concerned that Universal wouldn't like the distortion.

Al was concerned about the actors' ability to stand still.

task by setting up two shooting positions, the perfect position and then another position that was a little lower and to the right. Al used a Distagon 40mm CF lens on a Hasselblad with a 35mm back and Kodachrome 25 and 200 film filtered for incandescent light. He had chosen the 40mm lens because it is incredibly sharp edge-to-edge and optically corrected, and when used with a level 35mm back, there is virtually no distortion. Al ran some light tests and checked the Polaroids.

Satisfied with the lighting, Al asked to have the actors brought out on stage. The glass panels cheated Al out of two stops of light, so he had to make exposures that were 10 to 20 seconds long. This led to another problem. Because a few of the actors were tired or bored and wouldn't or couldn't hold still, Al was concerned that they would look either stiff or blurred in the pictures. He complained about the actors to me, but I explained that they weren't our responsibility and that we had no control over them. In situations like this, you just have to keep shooting and do the best you can. Uphold your part of the agreement, and let the client uphold theirs. Al had a hard time listening to my advice because he wanted this shot to be great. So did I.

After Al finished photographing the full stage from the audience side of the glass, he wanted to try some shots from the other side. He didn't have much time to spare because we still had to shoot the ghosts. So he quickly walked around to the other side of the glass and stood on the edge of the stage. An assistant held him by the belt so he wouldn't fall. Al mounted a Hasselblad with a Distagon 30mm lens, which is equivalent to a full-frame fisheye lens, on a tripod. Al preferred this setup and perspective because the action onstage appeared bigger. Because of the configuration of the stage, Al had only two shooting positions to choose from. Shooting from the audience side of the glass produced a good, undistorted view of the overall stage, but the actors were lost. Shooting from

Al photographed one of the ghosts as a reflection off of the optically flat glass between the audience and the stage. He used both the 2¼ and 35mm formats for the retoucher's convenience.

This was the second shot of Slimer that Al took after lighting corrections had been made.

Universal decided that it wanted Al to shoot this three-headed monster and planned to strip it into the main *Ghostbusters*™ shot later.

These extras were photographed to replace the people from the first *Ghostbusters*™ shoot. Al had to match the angle exactly so that they could be stripped in seamlessly later.

Here, Al waited for Rich and me to adjust the models' platform position.

This actor was another replacement for a member of the original *Ghostbusters*™ cast.

the stage side of the glass forced Al to use an ultrawide-angle lens to include the entire stage in the shot, which was one of Universal's requirements. Here, the stage was distorted, but the actors and action loomed larger and looked more interesting. Al covered the stage both ways so that Universal executives could have a choice.

Next, Al returned to the audience side of the glass to shoot the ghosts. The technicians ran the show a couple of times so that Al and Bob could select the two ghosts they liked the most and their positions. One of the technicians took notes on when to use E-stops during the show and went upstairs to the ghost gallery to work them out. She accomplished this quickly. The room had to be completely dark and the ghost images illuminated to reflect in the glass. Al then separately photographed each ghost reflection rather than the actual figure for several reasons. First, the reflected image looked more ghostlike. Second, there wasn't enough room where the ghosts were for him to maneuver easily. Bob and the retoucher could decide later how the reflections would work into the overall picture. Al finished the last roll of film by 7:00 AM.

On the fourth day of the second shoot, we were up at 5:00 AM to photograph the *Ghostbusters*™ actors again. Universal had decided that the actors looked too posed in the first group of pictures, and one of them was continuously blurred. So Universal gave us an entirely new cast with the exception of Gozer. We were to photograph these actors in a believable pose, and they would be stripped into the main shot later. The first problem was that we couldn't use the stage because we had to shoot in the morning during the *Ghostbusters*™ show and Universal wouldn't cancel the show to allow us to use the stage. Universal had been trying to find a place for us to work. Then Al came up with the great idea of photographing the actors in the "Animal Actors" amphitheater. The seat/steps were similar to the steps on

the *Ghostbusters*™ set, and Al could have the actors move up and down on the steps to match the perspective in the main shot. We had to be out of the amphitheater by 8:30 AM when the show opened. Universal agreed that this was the answer.

First, Al and his assistants positioned all of the strobes on apple boxes on the bleacher-style seats. Next, a platform was made on which the actors could stand. Al had one of the actors get into position and worked on balancing the light and color temperature to match what he had done a month earlier. These new actors were hardworking professionals—and fun to be with. Mike was pleased with the Polaroids of them. Universal had also told us that we would reshoot two ghosts because the technicians had worked out some of the bugs with their lighting, and that we would shoot a third ghost as well. This shoot was scheduled for that night, so we had the rest of the day to return strobes, walkie-talkies, and the other rented equipment.

We met at the *Ghostbusters*™ stage at 9:00 PM to photograph the ghosts. This session went like clockwork. Everyone had the routine down now. The lighting on the ghosts was much better, and the cuing of the ghosts took no time at all. The seats had already been removed to give Al room to work in. Luckily, the tape we had put on the bottom of the seats during the earlier shoot was still on them, so the maintenance workers had been able to just come in and remove them. We called this shoot a wrap by 2:00 AM.

I had made reservations for an afternoon flight to New York, but we still had to get up early and pack every-

thing. Al cleaned his cameras, and Dennis organized the film into batches and made a list of what was to be clip tested. The other assistants packed the equipment and worked on their petty-cash envelopes. Back in New York, the film was processed and looked great.

In between shoots, I had selected another sky backdrop for the *Ghostbusters*™ pictures. The one that Al had photographed didn't work well with Bob's layout. He didn't like the original sky, and neither did I. So I took the liberty of selecting a new one for Al to shoot. Bob said he trusted my judgement. He was busy retouching the images and working on the layouts for the new brochure that Universal was anxious to finish. Some time later, Jennifer called to tell me that Jay and Mike had seen all of the retouched composite photographs and had been pleased. Bob was very happy with the final results, and although Al and I haven't seen them yet, we are sure that we will be pleased, too.

This painted backdrop of a sky was selected to be stripped into the background of the *Ghostbusters*™ shot.

The first problem was that we couldn't use the stage because Universal wouldn't cancel the show.

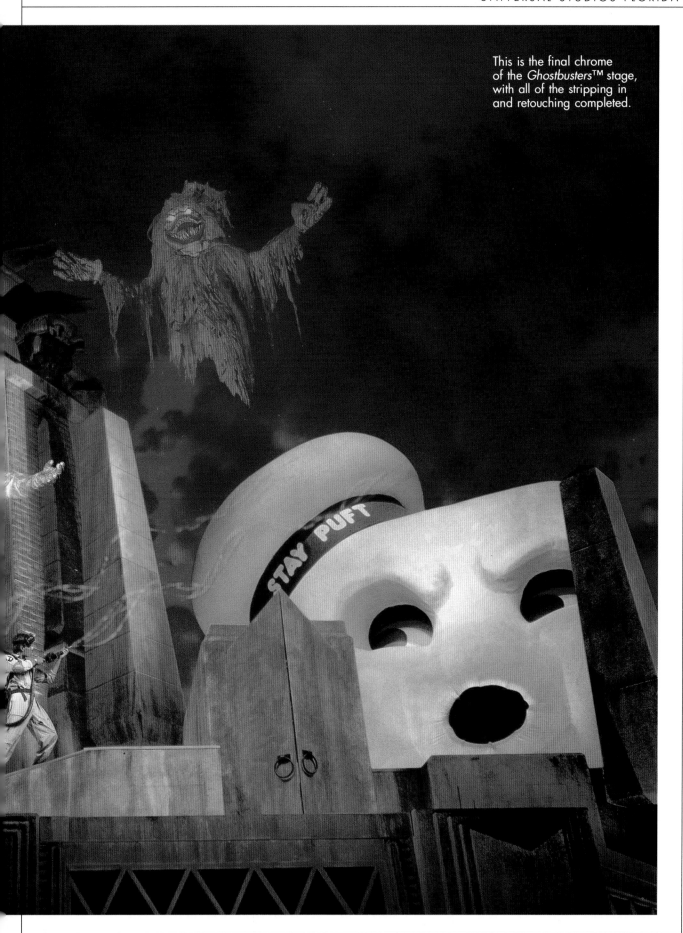

This is the final chrome of the *Ghostbusters*™ stage, with all of the stripping in and retouching completed.

INDEX